SHABBY
CHIC

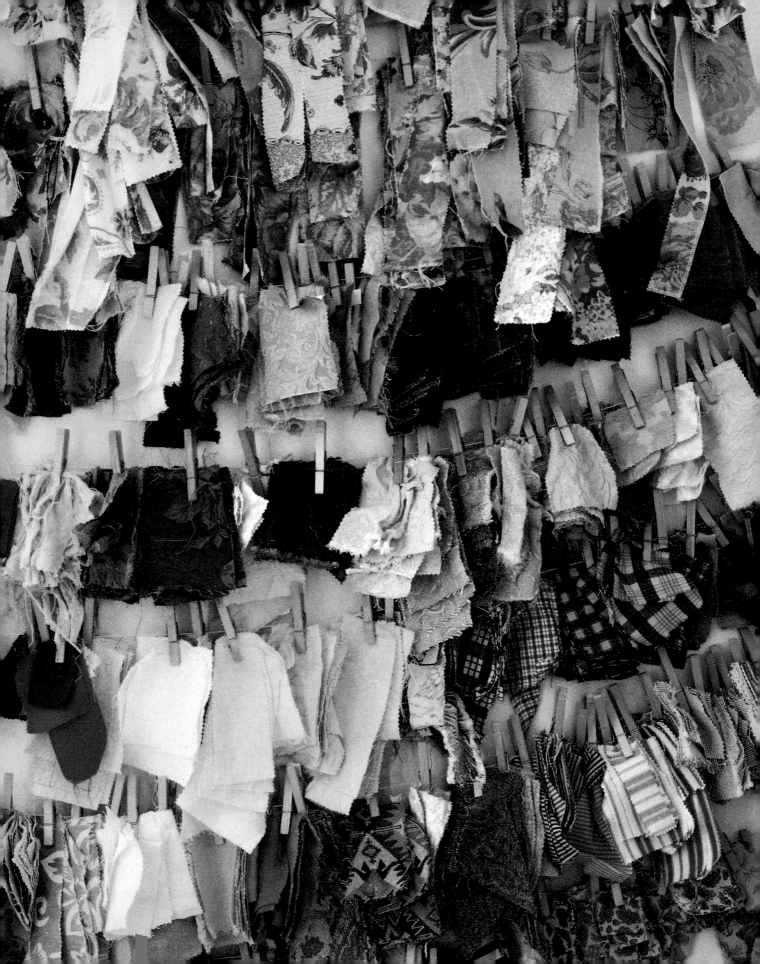

SHABBY CHIC

RACHEL ASHWELL
WITH GLYNIS COSTIN

PHOTOGRAPHY BY ART STREIBER

ReganBooks/HarperStyle
An Imprint of HarperCollins*Publishers*

PAGE i: Relaxing the formal quality of traditional linens is as simple as pairing them with offbeat or worn-looking companions. Here, pretty floral napkin rings made of paper give a casual look to these crisp linen napkins.

PAGE ii: The variety of patterns and textures on this wall demonstrates how cottons, linens, velvets, chintzes, damasks, and chenilles can be combined with neutrals, pastels, muted brights, checks, stripes, and florals to form a colorful bazaar of choices.

HarperCollins books may be purchased for educational, business, or sales promotional use. For information please write: Special Markets Department, HarperCollins Publishers, Inc., 10 East 53rd Street, New York, NY 10022.

FIRST EDITION

DESIGNED BY JOEL AVIROM AND JASON SNYDER

ISBN 0-06-098204-7

97 98 99 00 ❖/NI 10 9 8 7

—————

THIS BOOK IS DEDICATED
TO LILY AND JAKE.

—————

CONTENTS

ACKNOWLEDGMENTS

This book is a collaboration of many dear people and their support, enthusiasm, and knowledge.

First, my thanks to Ted, who helped me formulate and focus my thoughts, enabling me to express myself and discover what I didn't know I knew. If I hadn't had that ability, this book would have been very different.

I thank Glynis and Art for their expertise and their openness to understanding my so particular a vision.

I thank the loyalty and encouragement of Brendon McBreen and my Shabby Chic staff as well as all those clients who inspired me and allowed me to photograph their homes and possessions.

My thanks to Nina Krivanek for her gloriously refreshing floral displays. My gratitude to Judith Regan and Joseph Montebello, whose interest in Shabby Chic allowed for the book.

My thanks also to Luppe for the endless supply of beverages and laughter when we all became a little too serious.

And last, my many thanks to my parents, Shirley and Elliott Greenfield. They set examples for me of how to be comfortable with imperfections, and taught me that imperfections represent the traces of life that should be valued and respected, not covered up or discarded.

PREFACE

Shabby Chic evolved as a practical answer to family living. When I found myself a mother of two, in a world of sticky fingerprints and muddy shoe tracks, I began to throw rumpled white denim or cotton over my couches and chairs, as almost more of a whim or afterthought. Slipcovering my furniture wasn't a well-thought-out plan devised to protect my furniture, and it certainly wasn't something I invented. Yet there was a certain appeal to this sensible, washable, portable way of dealing with modern living, and soon my friends began asking for slipcovers for themselves. That is how Shabby Chic—the store—began.

Since then, Shabby Chic has evolved into furniture, fabrics, and home accessories that have the same casual appeal and easy style as slipcovers. It is a style that is quiet, simple, peaceful, and practical, allowing for the mixture of many tastes. It does not commit to Victorian, modern, or any other particular era and can work with a number of different styles or houses. Over the years I have learned that the house itself is of less importance than its contents and how those contents reflect the life within.

In my travels, many things have passed through my hands, but those few items that I hold on to are those with the character, wrinkles, and imperfections of history and experience. It is my hope that this book offers insight on knowing how to see these things, what makes them appealing and useful, and how they fit into the Shabby Chic style.

SHABBY
CHIC

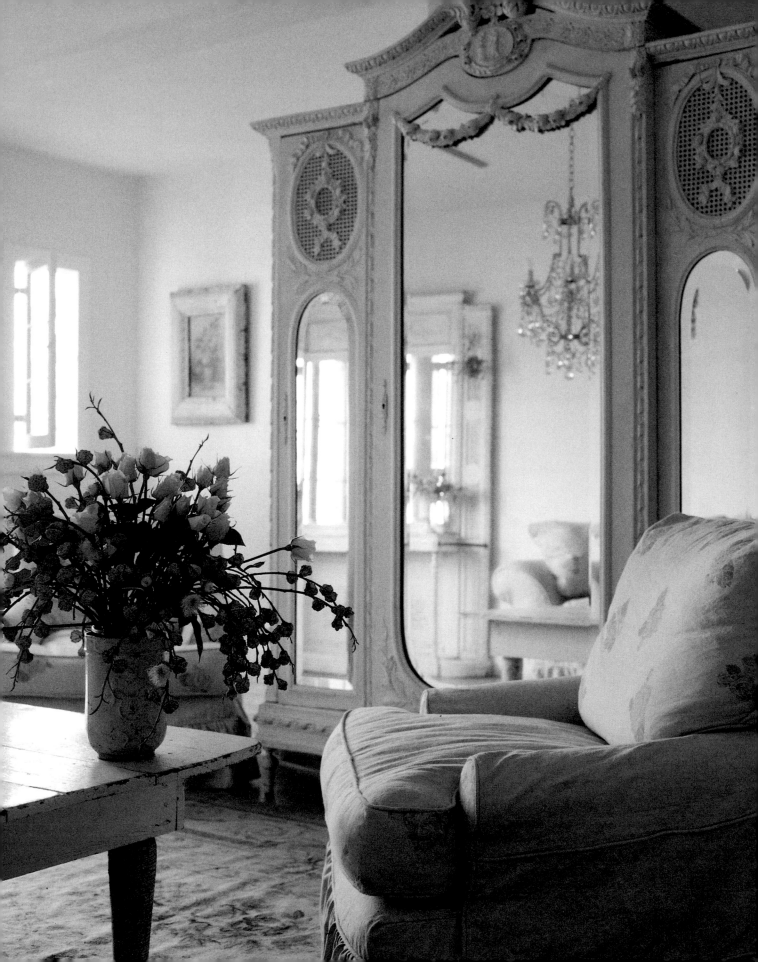

INTRODUCTION

Comfort, the beauty of imperfection, the allure of time-worn objects, and the appeal of simple, practical living: These are the cornerstones of what has come to be known as the Shabby Chic style. Shabby Chic, the home furnishings label and retail chain I founded in 1989, is now recognized not only as a brand name, but as a decorating style. Though some may find the phrase "shabby chic"—the idea that something "shabby" (faded and dilapidated) can be considered "chic" (elegant and stylish)—paradoxical, the two elements go hand in hand. Shabbiness, in its shunning of what is too new, modern, or ostentatious, as well as in its rebellion against perfection, is precisely what makes this comfortable look so alluring. The cozy familiarity of a well-worn, beloved pair of faded blue jeans—versus the starched stiffness of a new pair—is the appeal of Shabby Chic.

I didn't invent this relaxed style. Europeans have long appreciated this approach to living: Witness the dilapidated elegance of an Italian villa, French castle, or English country estate whose owners can easily afford new furnishings, but prefer the worn grandeur of faded velvets and peeling vanities handed down from their ancestors. Shabby Chic represents a revived appreciation for what is useful, well loved, and comfortable, for those things that some might perceive as being too tattered and worn to be of use or value.

Collecting important, rare, or costly objects meant to be seen and not touched is not part of the Shabby Chic philosophy. My philosophy of decor is that nothing should be too precious. A child should feel free to put her feet on the sofa, a guest, his cup on the coffee table. I believe in cozy, not fussy; relaxed, not stiff. I believe in living in, on, and around one's things, not merely with them.

A roomy, slipcovered chair big enough for a child and a dog or two, with slightly wrinkled, worn fabric and ample arms perfect for plopping your legs over; an old trunk, its paint peeling around the edges, given new life as a coffee table; a vase of roses from the garden, a bit wilted, a few petals missing; a vintage mirror, framed with a white floral iron piece salvaged from an old gate and chipped in places, but still charming; a slightly rusted flea market chandelier; a scratched-up coal scuttle used as a bread box; an array of vanilla-scented candles adding a warm glow to a cozy room—these are some of the elements of the effortless, inviting look I prefer. Colors in keeping with this way of living tend to be soft, palatable tones such as seafoam, mint, and celadon greens; dusty roses; pale sky blues; and ivories, creams, and grays that appear to be muted by age, or crisp, clean whites that blend with everything. Brighter or

darker colors can occasionally be a part of the look if they are treated with subtlety, combined with white or light colors, or if they appear to be faded by time.

But Shabby Chic goes far beyond the stereotype of a few tea-stained florals and some cushy chairs. Some have called this shabby yet elegant look "a marriage between the laid-back, breezy ease of Los Angeles beach life and the romantic prettiness of English country life at its most casual." Others have described it as having "the aura of old money, cushy comfort, and crafted indifference" or as "the merging of a romantic, old-fashioned, aesthetic appeal with modern functions." To these qualities, I would add that the style suggests things that are inherited rather than store-bought and handcrafted rather than mass-produced. It is also a style that is appreciative of the beauty of process and evolution.

I'm attracted to the quirky appeal of chips, stains, cracks, dents, and irregularities that assert character and reveal the charm of history. I gravitate toward the crumbling, the disheveled, the tattered, and the battered. I am drawn to materials that are happily vulnerable to the effects of time, weather, and touch, influences that result in discoloration, staining, tearing, shrinkage, and fading. But I also believe in function, eschewing waste, and in advocating new uses for old forms. In practical terms, this means using washable fabrics, recovering or restuffing an old sofa or chair instead of buying a new one, combining objects that are complementary rather than a perfect match (an approach that is especially handy if you are missing pieces of sets), and paring down as opposed to adding on. I have turned many an old door into a coffee table, crumbling moldings into picture frames, and wicker laundry hampers into end tables. I rarely discard anything that is serviceable and somewhat aesthetically pleasing without at least attempting to find a place and use for it.

Unlike some decorative styles that work only in certain types of environments, Shabby Chic is a style that is versatile and boundary free. As a design philosophy of comfort and faded splendor, it encompasses

BELOW: **Here is a good example of how flowers, in this case, ones made of painted leather, can be used to adorn common fixtures. Note how the cracks in the wall behind this beveled mirror echo the shabby feeling of the flowers.**

OPPOSITE: **I transformed this old coal scuttle I found at a flea market into a bread box simply by cleaning it up and adding a piece of white linen. The box could also be used for cookies, rice, pasta, or other dry foodstuffs.**

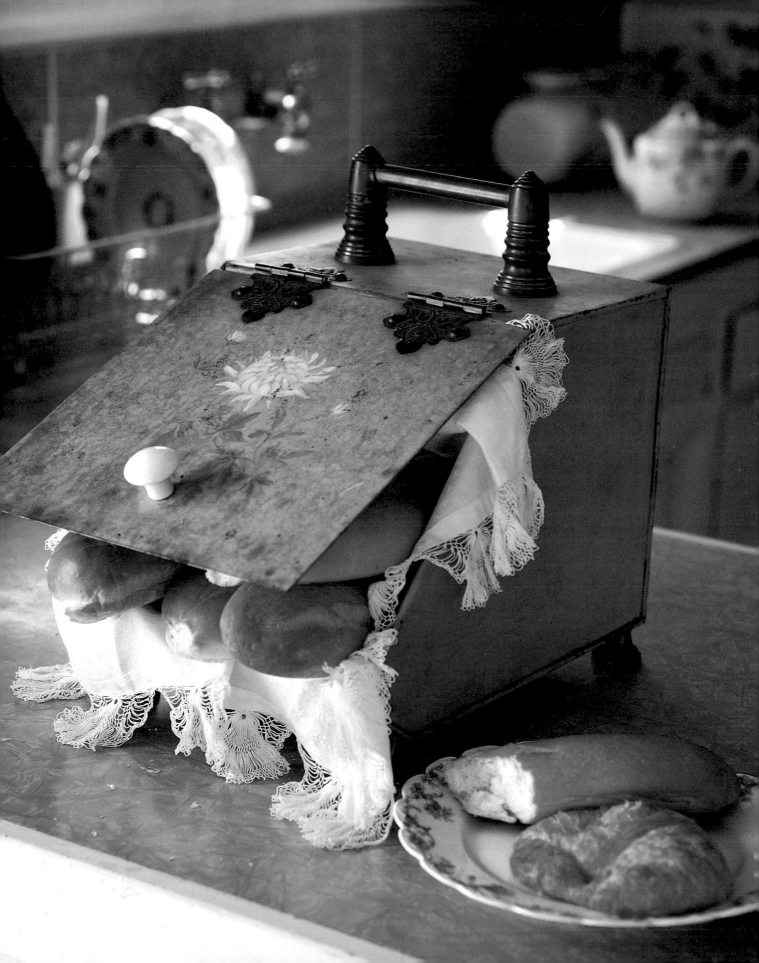

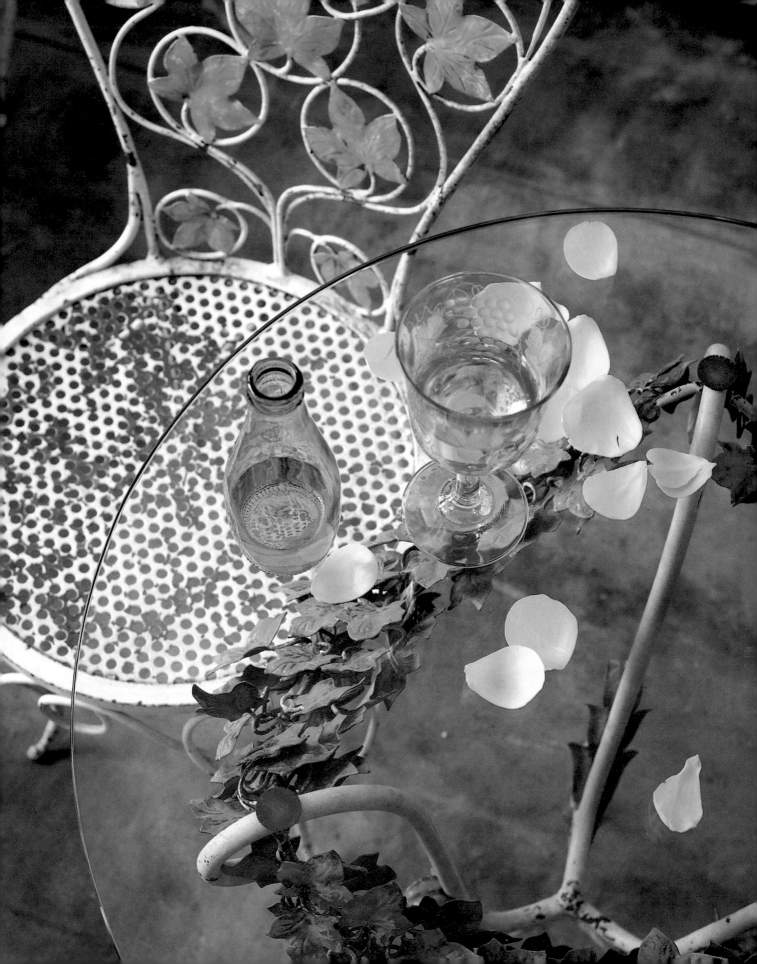

not only furniture and fabrics, but also the more subtle nuances of lighting, flowers, and color. This book will help you learn how you can easily incorporate this unaffected look of timeworn elegance and practicality into your own home. Here, I show you how the style works not only in traditional country homes and cozy beach cottages, but in high-tech contemporary houses and rented apartments where one is forced to work around certain unchangeable structures. I illustrate how different rooms—from bathrooms and bedrooms to eating areas and living rooms—respond to distinct elements of this style and suggest several ways to help these spaces achieve a simple and unpretentious style, sometimes by simply taking away clutter or by adding a touch as basic yet as luxurious as a basket of fluffy white towels. With a trip to the flea market, I demonstrate how to find treasures amid the trash, showing you what to look for and offering ideas on restoring and revamping. I emphasize the significance of furniture that highlights comfort, has classic appeal, and complements an entire look. I also point out the ways in which different fabrics can help to create a specific mood and stress the importance of using personal inspiration—from nature, life events, or even ordinary observations—to create a home with an individual, welcoming feel. The ephemeral beauty of flowers in all their stages, from the garden to fresh arrangement

ABOVE: **I loved the rusty patina of this little iron end table I'm holding here at a flea market. All I did to make it functional was to top it with a piece of glass.**

OPPOSITE: **The intricacy of the ironwork on this Italian chair and table with an ivy motif indicates the pieces' age. Modern iron pieces tend to be much cruder. The worn patches on the leaves and the variations in color add to the authenticity and appeal of the furniture. (See Resource Guide.)**

to falling, faded petals, as well as the way they are represented in paintings, on fabric, or on decorative objects, is also discussed.

Although I offer several helpful hints, this book is not a manual, but rather a detailed illustration of the various ways in which you can easily achieve your own version of the Shabby Chic style. The key lies in simply weeding out the unnecessary, trusting your instincts about what is comfortable and practical, noticing details, experimenting with new and complementary combinations of colors and fabrics, and looking at imperfection and age with a whole new appreciation for their unique significance and beauty.

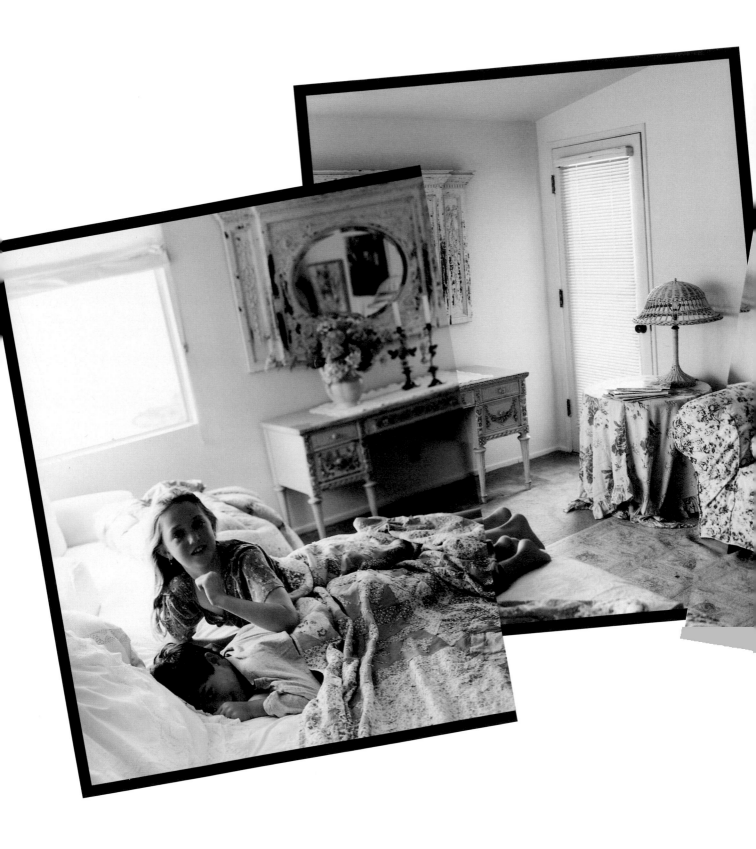

1

DIVERSE STYLES

What is essential to the relaxed, shabby yet chic look, marked by what is comfortable, worn, and often tattered, can be incorporated easily into a variety of decorating styles. A cushy, white slipcovered chair, a casual floral arrangement, a peeling vintage piece, soft lighting, the use of white, and mixed and matched fabrics and textures can look as natural in a sleek, contemporary home as they do in a more traditional setting, such as an eclectic Spanish, French country, or casual beach house. Making the style work is a simple matter of how the elements are put together.

The key to making everything work is to include a balance of complements and contrasts, a display of the effects of time, traces of real life, and a merging of gilt and grit. Anything that appears too contrived or calculated is the antithesis of this look. The Shabby Chic style opts for haphazard arrangements over perfectly symmetrical ones, framed pictures propped against walls rather than hung neatly, and rumpled fabrics rather than pressed finishes.

There are certain floor, wall, and ceiling treatments that I consider to be effective foundations for the Shabby Chic look. Sisal rugs, tile, and hardwood floors, for example, work in formal and casual settings and with a variety of furniture styles, be they traditional or contemporary. White and off-white walls, textured wallpaper, interesting molding treatments, and natural cracks and crumbles can work in almost any style home, as can high, exposed wooden beam or embossed tin ceilings.

While there are certain elements that work with most style homes, such as white slipcovered chairs, there are certain variations that work better for some styles than others. In a high-tech contemporary home, for example, fitted slipcovers may work better with the sleek surroundings than would the loose and roomy look more typical of the Shabby Chic style. Whereas, in a beach house, a casual, more rumpled look blends in better with the overall relaxed mood. Following are some specific examples of how basic elements of the Shabby Chic style, as well as modifications of the look, work in different homes from modern to traditional.

PREVIOUS PAGES: This bedroom is composed of a series of misfit pieces. Nothing quite matches, but everything manages to blend into a comfortable mix of soft creams and pinks. I've managed to ignore the crudeness of the Levelor blinds and nylon carpet—aspects that are fixed by virtue of the beach house being a rental—by simply working around them. Children's artwork is the only wall decor. The daybed, to which I added comfortable neck rolls, does double duty as a refuge for the kids when they wander in in the middle of the night. (See Resource Guide.)

OPPOSITE: This vintage crystal beaded chandelier, the rumpled silk fabric, rusty white table leg, and slightly withered linen flowers in a tarnished mercury vase all represent the less than perfect look of Shabby Chic.

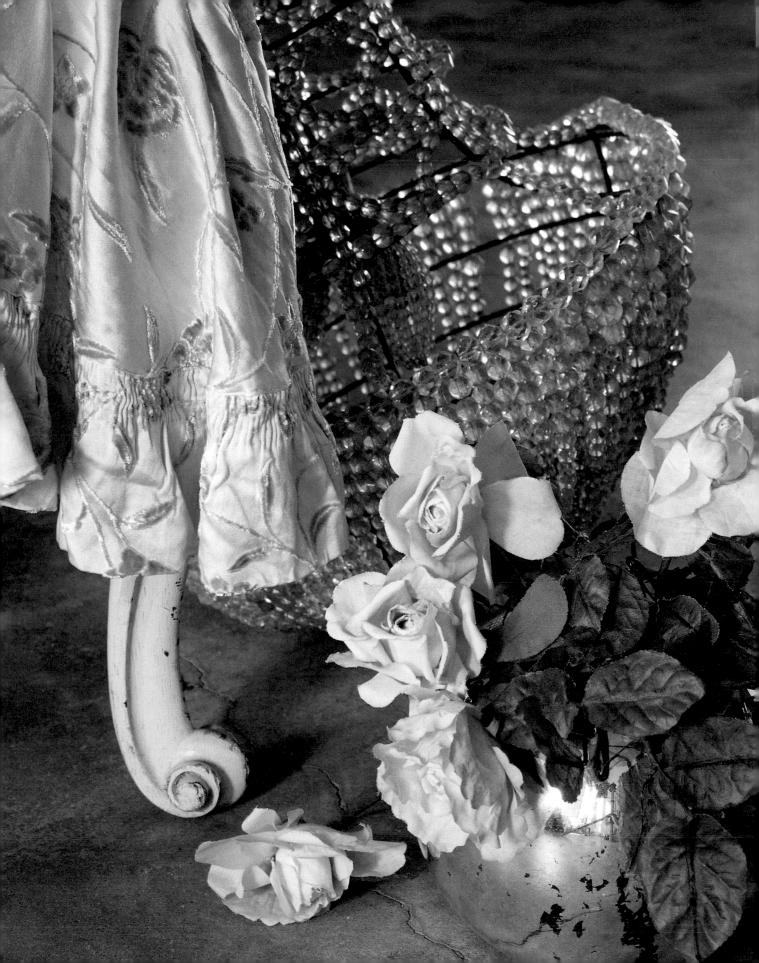

CASUAL BEACH

My rented seafront home is an example of how unchangeable structures can be worked around and strong points (such as picture windows with ocean views) played up. It also shows how pieces with a bit of faded grandeur can add a touch of elegance to a casual beach environment. Because the home is a rental, I did what I could, covering the existing ugly carpets with sisal rugs and adding simple white Roman shades to the windows, while ignoring elements like aluminum window trim, louvered blinds, and unsightly light-switch covers. Because I prefer a subdued look, every room is done in a monochromatic scheme of muted and sun-bleached floral prints. Cushy slipcovered seating is paired with crumbling, painted vintage or wicker furniture. Floral-motif accessories and paintings are combined with wrought-iron chandeliers or wicker lamps. Fresh, but not perfect, garden flowers and my children's artwork add unique personal touches.

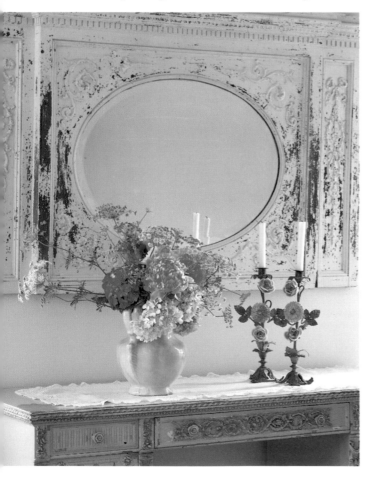

LEFT: Fine details are crucial indicators of a piece's quality. The intricate wood-carved detailing on the molding of this old bar mirror belies the frame's age, marking it with value not easily matched in newer pieces. The play of shapes—an oval mirror in a rectangular frame—adds interest, too. The piece complements the muted mustard sideboard, also characterized by carved detailing. Fresh peonies and porcelain candleholders emphasize the flower carvings and add color.

OPPOSITE: A delicate blend of different elements—light, fabric, texture, and color—make the difference between a functional corner and a functional yet inviting one. A combination of candles and early morning light imbue this cozy living room alcove in my beach house with a soft tranquillity. The muted seafoam greens, creams, and whites echo the tones of the ocean and sand outside, while wicker, wood, and fabric blur into a harmony of textures. A vintage piece of lace placed over the back of a slipcovered chair hides the inevitable sticky fingerprint left by a child. Sisal rugs cover the drab carpet, and a vintage pitcher and glass decorated with painted flowers offer cool refreshment. (See Resource Guide.)

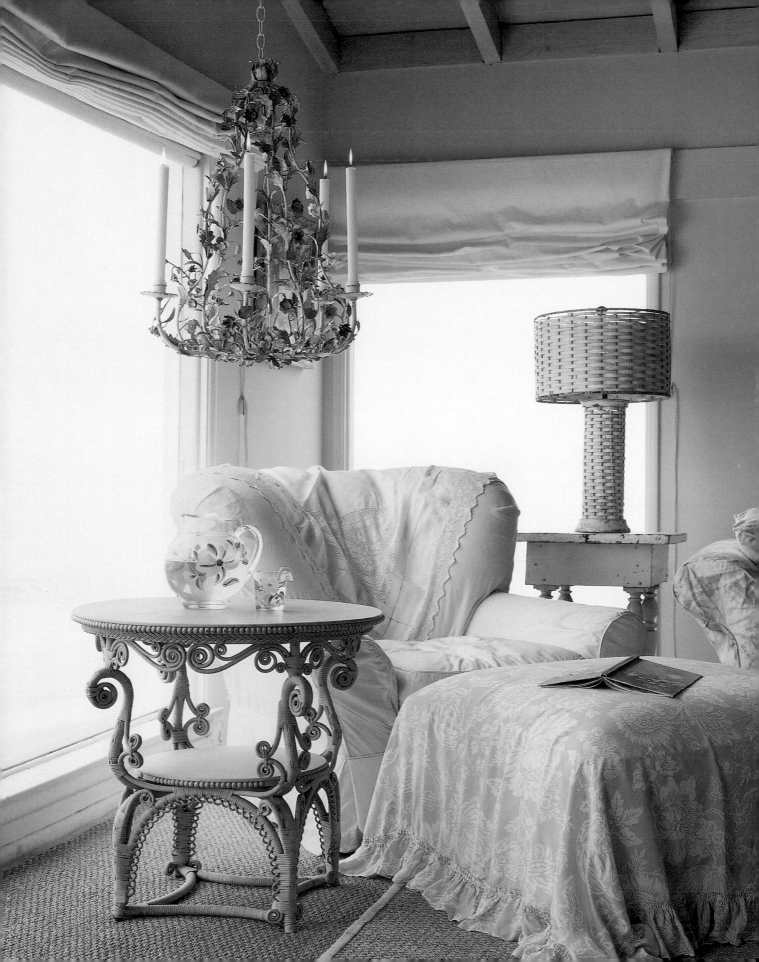

Flowers—both real and represented—are the unifying theme in the living room of my beach house. Toile candleholders and floral paintings expand upon the mood set by the large and small rose-print fabrics used for the slipcovered sofa and chair. Petals from a fresh arrangement of roses that have fallen to the tabletop are left to stay, adding to the room's melancholy, peaceful feel. Because the tones are a monochromatic blend of seafoam, sage, olive, and celadon greens and cream, the look is prevented from appearing too busy or romantic. (See Resource Guide.)

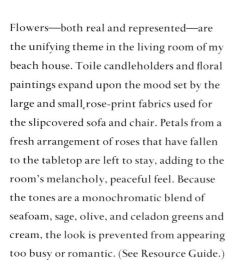

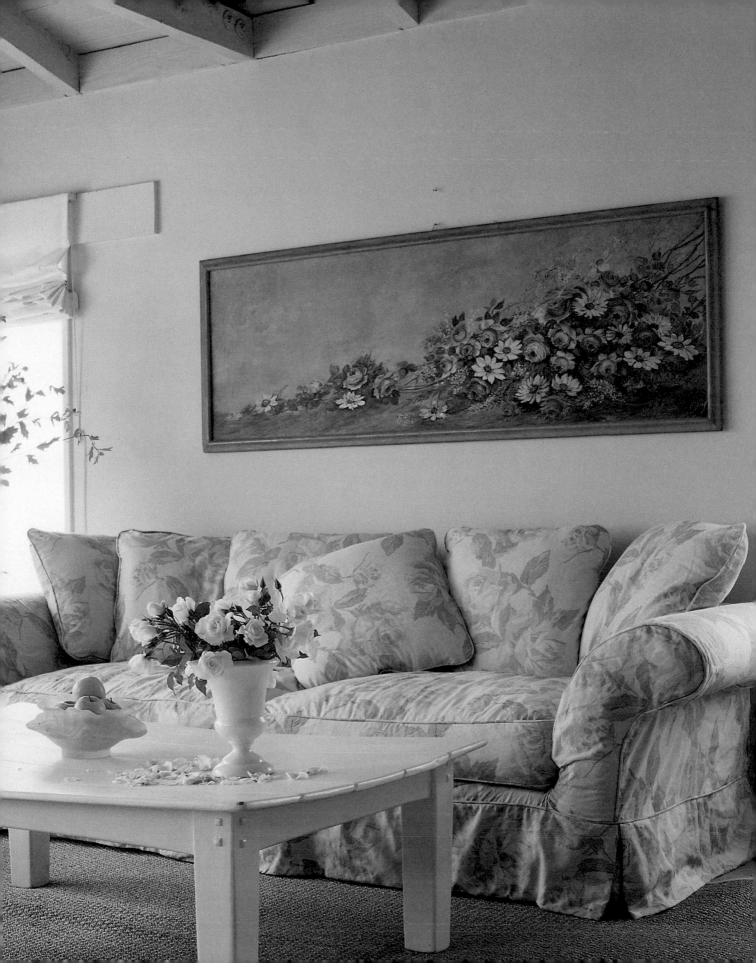

CONTEMPORARY

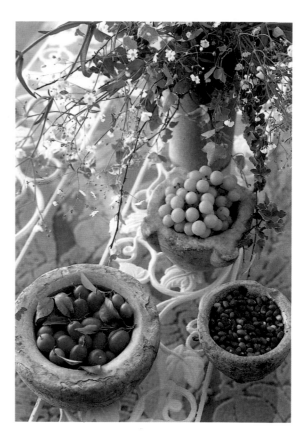

In a contemporary home in Venice, California, with its living room of marble, modern shapes, and slick surfaces, an inviting slipcovered sofa and chair break up the starkness and offer warmth. In keeping with the house's streamlined style, however, the slipcovers are more fitted than the usual Shabby Chic loose and roomy style and can be dry-cleaned rather than laundered to maintain their sleek look. Other worn yet stylish additions that offset the home's high-tech look are slightly worn vintage pieces and rugged textures, such as an ornate iron gate converted into a coffee table. Quirky antique fixtures and accessories merge the old with the new and give the polished bathroom a less inaccessible feel, as the photos on these pages show.

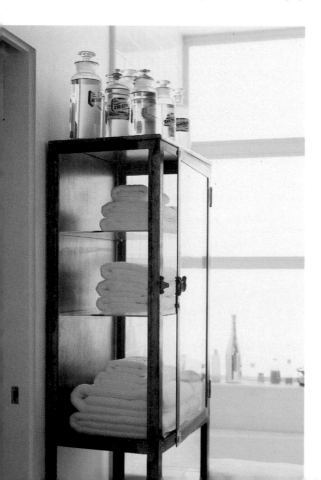

LEFT: In sleek, contemporary settings such as this, a touch of the old can add comfort and approachability. In this modern California bathroom, a vintage dentistry cabinet and chemist's bottles introduce the patina of old textures and shapes to alleviate the starkness. These items are functional, too: The cabinet is used to store stacks of fresh white towels and the bottles to hold shampoos, oils, and lotions. In full view, the contents themselves are objects to be appreciated aesthetically. (See Resource Guide.)

ABOVE: Native American stone bowls echo the granite floors and hard gray walls of this contemporary house. The intricate wrought-iron table salvaged from an old gate lends texture; the flowers, softness; and the fruit, color to the surroundings. (See Resource Guide.)

OPPOSITE: The slipcovered furniture in this modern house adds an element of comfort, but is fitted and modern in shape in keeping with the room's sleek mood. I also covered the table with a high-gloss white finish and topped it with a sheet of glass rather than let the rust and chips of this iron tabletop show through, as I usually would. (See Resource Guide.)

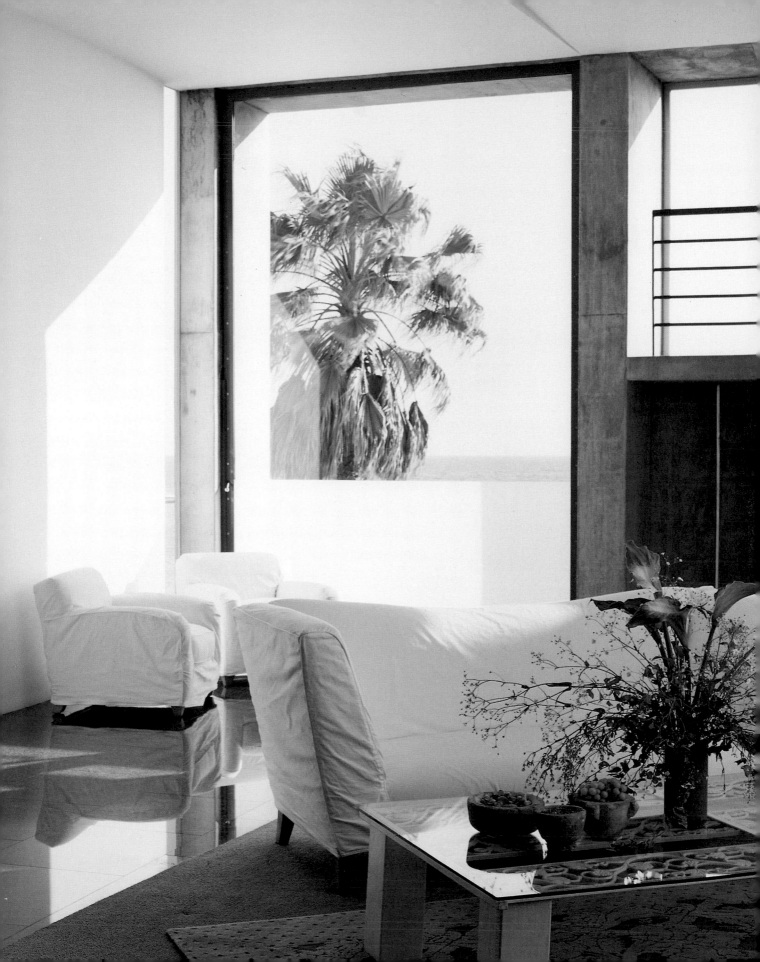

TRADITIONAL

The Mediterranean-style home of film director Tony Scott and his wife, Donna, though traditional and somewhat formal in style, is made more approachable with the introduction of vintage Italian wall sconces, crackled moldings used as mirror frames, slipcovered furniture (though of a formal fabric and fitted tightly), pillows made from antique textiles, and scuffed wicker. These worn and comfortable pieces merge with the Scott's collection of formal antiques, lacquered pieces, fine oil paintings, precious rugs, and chandeliers in a way that retains their grandeur while rendering them less pristine. Framed family photographs lend a personal touch, and loose, gardenlike floral bouquets, rather than stiffly composed arrangements, are used to further maintain a relaxed atmosphere.

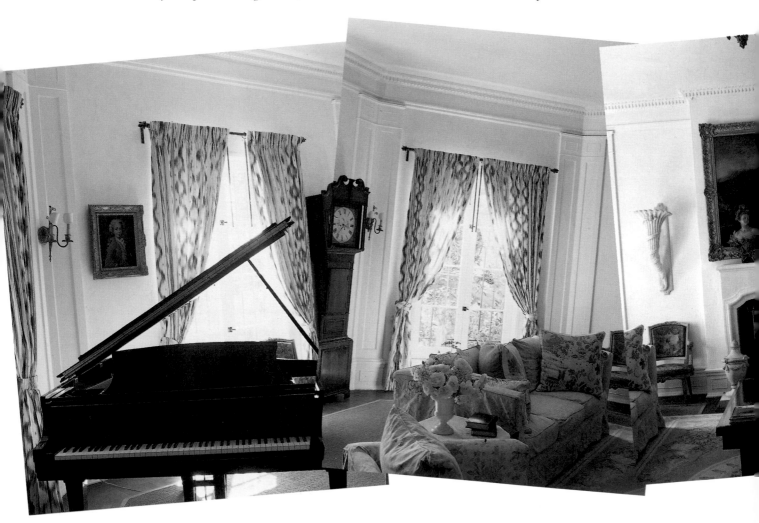

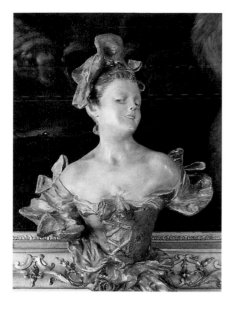

LEFT: When decorative objects have no real function other than beauty, an element of whimsy can make surrounding expensive, formal pieces feel more approachable. This delicate Goldscheider bust on the mantel in Tony and Donna Scotts' formal living room attracted the couple because of its mischievous expression.

BELOW: Important pieces and formal trappings do not have to make a room feel unlivable. The Scotts' octagon-shaped living room is filled with precious works of art, a grand piano, nineteenth-century French oil paintings, and an Aubusson carpet, yet it maintains an inviting, comfortable atmosphere. The starkness of the room's black lacquer pieces is offset by the coziness of slipcovered chairs and sofas, personal photographs, casual flower arrangements, and pillows made of antique textiles. (See Resource Guide.)

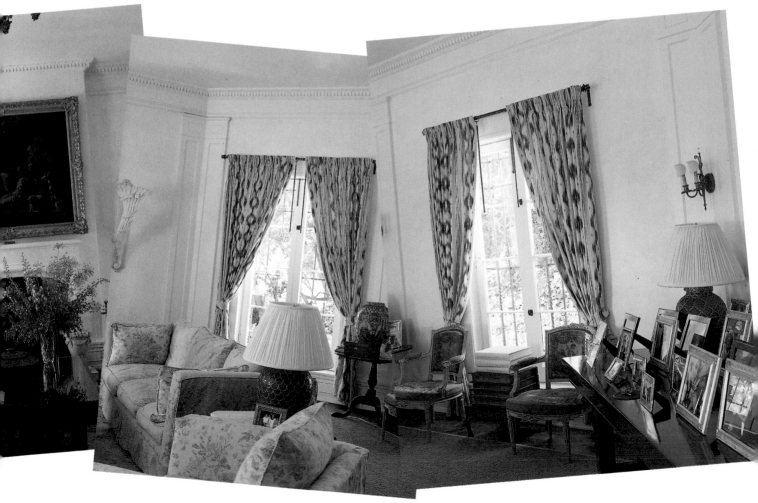

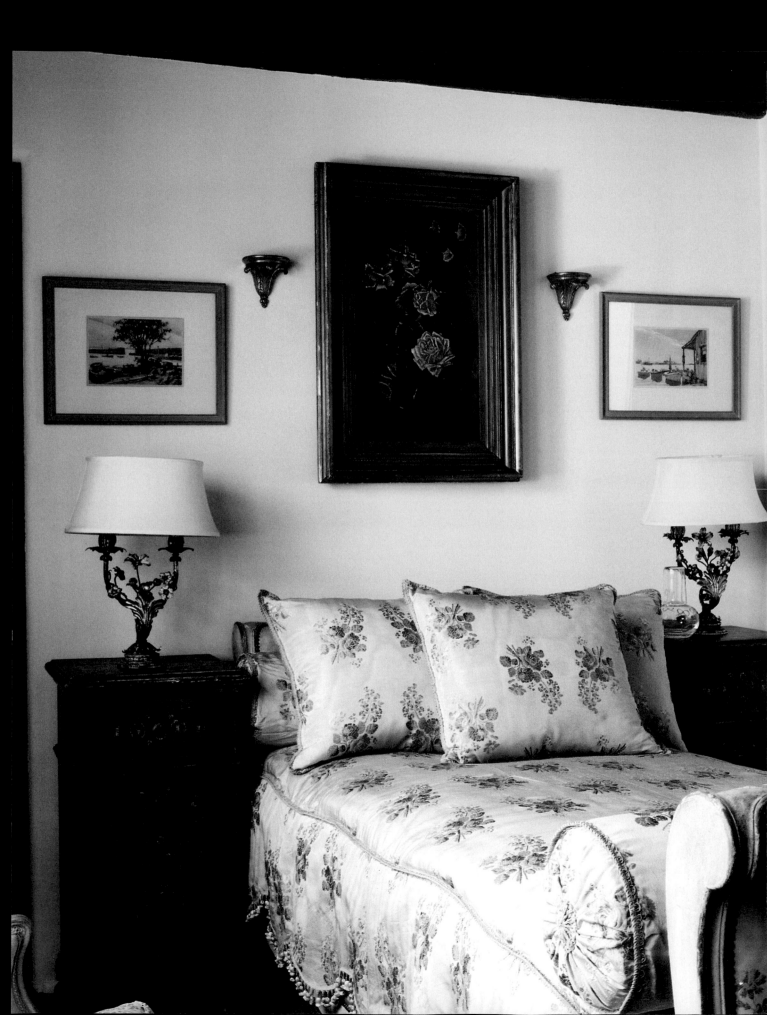

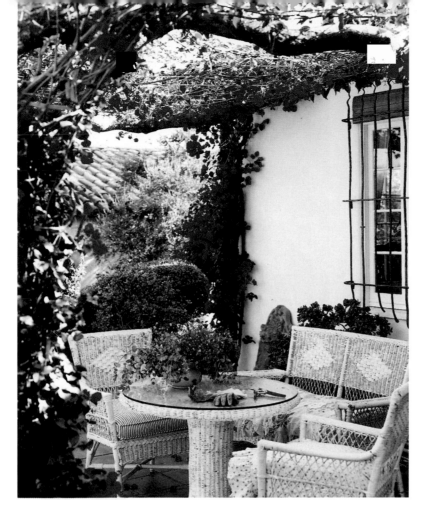

LEFT: Print cushions are a good way to lend comfort—and beauty—to lightweight wicker furniture, which can be used indoors as well as out. The classic white wicker chairs, bench, and table in the Scotts' shady, bougainvillea-covered garden terrace are a favorite spot.

OPPOSITE: A subtle touch and cool, restrained tones can prevent a floral motif from becoming overpowering, as is evidenced in the Scotts' formal guest bedroom. The rose still life hanging above the hand-painted nineteenth-century French bed, covered with a dainty rose print in French chinoiserie embroidered silk, rose details on a pair of antique bedside dressers that have been painted blue, and a set of toile bedside lamps—all combine to create a subdued, delicate treatment that imbues the room with a gentle patina of Old World charm.

RIGHT: Flowers bring the freshness of the outdoors into the light, casual entry room of the Scotts' guest house. The beauty of garden roses and Queen Anne's lace are complemented by the imperfection of a peeling vase. Along with rose-print curtains and shades, the fresh arrangement softens the harder elements of the room— a scratched wooden table, well-worn wooden chairs, an old grandfather's clock, and wooden ceiling beams.

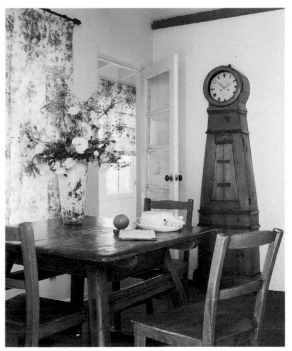

Talent manager Sandy Gallin's Malibu home overlooking the Pacific Ocean has a classic New England-meets-California look. Furnished somewhat formally with dark antiques and dark wood floors, hoards of hard-bound books, handcrafted carpets, formal oil paintings, and a grand piano, the house feels semicasual and inviting due to the predominance of deep, white denim and Marseilles slipcovered chairs and sofas in every room. Gallin and his longtime decorator, Bill Lane, installed these luxurious chairs and couches not only in the living room, den, library, bedroom, and guest house, but in the bathrooms, screening room, and gym, too. "The white slipcovered effect comes from both Sandy's love of the Hamptons look and also because [the slipcovers] are practical—he lives at the beach and he has three dogs," says Lane. "Sandy is also very consistent. Not very many people would do every room in their house in the same colors—dark wood, some green velvet, and white furniture, but in this case it absolutely works." Another presence in every room is Gallin's flower of choice, orchids, which, while echoing the house's rather formal atmosphere, bring life, the outdoors, and color into the somewhat monochromatic scheme.

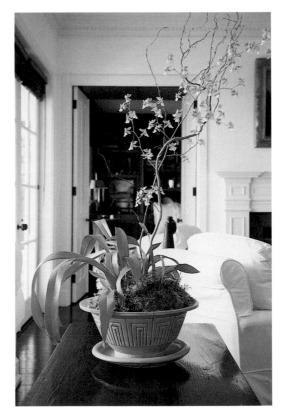

The Malibu home of talent manager Sandy Gallin illustrates how the formal and the traditional can be made more casual for California beach living with the use of roomy chairs and sofas, slipcovers made of white denim, and old Marseilles bedcovers. With the help of his interior designer, Bill Lane, Gallin has created an elegant simplicity, remaining faithful to white throughout, including chairs, sofas, towels, and dishes. The generous use of white also adds light to the dark wood antique furniture. OPPOSITE: A corner of the library.

PAGES 24–25: The master bedroom.

PAGES 26–27: Oftentimes, it's the unexpected that makes the difference between an ordinary room and a spectacular one. Rather than traditional theater seats, Gallin's screening room has two tiers of plush white denim slipcovered couches. Further personalizing the room is a large photograph of Gallin's pug dogs, which drops down during screenings to reveal the projection booth, old-fashioned jars filled with candy for guests' enjoyment, and orchids, which add life and color.

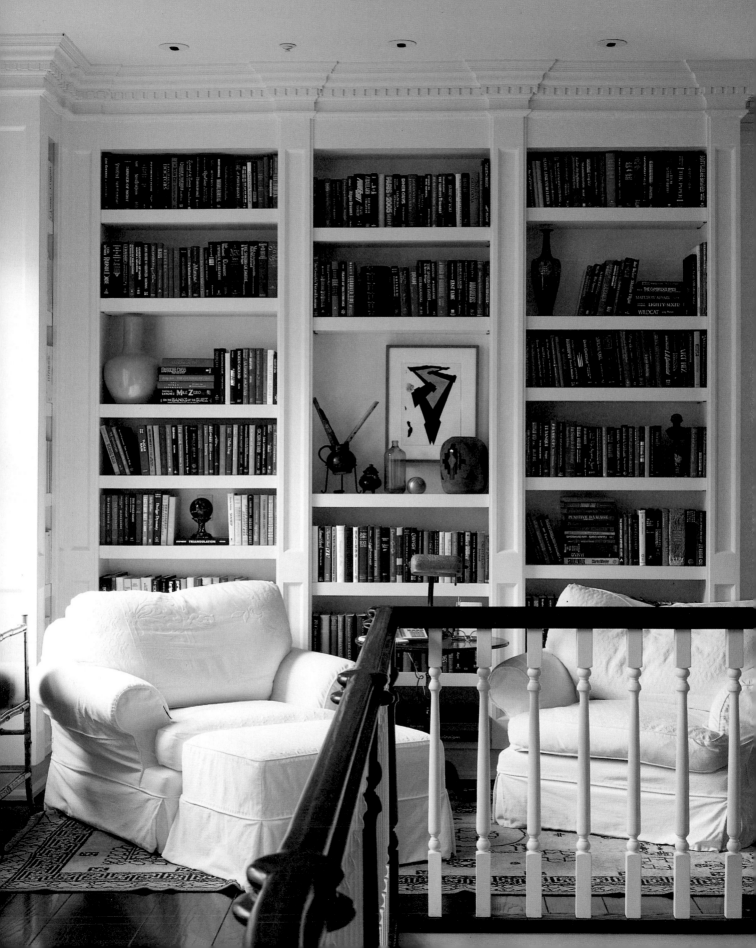

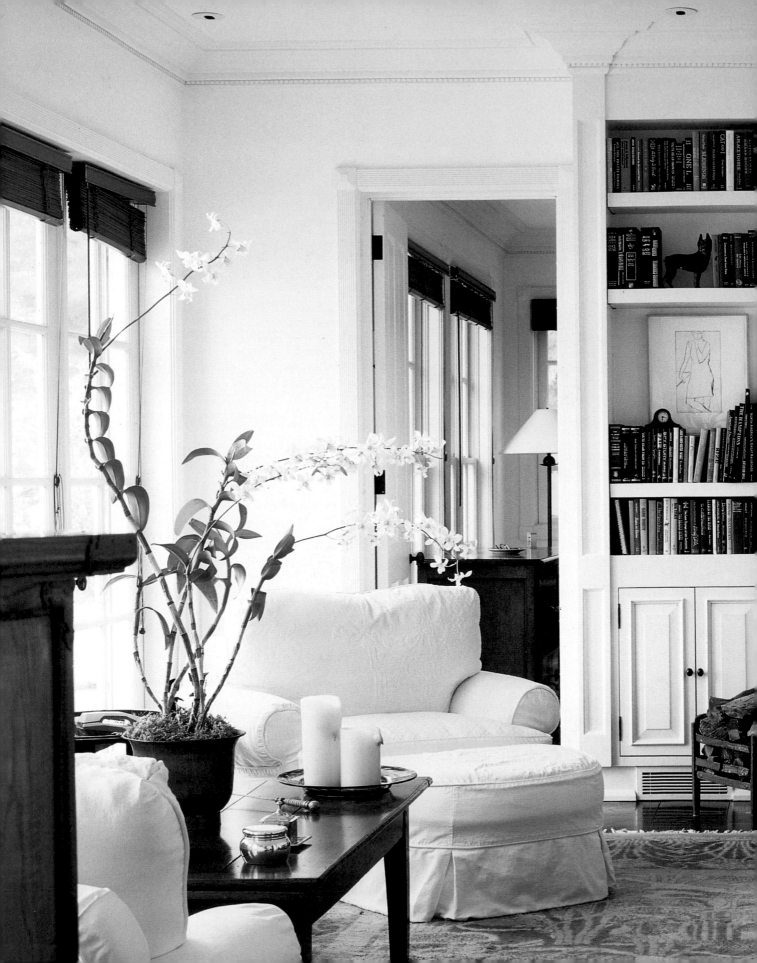

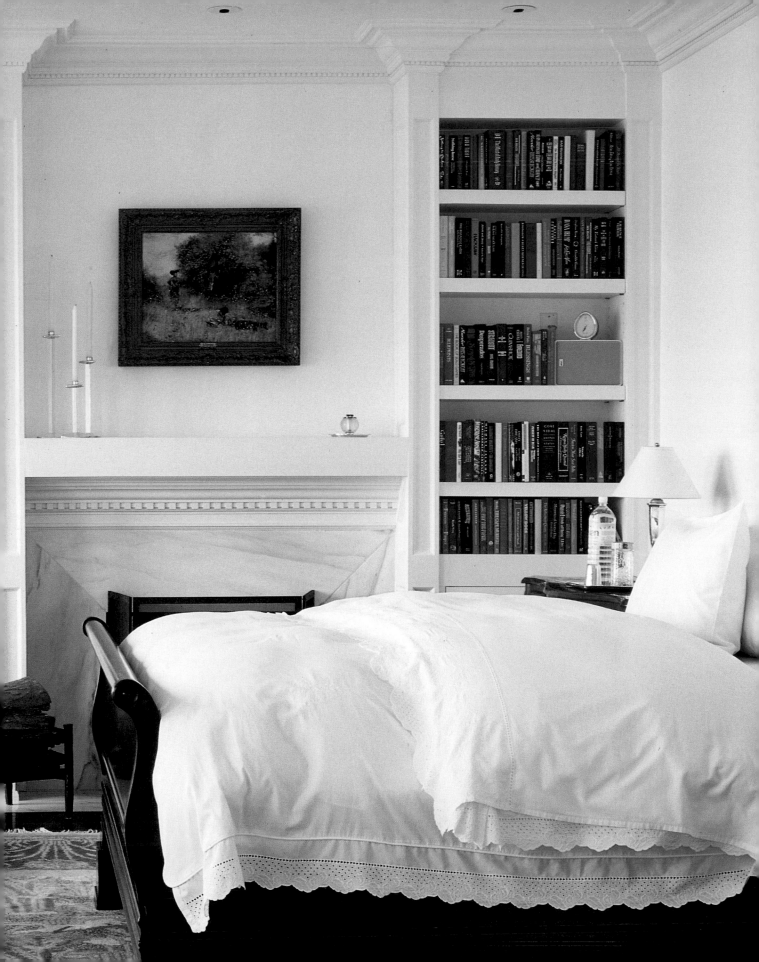

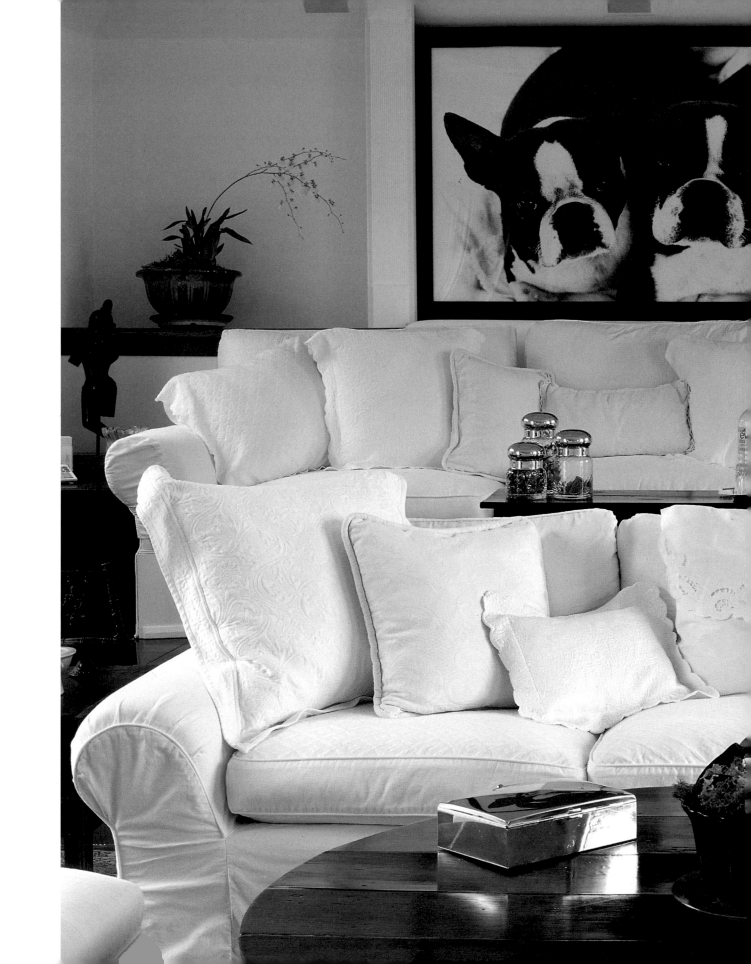

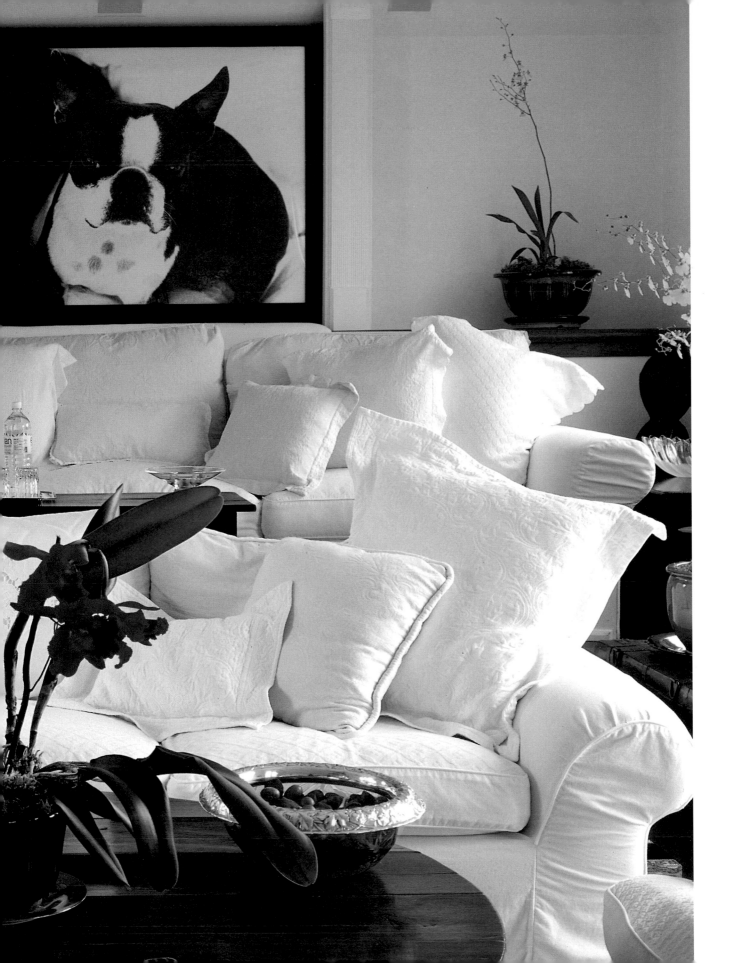

ECLECTIC

ny home can be transformed to express its owner's personal statement. Homes that integrate several different looks and reveal their owners' interests and tastes are far preferable to homes that appear too planned, look too professionally decorated, or where decor is enslaved by theme.

The Spanish-style home of interior stylist Philomena Giusti demonstrates how the cluttered, eclectic look can be successful. Giusti's house is brimming with examples of new uses for old forms and with items that may seem shabby but have great style, making the formal casual and the casual formal, and bringing the outdoors in. The key is that all of the pieces have character and function, hold special meaning for Giusti, and have been put together in an interesting way.

A peeling Mexican bar is used as a kitchen cabinet, an inexpensive lace curtain as a tablecloth. Chairs are mismatched. Checked fabrics are mixed

ABOVE: Though pieces in the casual, comfortable Shabby Chic style are usually as much about function as they are about form, objects without a real purpose that add life or create a distinct mood are desirable, too. This Roman-style statue standing guard over Philomena Giusti's front rose garden sets a gentle, welcoming tone.

RIGHT: In the living room of Giusti's Spanish-style home a cushy antique red sofa adds a shock of color, an antique zebra rug lends a note of old-world whimsy, and a worn leather chair with a velvet cushion offers a cozy corner to relax in. Eighteenth-century Italian angels tucked into niches over the fireplace stand guard over the room, along with oil paintings of women dating from the twenties and thirties that Giusti believes resemble her mother and sister. A scattering of plants and fresh roses from the garden bring the outdoors in.

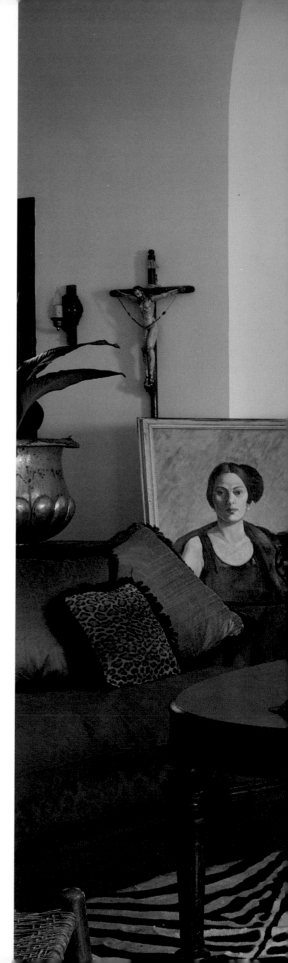

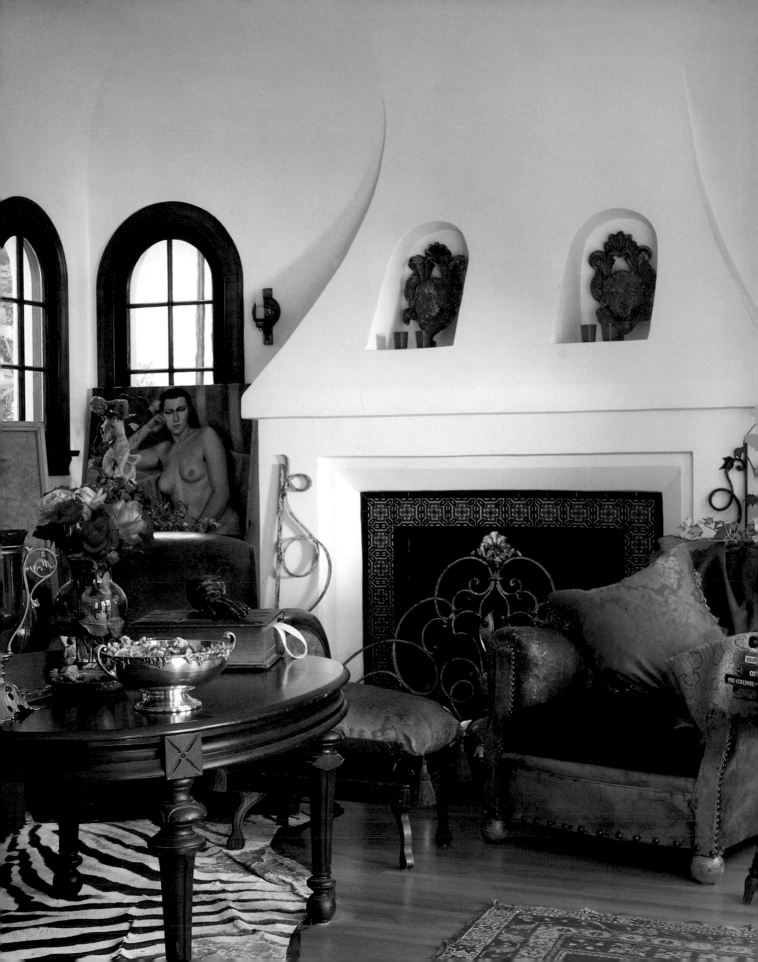

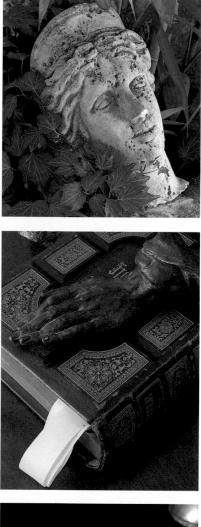

with florals throughout the house. Old leather armchairs and chipped iron sconces are allowed to proudly flaunt the effects of time and wear. Chandeliers become less imposing when used in the bathroom and garden, and silver less formal when used for a casual snack atop an old wine taster's table. Rusted patio and wicker furniture, garden plants and statues are brought inside to blur the distinction between indoors and out. The house contains a wealth of personal objects that Giusti has collected over time, including the worn and cracked hands and feet of statues, vintage oil portraits that she rests against the wall rather than hangs, and family photographs displayed in an array of antique frames. "There's no real rhyme or reason to what's here or where it's placed," says Giusti. "It's not about what country or which era anything's from. It's about what I like, which is pieces with character. And it's definitely not about matching."

TOP LEFT: This weathered head from a garden statue, which rests peacefully in a planter inside Philomena Giusti's living room, illustrates how pieces meant for the outdoors can work just as well indoors.

CENTER AND BOTTOM LEFT: Objects that show the ravages of time have their own beauty, and parts of an object can be as attractive as the whole. The delicacy and sense of decay of this broken hand and pair of tiny chipped feet from an antique statue attracted Giusti.

OPPOSITE: Eating in the kitchen used to be a practice reserved for servants and children, but this room is now considered a favorite place for informal gatherings in many homes. The colorful food, bright sunflowers, and mismatched plates and napkins add to the eclectic, friendly clutter of Giusti's kitchen. A toile chandelier from the forties sheds soft light on a worn farmer's table surrounded by stools covered in a vintage vegetable-print fabric. In the background, a decaying green cabinet houses neatly stacked dishes, while a floral pillow blends easily with a casual red and white striped wooden chair.

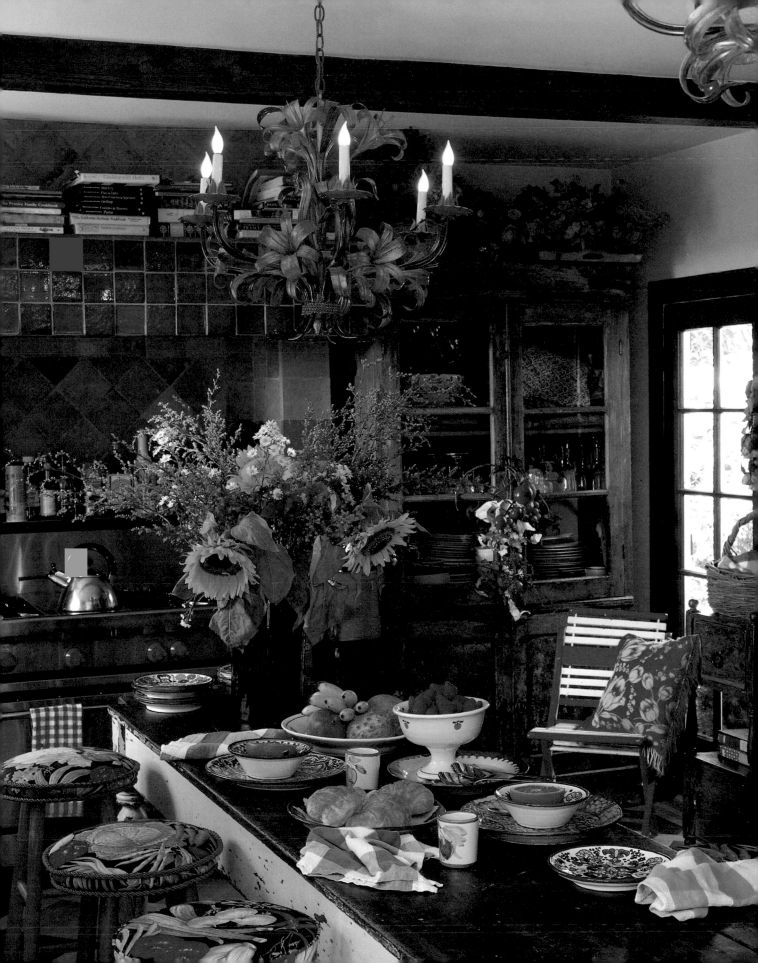

The eclectic Topanga Canyon home of Chantall Cloutier, owner of the hair, makeup, and style agency by her name, also incorporates some basics of the Shabby Chic style. In this case, white walls, white slipcovered chairs and couches, and a coffee table fashioned from a vintage door painted white all serve as backdrops for Cloutier's plush velvet throws, pillows, and curtains in deep jewel tones. The introduction of white prevents the richness of the rest of the furnishings from becoming overbearing. "I love white," says Cloutier. "It's so versatile. A different color couch wouldn't allow me to make changes as easily and I'm constantly changing and rearranging."

Cloutier allows the style of her house to evolve, adding and subtracting pieces she collects at flea markets, auctions, and vintage and antique shops. Her somewhat theatrical bathroom illustrates how merging the formal with the casual and using the element of surprise can transform a room into something that is unpredictable yet comfortable and functional. Mirrors are used to create the illusion of more space. An overstuffed, slipcovered armchair and Turkish rugs helped turn the area into a plush sitting room of sorts. A bust, oil paintings, and a gilded towel rack made from a vintage pedestal—all picked up at flea markets—are whimsical yet formal additions that enhance the room's unique feel. Throughout the house are many windows that Cloutier had installed to lighten the look of her gilded mirrors and frames, columns, and dark fabrics.

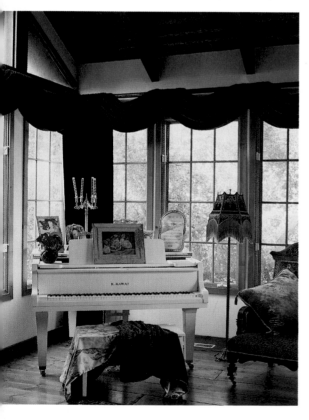

LEFT: An old theater curtain in burgundy velvet draped in loose swags lends formality to this eclectic corner in Chantall Cloutier's home. The stark white piano is offset by the dark velvets of the antique chair, blue pillow, piano bench cover, curtains, and custom-made lamp shade. An array of personal objects—silver frames, a mirror, floral painting, red roses, and a candelabrum—carry through the theatrical theme.

OPPOSITE: Cloutier's home office is luxurious yet very functional. The ornate, carved wooden desk is made from an old table topped with glass. The bookends are a new use for rose-motif fireplace andirons. The lamps, flea market finds, have custom-made lamp shades. The vintage carved wooden mirror creates a sense of light and space.

FOLLOWING PAGES: The Topanga Canyon bathroom exemplifies the idea of creating the unexpected. Five mirrors, several windows, and French doors leading to a garden add to the spacious feeling of this already large bathroom, where Cloutier created an indoor-outdoor mood. An overstuffed armchair made from different tablecloths sewn together, an angel towel rack, and reproduction Turkish rugs transform the space into an almost luxurious sitting room. Tiled floors, walls, and door trim add an aesthetic as well as a practical touch.

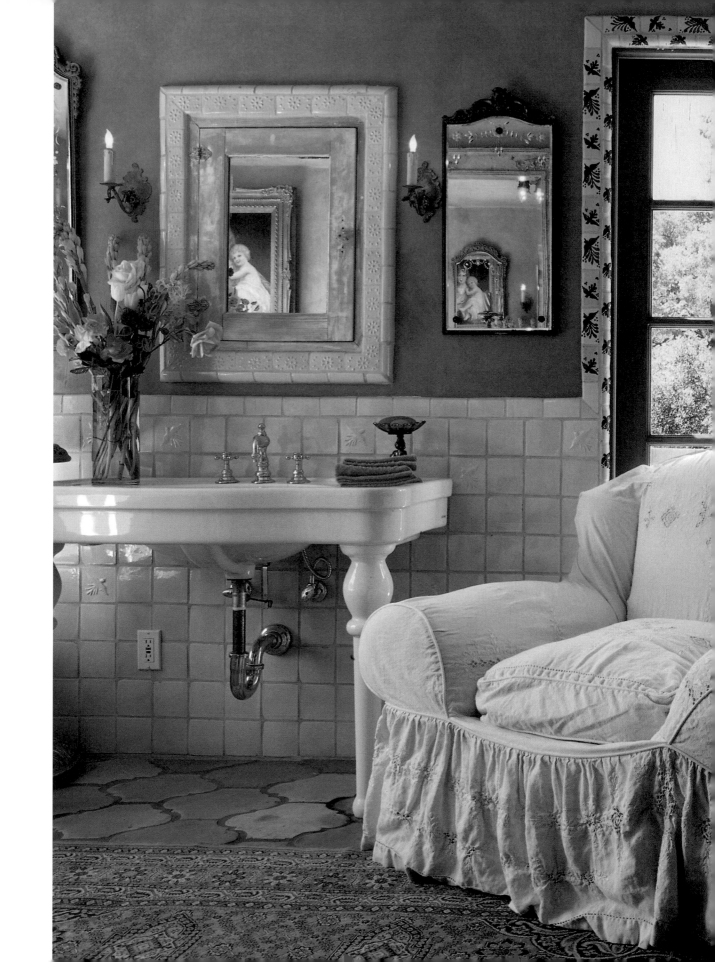

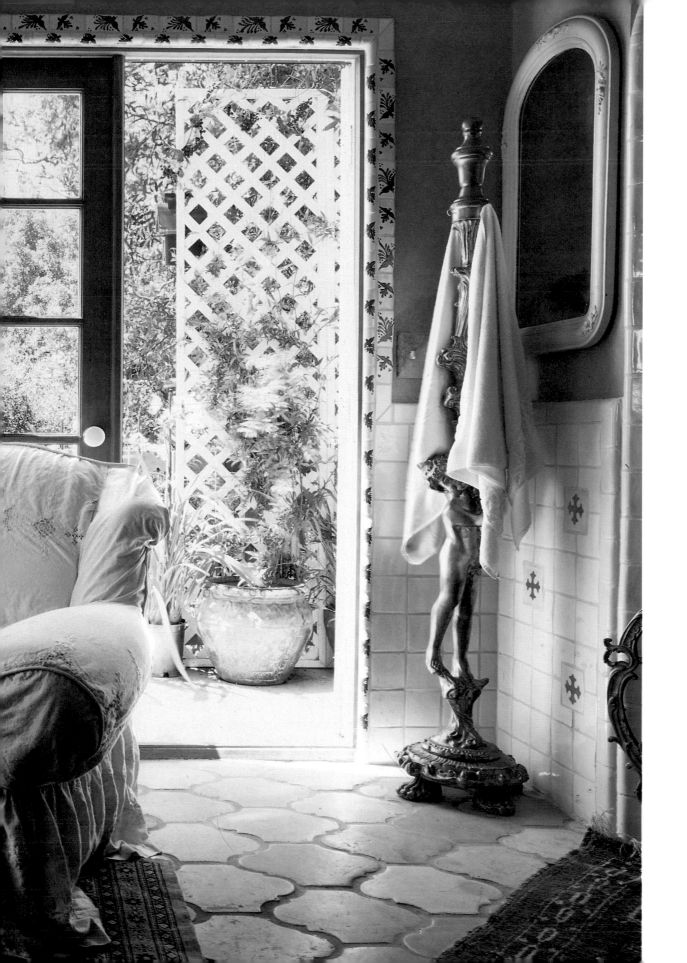

THE COMPONENTS
OF STYLE

Time-worn furniture, crinkled fabrics, muted colors, and imperfect chandeliers or cracked paintings may be the mainstays of Shabby Chic decor, but before combining them to create an overall ambiance for a room, there are other, more basic components to be dealt with. The structure of the room itself, in the form of its floors, walls, and ceilings all need to be considered before, or at least in conjunction with, tackling its contents. The following section points out which of these elemental components blends best with the kinds of pieces that define the Shabby Chic style, whatever the architectural style of the house.

Floor, wall, and ceiling treatments are the basis of every home's style and ambiance. These three components are often noticed on a more subtle rather than overt level, but they create a world of difference in setting an atmosphere. The contrast between a hardwood floor and wall-to-wall carpeting, paneled and clean white walls, and high and low ceilings illustrates how vital these basic elements are to a room. The way they are treated makes a vast difference as to whether they will serve as backdrops or take a more active role in a room's actual appeal.

Although floor, wall, and ceiling treatments can be done after a room's fabrics, furniture, and accessories have been selected, I find that using these three surfaces as a starting point is the easiest way to go about decorating a home.

FLOORS

When it comes to floors, I believe first and foremost in simplicity of look and ease of care. Floor coverings that create the most relaxed yet classic appearance include hardwood floors, sisal rugs, variations of Spanish or Mexican tile, and sandblasted cement. Floor coverings might set up a pleasing contrast with the rest of the house's look, for example, a sisal rug in a formal living room lends a touch of the casual. Or a floor may act as a complement to the surroundings, as a sandblasted cement floor would in a very modern home. These floorings also work best with the furniture and fabrics I prefer.

Hardwood floors work with almost any style furniture and are relatively easy to keep clean. Hardwood is generally more expensive than carpeting, typically costing six to thirty dollars per square foot, depending on the

wood. Preassembled hardwood floors that are glued down are slightly less expensive, costing about five dollars per square foot, but they are less flexible in terms of sanding, sealing, and staining. In some cases, you may want to put down a waterproof barrier between your hardwood covering and the floor—a professional can give you advice. I also like to add throw rugs to hardwood environments, as the additional color and pattern create a cozy appeal.

Sisal rugs have become increasingly popular. Made of natural root fibers woven in a ropelike fashion, they tend to give rooms a casual, almost indoor-outdoor feel. Most sisals are bound by rubber and backed by latex to make them more cushiony.

The tricky thing about sisals is that they're not that simple to care for. They absorb spills quickly and can easily ravel and pull. They also come in bolts that are typically twelve feet wide, so if a room is wider than this, other strips of sisal need to be added carefully along the sides to make the seams invisible.

Tiles, referred to by professionals as pavers, are great choices for kitchens, entryways, and bathrooms, but they also work well in dining and living rooms. Terra-cotta tiles in nine- to twelve-inch squares are relatively inexpensive. Fancier, imported tiles are much costlier, and marble even costlier, depending on its

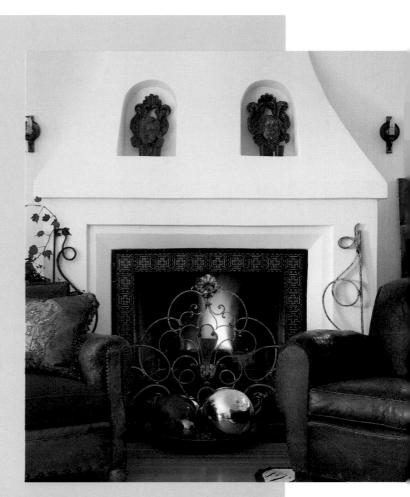

quality. Typically, a mudpack—a base of roofing paper, chicken wire, then mortar or cement—needs to be laid down as a foundation for tile. This should be done professionally.

Sandblasted cement has become a common floor covering choice for many modern retailers. I used sandblasted cement in my Santa Monica shop because I like the cool patina it emanates, but it can also work well in residential situations. Sandblasting is a process that removes the creamy top layering of a

cement floor to expose the rougher, sandy layer just below the surface, creating a textured appeal. Sandblasting machines can be easily rented, but keep in mind that the wear and tear that sandblasting can put on a house is tremendous. Everything must be removed, and walls and windows must be carefully protected with thick blankets.

WALLS

White walls are the most classic, clean foundations for any room. Acting as a sort of blank canvas, white complements and contrasts with a variety of colors, tones, and textures and serves well as a backdrop for all styles of furniture. Pure white, however, can be stark, so I prefer off-whites, eggshells, ivories, and creams. I often paint wall trimmings in a slightly different hue from the rest of the wall so that they stand out.

Like the humble appeal of a dresser with peeling paint or a leather chair with worn patches, imperfections in walls can be beautiful. Before rushing to cover natural cracks or crumbles with plaster or paint, take a good look at any flaws to discern whether they add charm and character.

Treatments such as wainscoting or anaglypta wallpaper (an embossed paper with a raised pattern) are other ways I like to add detailing to walls. These particular details tend to work best in homes that are traditional or old-fashioned in mood rather than in sleek, contemporary ones. In bathrooms, kitchens, and dining rooms, tongue-and-groove wood slats (they fit together like puzzle pieces) that extend from floor to chair height add texture. The slats are also functional, protecting the wall from banging chairs. When finished in high-gloss paint, wainscoting is easier to wash than regular walls. I installed a wainscoting of tongue-and-groove slats in my old bathroom for just these reasons.

Anaglypta adds texture and detail to a wall without overpowering it. Though it is applied like wallpaper, true anaglypta comes only in white and without a finished surface. Anaglypta must be painted (even if you repaint it white), otherwise spills will seep right through. As with wainscoting, I use semi- or high-gloss paint on anaglypta because it's very washable. Anaglypta is most often used for only the bottom half of a wall and is typically separated from the painted top portion by a chair rail or wood molding (I prefer moldings at least three inches thick to create a stronger demarcation). Some types of anaglypta can be purchased for as little as twelve dollars for a twenty- to twenty-five-square-foot roll.

This anaglypta wallpaper shows how a plain wall can become decorative in and of itself rather than simply serve as a backdrop for other pieces. Anaglypta—or embossed paper with a raised pattern—common at the turn of the century, can still be found at better wallpaper stores.

Wall and ceiling trimmings such as crown moldings (used at the junction of wall and ceiling), friezes (a band just under the crown molding), and other architectural ornaments can also be lovely decorative additions to a room. Most lumberyards offer a variety of standard wall moldings, but outlets specializing in architectural ornaments that look like carved wooden or plaster relief but are actually a special type of claylike dough offer a more interesting variety. Shaped and molded with heat and water, these ornaments are then steamed and bonded to a surface. They can also be glued with regular white glue to wood, metal, plaster, paint, or wallpaper, but steaming creates a better bonding effect. This little-known process dates back to sixteenth-century Italy, and the ornaments, referred to as composition ornaments, or compos, are common sights in elegant old hotels, theaters, and grand estates.

Composition ornaments are available in hundreds of different patterns, from columns, curves, and swirls to fleurs de lis, flowers, lions, urns, and cupids. The ornaments can be used as trim for walls, windows, floor edges, and ceilings as well as on furniture and fireplaces. Though I prefer original carvings on furniture rather than additions, compo has

the ability to blend in easily as part of a piece and is more detailed than newer wood carvings. (I have occasionally used new compo pieces to add detailing to mirrors and frames.) Because it is semiperishable and becomes brittle over time, compo should be used no later than a month after it is ordered—the fresher it is when used, the better.

CEILINGS

High ceilings, especially those of exposed wood or wooden beams, while not always possible to achieve, are my choice for every style of home. But even if a room doesn't have a high ceiling, you can turn what exists into something more than an overhead covering and make it a prominent part of the decor of the space. Detailing such as medallions and rosettes—architectural ornaments that hold or surround light fixtures—and other trims

Stamped tin ceilings, which were very common at the turn of the century, are making a comeback. This one, at my Santa Monica store, is intricately detailed and was placed together piece by piece. Though expensive (this ceiling, which covers a three-thousand-square-foot area, cost four thousand dollars for materials and an additional four thousand dollars for installation), they come in a variety of patterns and completely transform a plain room into something grand.

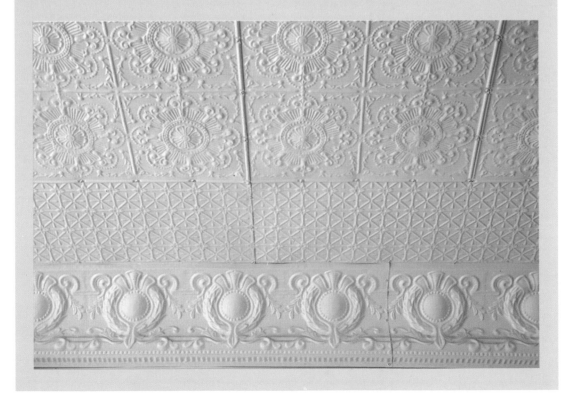

are the types of touches that make a ceiling noticeable.

My favorite way to make a ceiling into something really special is to cover it with sheets of embossed or stamped tin. Common at the turn of the century and still found in old country stores, courthouses, and other buildings, embossed or stamped tin can still be purchased from a few outlets that have been in the business for years (see Resource Guide). Though expensive, tin ceilings, with their intricate designs, are truly beautiful. While you can hang tin ceilings yourself for about half the cost of having a professional do it for you, it's a complicated process requiring the installation of a dropped grid or acoustic framework. This is why I highly recommend using a professional contractor. Once installed, the ceiling needs to be painted. I use a pale color such as cream or mint green to prevent the ceiling from seeming too heavy.

Whether sisal rug or hardwood floor, plain white walls or embossed wallpaper, wooden beam or tin ceiling, the unifying characteristic of environments that work best with comfortable and worn Shabby Chic decor is simplicity. While floors, walls, and ceilings can certainly be interesting in their own right, I look at them more as backdrops to highlight a room's pieces. Overly decorated, colorful, or patterned structures not only detract from the interior furnishings of a room, but they also have less versatility and longevity. Neutral colors and plain or subtle textures have a longer lifespan and blend easily with any style home or specific space—living room, bathroom, or bedroom.

The next chapter addresses the particulars of these rooms from the functional to the aesthetic and explains how different approaches can be taken to imbue them with a Shabby Chic ambiance beyond floor, wall, and ceiling.

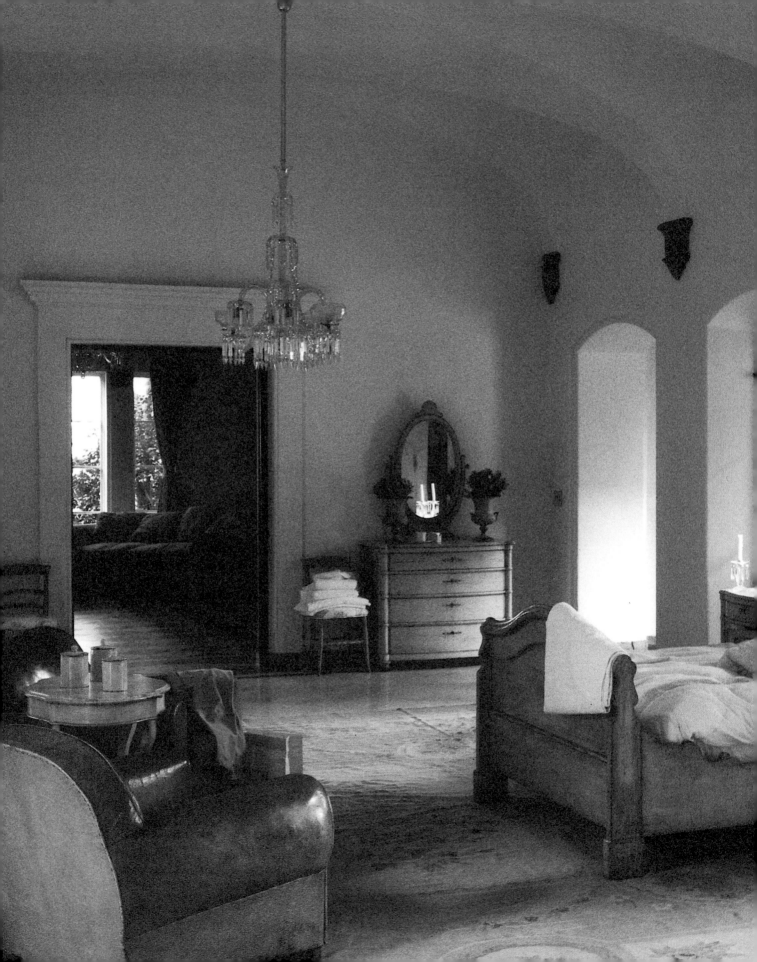

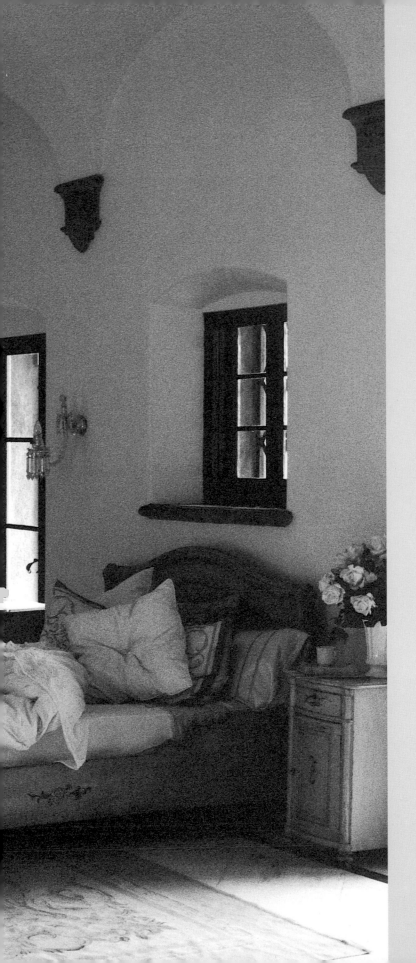

2

R͟OOMS

Every room in the home serves a specific purpose, so the decor of each must be approached individually. Focusing on the particular function of a room is an important first step in deciding how to decorate it. Whether a room is meant to be a private or social area, a place for work or for rest, and whether it will incur a little or a great deal of foot traffic are all factors that influence everything from fabric choice to furniture style and placement to lighting.

There are certain basic guidelines, however, that apply to every room. When I approach a room that needs to be redecorated, I sometimes empty out the contents to get a fresh perspective, then work my way back again. I may reinstall some of the items I took away, but I find that it's helpful to start with a blank slate. While I'm a firm believer in less being more, I'm also an advocate of recycling rather than discarding, so before throwing an item away, I consider whether or not it can be cleaned up, reupholstered, repainted, or given new hardware (see Chapter 3, "Hidden Treasures and Inspirations"). With regard to acces-

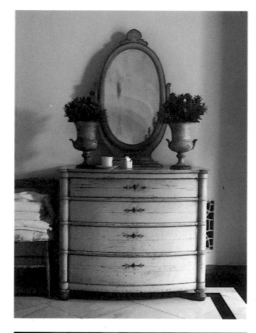

PREVIOUS PAGES: This exquisite, five-piece antique French bedroom set was one of my biggest splurges. The pale green bed, vanity, bedside table, oval table, and small table in the window are all marked by painstaking detail and attention to proportion. Every piece is dovetailed, and every curve, edge, and leg is indicative of fine craftsmanship. The tables are topped in gray marble, with ogee, or layered-effect, edges. The vanity mirror is mottled but not to the point of distortion, and all the pieces with drawers include keyholes and keys instead of knobs. With the needlepoint carpet, crystal chandelier, and French leather camelback chairs, the entire atmosphere exudes a faded Old World elegance. (See Resource Guide.)

TOP LEFT: Here, fragrant green plants in iron urns and a stack of white towels on an antique chair add freshness to what otherwise might have been a stuffy corner.

LEFT: What prompted me to buy this pale green table has everything to do with its detailing. The curvy shape of the legs, the casters, the tapered proportions, the marble top, and the bottom shelf with its intricate center ornament are all indications of quality. (See Resource Guide.)

OPPOSITE: A mix of silk, linen, lace, satin, and cotton give depth and luxuriousness to this vintage bed. The duvet is made of old Indian saris. (See Resource Guide.)

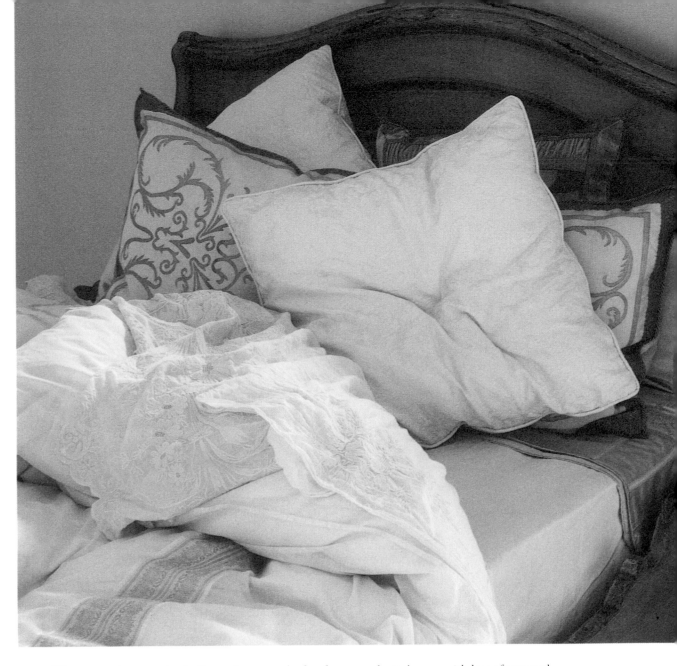

sories, I like to use them sparingly. Some clutter can be fine for very eclectic houses with lots of personal collections, but generally, I prefer a simple, clean, unfussy look.

If you're starting from scratch and need to buy almost every piece for a room, take your time and let the room evolve slowly. Allowing for such evolution always looks more natural, creates more character, and provides for the possibility that your tastes might change slightly over time. I find that rooms put together too quickly often look artificially decorated.

Sometimes a specific focal point—a fireplace or a picture window—is an obvious point of departure from which to base a room's particular arrangement. Other times, the focus of a room can be created by installing a large or dominant piece, such as a rug, couch, painting, or grand mirror.

BEDROOMS

Bedrooms should convey warmth, comfort, luxury, and intimacy. Bedrooms are where we begin and end our day—they ease us into the next phase of our daily schedules—and for that reason they shouldn't have too many distractions or too much clutter. In bedrooms, elements that bring on stress should be minimal—a work desk, a television, or a fax machine, for example, are better left for other rooms.

Since the bed itself is the focal point of most bedrooms, bedding is crucial. No matter its size or style, a bed should be an inviting sanctuary. Plenty of luscious layers—sheets, blankets, and goose-down duvets are the best way to make a bed luxurious, while comfort is the primary consideration when choosing cottons, flannels, or linens (see also Chapter 4, "Fabrics").

Crisp, clean white always looks and feels freshest when it comes to bedding, though, of course, color has its place. Mixing and matching patterns with pillows and quilts can create eye-catching contrasts in color and texture, while bed skirts are a way of adding detailing via ruffles.

Vintage headboards are one way to instill an element of faded grandeur. I often pick up dilapidated wooden architectural pieces at salvage yards and flea markets and turn them into headboards. It doesn't matter if these pieces are slightly larger than the bed—the extra bits at each end can serve as backdrops for end tables, as does the wooden headboard on my own bed.

In addition to the bed, seating is an important element of both formal and casual bedrooms. Chairs and love seats not only offer nonbed options for lounging with a book, they are also great temporary holding areas for clothes and bags. Since my bedroom is a gathering place for the whole family, I put in lots of cozy seating. My children love to curl up on the big slipcovered chair in the corner of the room or sprawl on the floral-print chaise lounge across from my bed.

Bringing in a bit of the outdoors—such as white wrought-iron garden furniture or a potted flowering plant—can also be a nice touch in the bedroom. And if you do a bedroom along a particular theme, such as florals, I suggest keeping the approach subtle.

OPPOSITE: This ragged old piece of wood that was once part of a gate now functions as a headboard in my bedroom. What made the piece worth unearthing at a salvage yard was its detailed wreath carving. That the headboard is larger than the bed is not a distraction. In fact, its size is an unexpected benefit that lets it serve as a backdrop for the end table. (See Resource Guide.)

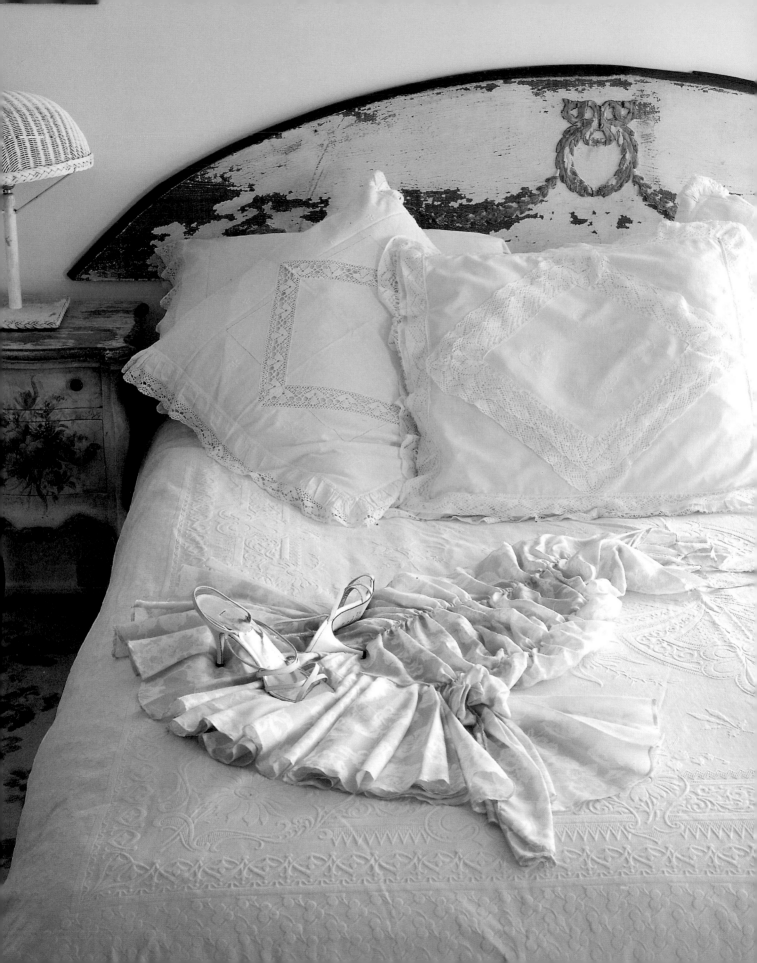

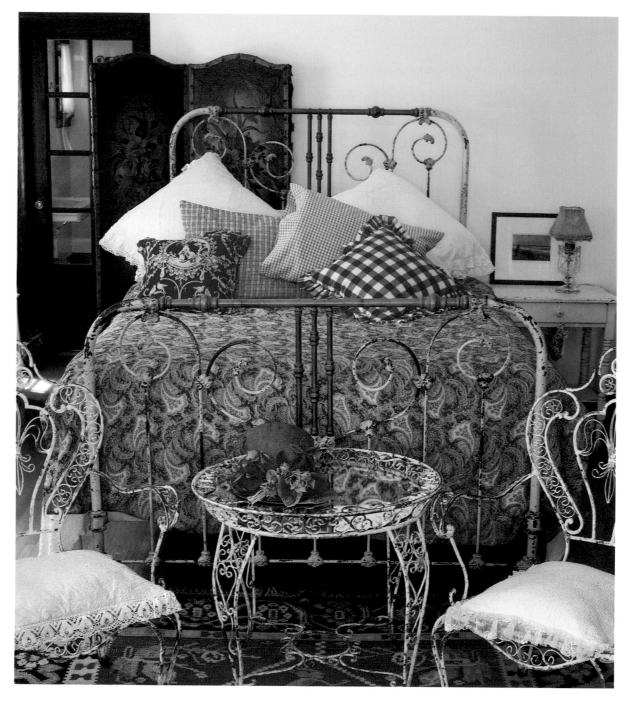

French iron garden furniture brings in the mood of the
outdoors to Philomena Giusti's romantic bedroom. Rather
than adding a predictable piece of glass to the tabletop, Giusti
put in a mirror and placed white lacy pillows on the chairs to
give the pieces a boudoirlike feeling.

BATHROOMS

C lean, simple, private, luxurious, and practical: These are the words that best describe a Shabby Chic bathroom. The basics of any bathroom should be functional fixtures that provide plenty of space for displaying toiletries, towels, and other bits and bobs. For bathroom storage space, I suggest vintage vanities or flea market cabinets. Bathrooms can also be the perfect space for incorporating unexpected, glamorous touches such as old chandeliers, busts, painted mirrors, or fancy footstools.

Unusual containers for soaps, oils, salts, cotton balls, and hand towels are another way to lend individual touches to a bathroom. Large stone bowls, wire baskets, apothecary jars, wooden boxes, and fish bowls all make great repositories for sundries.

If a bathroom is large enough, cozy, roomy, slipcovered chairs can be the ultimate luxury, providing a loungelike quality, regardless of whether the space is formal or casual. For overly sleek contemporary bathrooms, I like to introduce offbeat vintage pieces, such as scruffy old, but cleaned, dentist's chests or medicine bottles, whose character and a sense of age act to offset the cool, polished tone.

Fresh stacks of plush towels on hand—preferably in white—are a welcome luxury, as are bountiful piles of pretty soaps. Tile and marble are terrific finishes for bathroom walls and floors, but if the floor is too cold, add a throw rug or two for warmth.

Apothecary jars used for cotton balls, cotton swabs, and other sundries add a bit of old-fashioned glamour, like these belonging to Sandy Gallin.

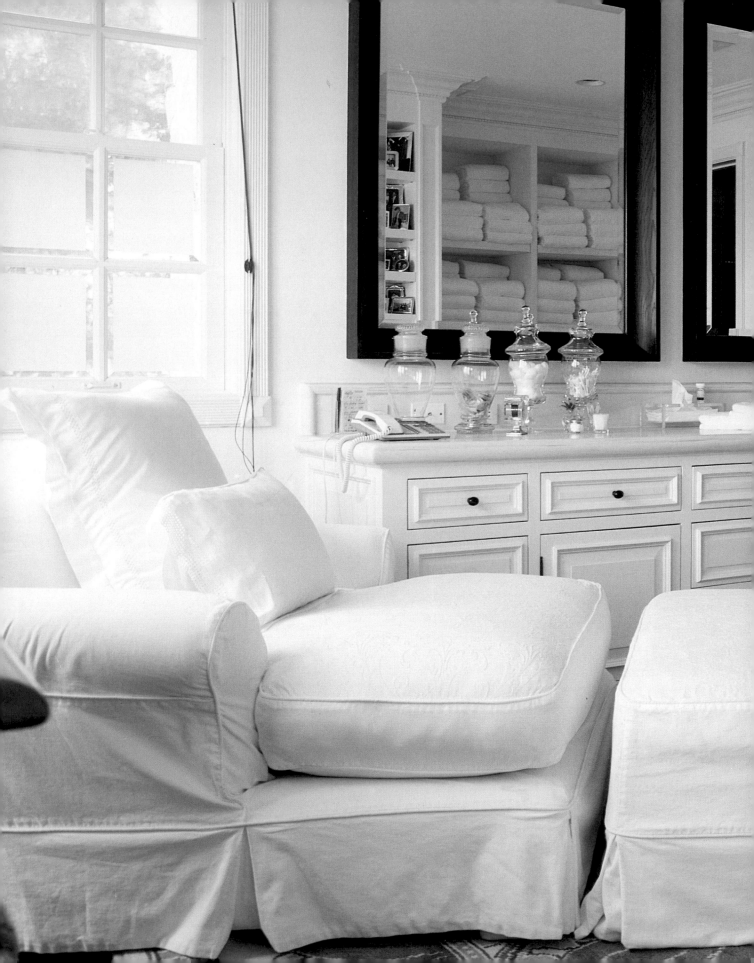

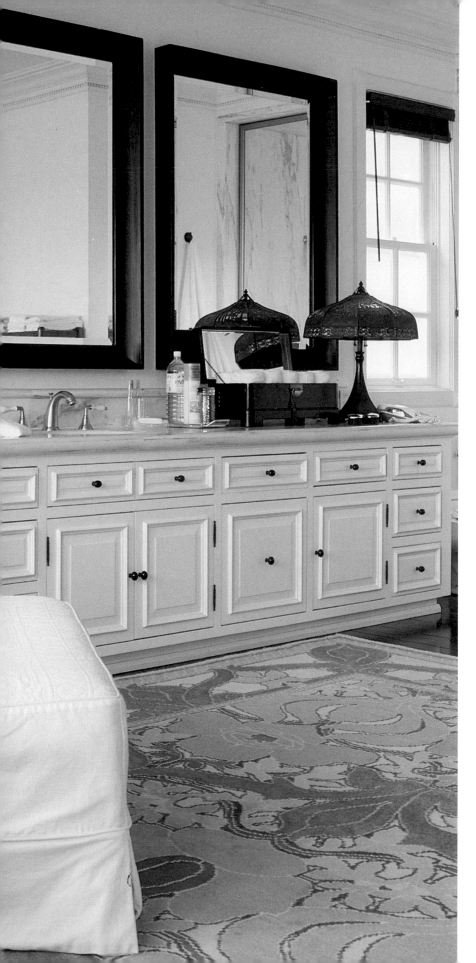

This huge bathroom belonging to Sandy Gallin is made more intimate with the warmth of a cozy rug and squishy slipcovered chair and footstool. The endless stacks of plush white towels give it a fresh, clean look.

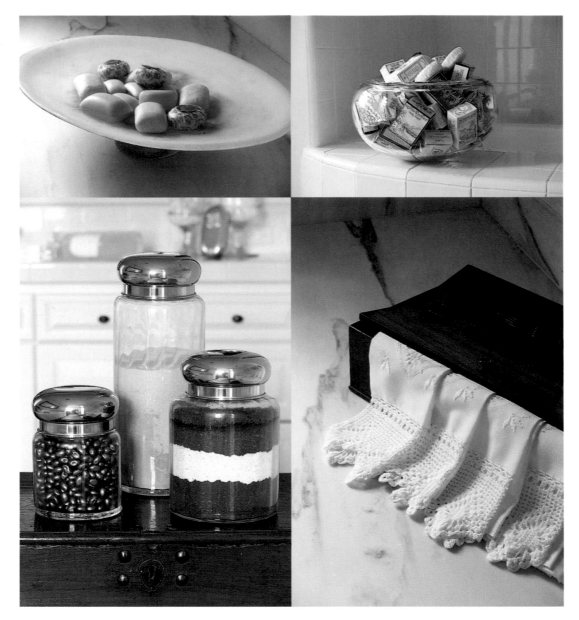

ABOVE: The bathrooms in Sandy Gallin's Malibu home are filled with simple, beautiful containers made of wood, glass, and marble and hold an array of sundries. (CLOCKWISE FROM TOP LEFT) A marble dish holds creamy soaps; a glass fish bowl contains imported soaps in little boxes; a wooden box contains fine linen hand towels; glass jars in the guest bathroom hold bath crystals and oils .

OPPOSITE: When using pieces found at salvage yards or flea markets, such as the sink shown here, always take care to replace rusted parts and faulty piping with updated fixtures. No matter how great a piece looks, if it's meant to function, it should. Adding to the practicality of this simple, monochromatic bathroom, the wainscoting was painted with a high-gloss finish for easy maintenance.

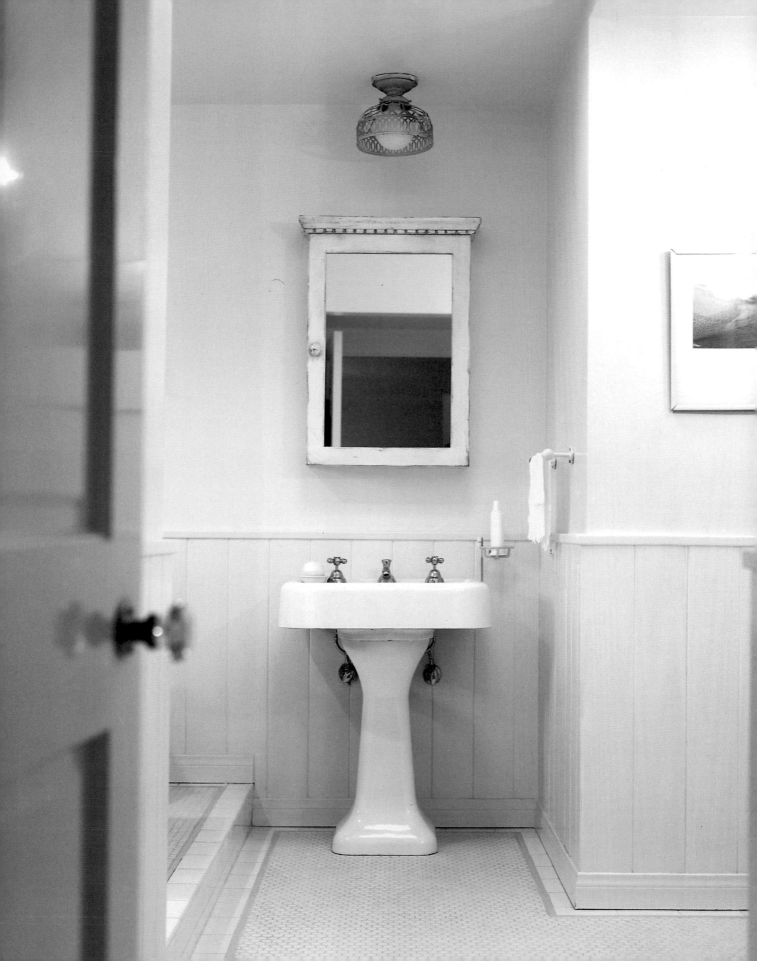

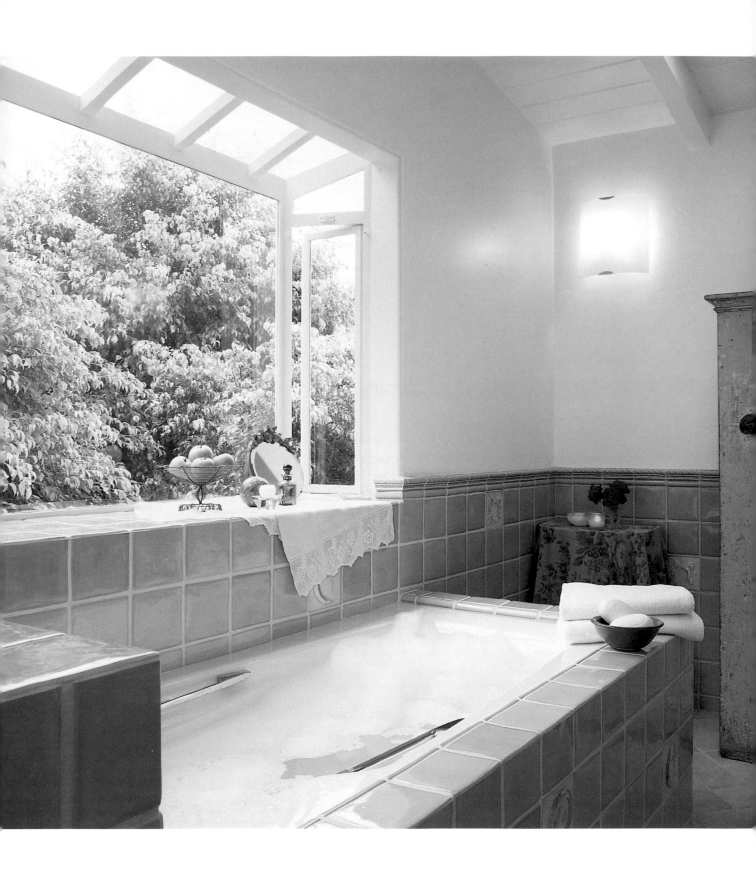

LEFT: The practical and the aesthetic merge in this soothing green, light-filled Malibu bathroom. Since the bathroom had no built-ins, an old, peeling green cabinet is used for storing unattractive necessities.

TOP RIGHT: This decaying Victorian mantel, beads framing its beveled mirror, illustrates rich detail. That a small part of the curled design on the left of the mantel is broken does not detract from the beauty of the piece. Functionally, the mantel offers extra shelf space for perfumes, vases, and boxes.

BOTTOM RIGHT: A floral painting done on glass circumvents the damage steam can do to canvas. A wide window shelf and tile ledges around the bathtub provide ample space for soaps, flowers, a mirror, bath oils, and even a cup of tea.

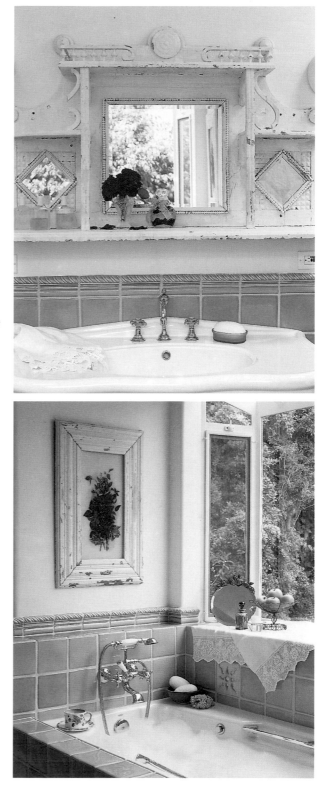

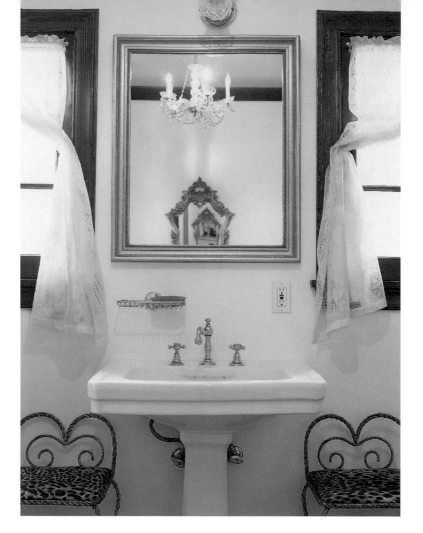

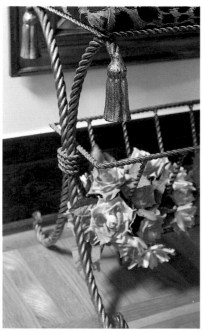

ABOVE: Refined accents add an air of formality to a basic bathroom. A chandelier, gold-framed mirrors, white lace curtains, and Italian footstools are elegant touches in Philomena Giusti's otherwise simple white and wood master bath.

LEFT: A bouquet of silk flowers is an unexpected touch at the base of this Italian footstool in Giusti's master bath. Gold metal rope, tassels, and a leopard-print cushion add to the visual surprise.

OPPOSITE: Simplicity of color and wood unify Giusti's light and airy master bath. A black reproduction vintage bathtub with silver feet is updated with the addition of a wire rack that keeps soaps and oils well within reach. A fluffy white towel, a welcome element in any bathroom, hangs nearby, while an ornate gold-framed mirror enlarges the sense of space and reflects the colorful tile details of the shower.

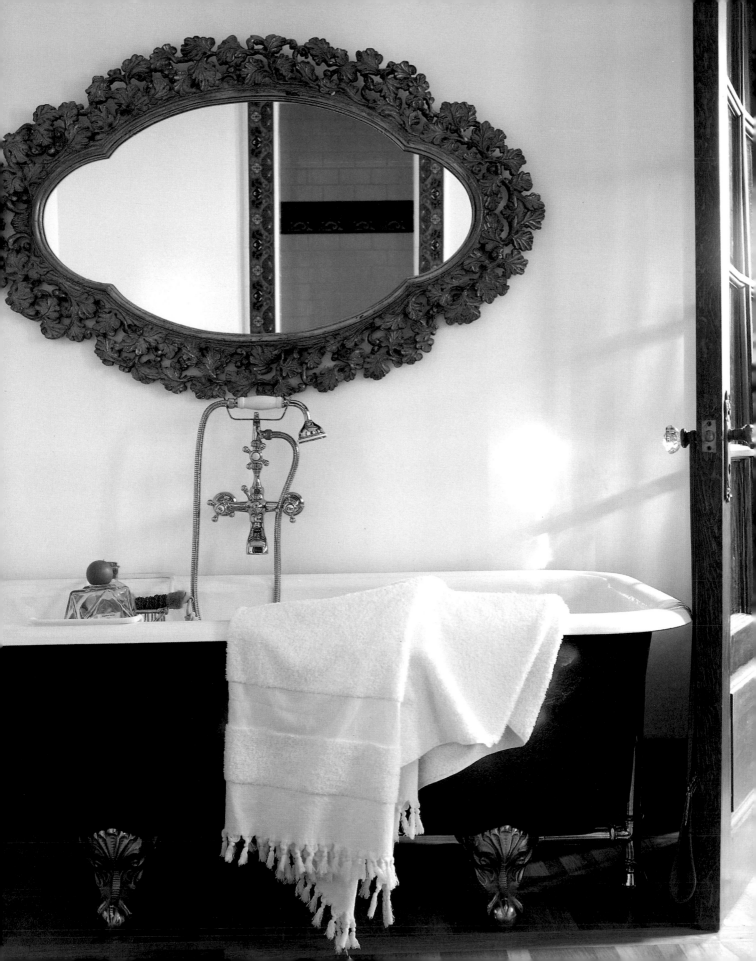

EATING AREAS

Whether a dining room, a kitchen, or a table on a terrace, eating areas should be comfortable, enticing places where atmosphere and decor do not take precedence over function, but encourage socializing and make guests and residents alike feel at home. The basics of any eating area are a sturdy, functional (and preferably large) table with comfortable seating and soft lighting. Kitchens, with their aura of warmth, are a natural place for families and guests to gravitate toward. Since more and more families are eating and entertaining in the kitchen these days, it's ideal for this room to offer a roomy table and plenty of accommodating seating.

Table settings are what usually create the atmosphere for an eating area. My favorite table settings are mismatched in terms of dishes, chairs, napkins, and even silverware. Mismatched place settings render a formal setting less stiff and add whimsy. The mismatching can be as blatant as using completely different colors and patterns at every place setting, or as subtle as using different patterns in the same shade or two. (I like to use variations of Old Willow—a traditional English blue and white pattern.) The hodgepodge effect of using mismatched pieces can be achieved by either combining your own sets of dishes or by actually purchasing single pieces from various sets at flea markets and creating your own look (see Chapter 3, "Hidden Treasures and Inspirations"). Either way, there are no rules.

While tablecloths can be beautiful additions to tabletops, I sometimes dispense with them altogether and let the scratched character of the table show through. I also like the idea of using a formal dining room very casually, as Philomena Guisti does, mixing a twelve-dollar tablecloth with real silver, and using a casual setting like the outdoors in a formal way, with crystal glasses and linens.

Mismatched patterns add both charm and a casual air to table settings. At this table set for tea, I used blue and white to mirror the cool, peaceful hues of the sea outside the window, although no dish or fabric cushion at the table matches another precisely. A vintage lace curtain was thrown casually over the chipped green picnic table, and a fresh arrangement of flowers was placed at the end of the setting so as not to impair guests' views. (See Resource Guide.)

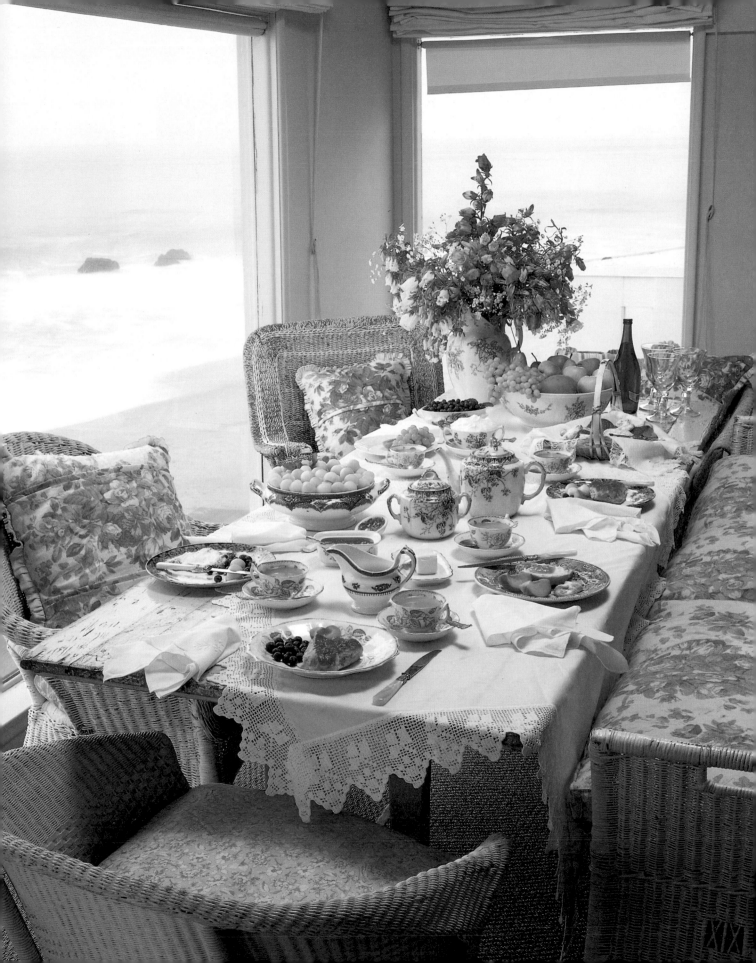

ABOVE: An old standing cabinet with chicken-wire sides finds a new function as a hanging cupboard for an array of towels, teacups, bowls, and mugs in the corner of Philomena Giusti's kitchen.

OPPOSITE: The intimate dining room of Giusti's Spanish-style home illustrates how the formal and the informal, and the expensive and the inexpensive, combine to achieve a pleasing effect. A grand feast or a light snack are equally suitable in this room, where a white lace drape found at a flea market serves as the tablecloth for a French country wine taster's table surrounded by well-worn leather-backed chairs. A simple bouquet of fresh roses from the garden placed casually in a silver vase and a pair of crystal candle-holders serve as a centerpiece, while an antique chandelier adds an air of faded grandeur.

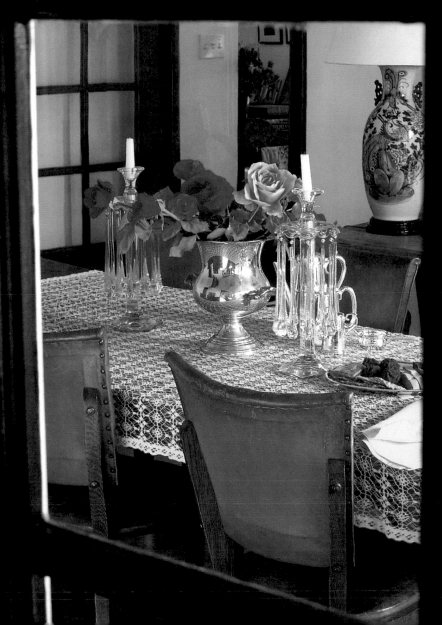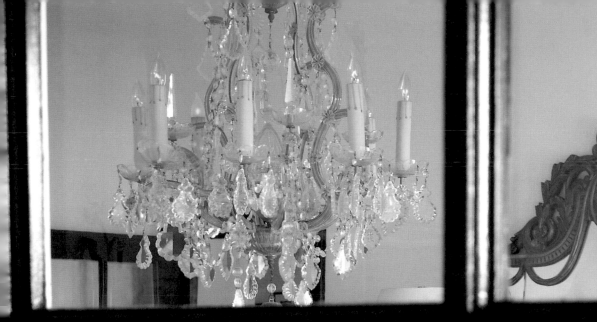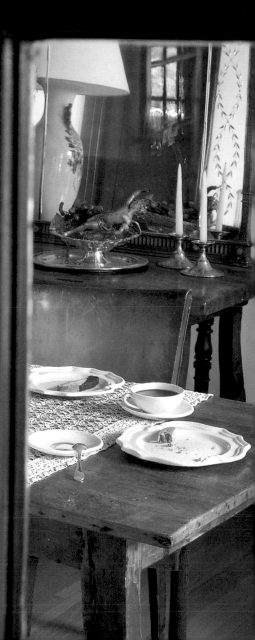

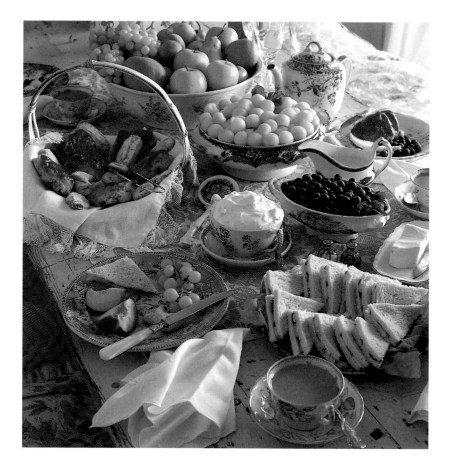

ABOVE: The food itself can be an intregal part of a dining room's decor. These cucumber sandwiches, blueberries and cream, honeydew, apples, and grapes blend together and with the table setting to create a cool tranquillity. (See Resource Guide.)

OPPOSITE: This bright alcove off Tony and Donna Scott's kitchen is put to good use. A scratched and worn wooden table and benches are used for quick meals or snacks, as a temporary holding area for purses, keys, and magazines, and as a space to set a large, fresh bouquet from the garden. An iron chandelier painted green adds a soft glow, while in the corner an antique masthead from a ship's bow seems to watch over the room. "This room is really the heart of the house," says Donna of the kitchen area. "Guests always seem to end up congregating here because it feels so comfortable."

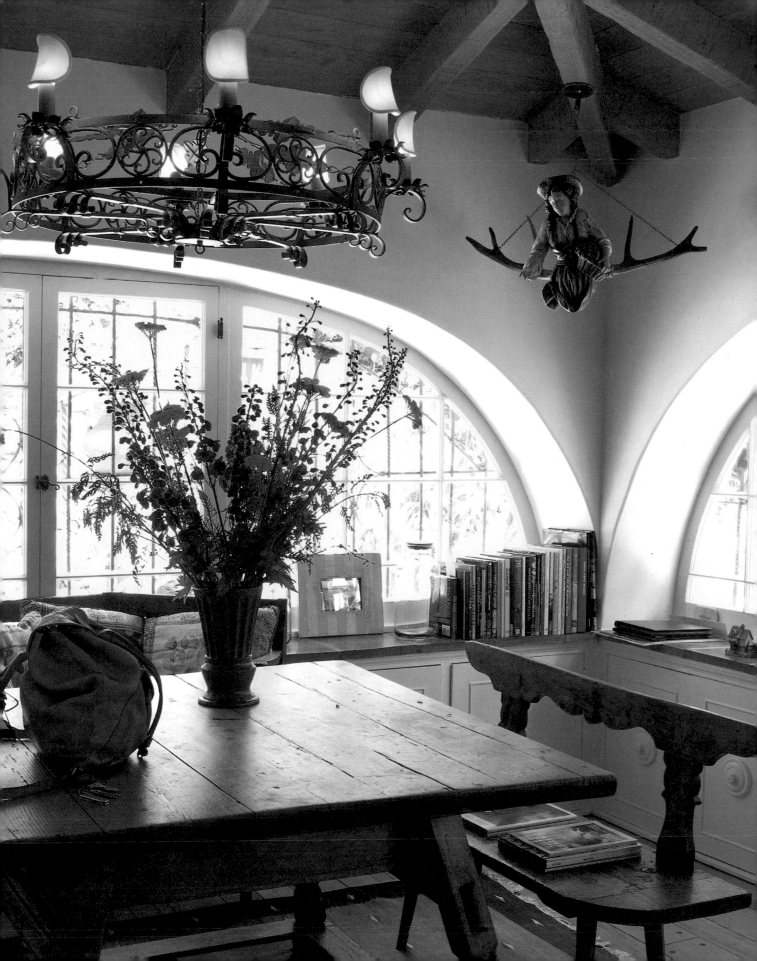

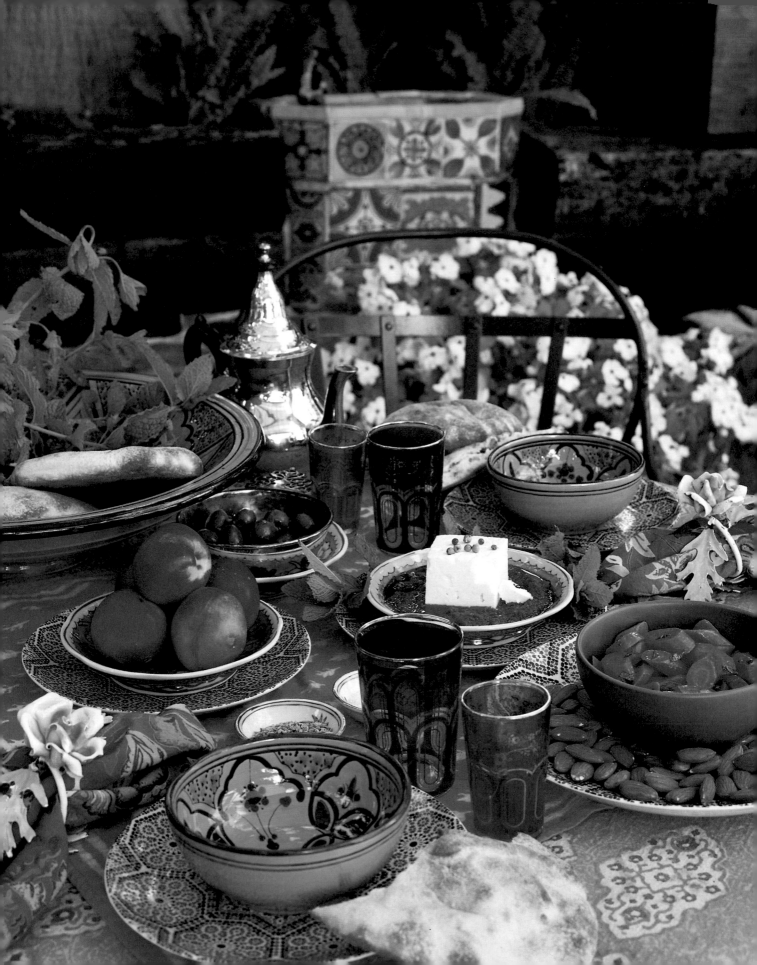

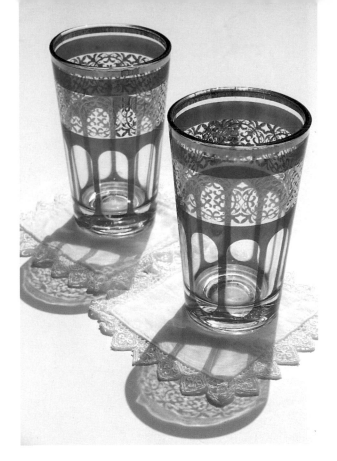

OPPOSITE: While subtle, muted tones are the usual markings of the Shabby Chic style, a mix of fabrics in a range of colors and patterns can make a tabletop more inviting, if not exciting. This Moroccan-style feast on Tony and Donna Scott's poolside terrace blends colorful foods with bright dishes and a rainbow of fabrics in differing Indian-print patterns to create an eclectic, tapestrylike atmosphere. (See Resource Guide.)

RIGHT: These etched blue glasses from France are a tiny size perfect for children, who never seem to finish the contents of a large glass. The glasses are inexpensive and come in an array of fun colors that can be mixed and matched with different fabric patterns. Here, they're paired with linen and lace placemats from my daughter Lily's doll tea set.

TIPS FOR TABLES

- ☐ If you're able to without creating too much clutter, have everything on the table you think you're going to need before the meal begins. It can be helpful and creates an abundant look. Otherwise, you'll be constantly getting up and down. This is also especially helpful if you have children, who always seem to be asking for something else.

- ☐ Centerpieces should be low or put at the end of the table. You want your guests to be able to see and talk to one another. It's also nice if the centerpiece carries out the colors or theme of the meal.

- ☐ Buffets are a great way to create a relaxed atmosphere and are an especially good choice when children will be among your guests. Children can be finicky eaters and buffets give them lots of choices.

- ☐ Candles are a must, for they set a wonderful mood and emanate flattering light both for food and people. It can be attractive to display all different shapes and sizes, but make sure there is adequate light. People should be able to see what they're eating.

- ☐ The bigger the table, the better—room permitting.

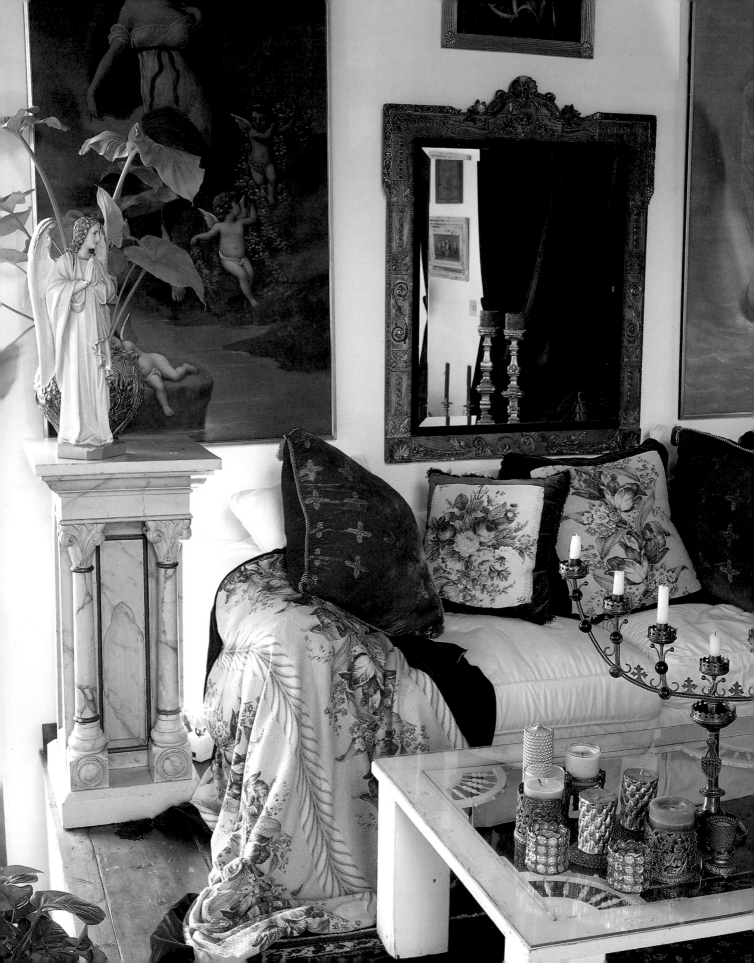

LIVING ROOMS

The most important quality of a living room is that it can actually be lived in. Rather than being a showpiece, a living room should be a functioning space for socializing, reading, and relaxing. Regardless of its style, a living room should maximize comfort with seating arranged in a way that is conducive to conversation.

Even very formal living rooms can be made to feel more casual. Furniture that wears well, like leather, which can actually improve with age, or slipcovered chairs, which remove the fear of stains, can make a formal living room more welcoming. The elimination of anything too precious and the belief that objects are to be used, not merely looked at, are other ways to keep a living room from becoming too stuffy. If something breaks, tears, or gets stained, this should not constitute a crisis. Pieces with wrinkles or imperfections further open the door toward real living. Candles that have been burned, throw blankets that are really used, and earmarked books are all signs of life that make a room more inviting.

Coffee tables should be roomy enough for books, magazines, resting feet, flowers, and tea cups. Personal objects such as framed family photographs add individuality, while mirrors are good for maximizing space in small living rooms. Mirrors should be hung where they will reflect light and something interesting—the view from a window can provide both.

Regarding fabrics and colors, I prefer muted tones, monochromatic color schemes, and subdued themes for living rooms as evidenced by the variations of pale greens, creams, and subtle floral patterns in my own house. But, as in any other room, unexpected touches and contrasts sometimes can be appealing additions (see Chapter 4, "Fabrics").

OPPOSITE: Chantall Cloutier's theatrical living room is a good illustration of how a white denim slipcover can work anywhere as a base for layering color. The throw is made from an old piece of floral fabric lined in velvet. The coffee table is a vintage door painted white and topped with a piece of glass. A marble plant pedestal, gilded mirror, candles, and oil paintings are touches that add a rich feel.

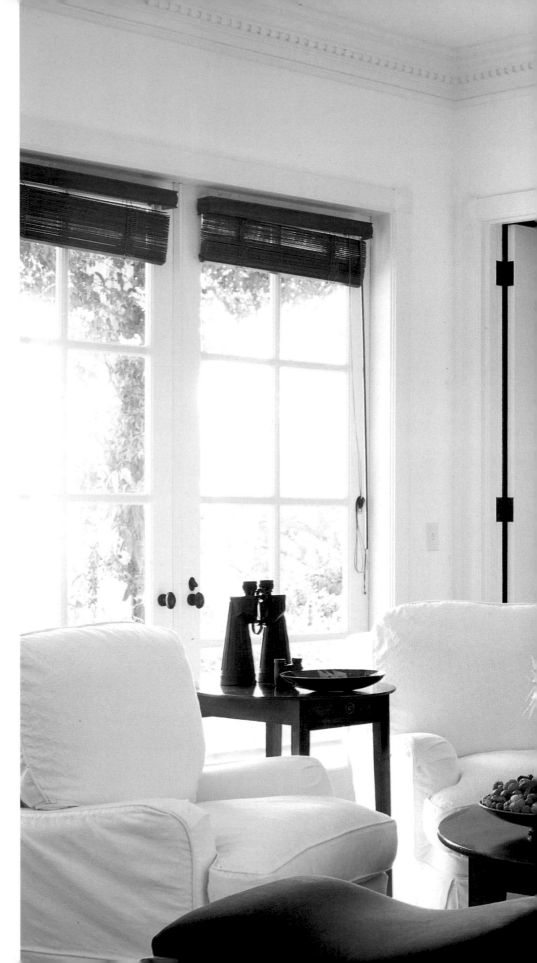

RIGHT: The white slipcovers
ease the formal mood of Sandy
Gallin's living room.
FOLLOWING PAGES: Tony and
Donna Scott's octagon-shaped
living room.

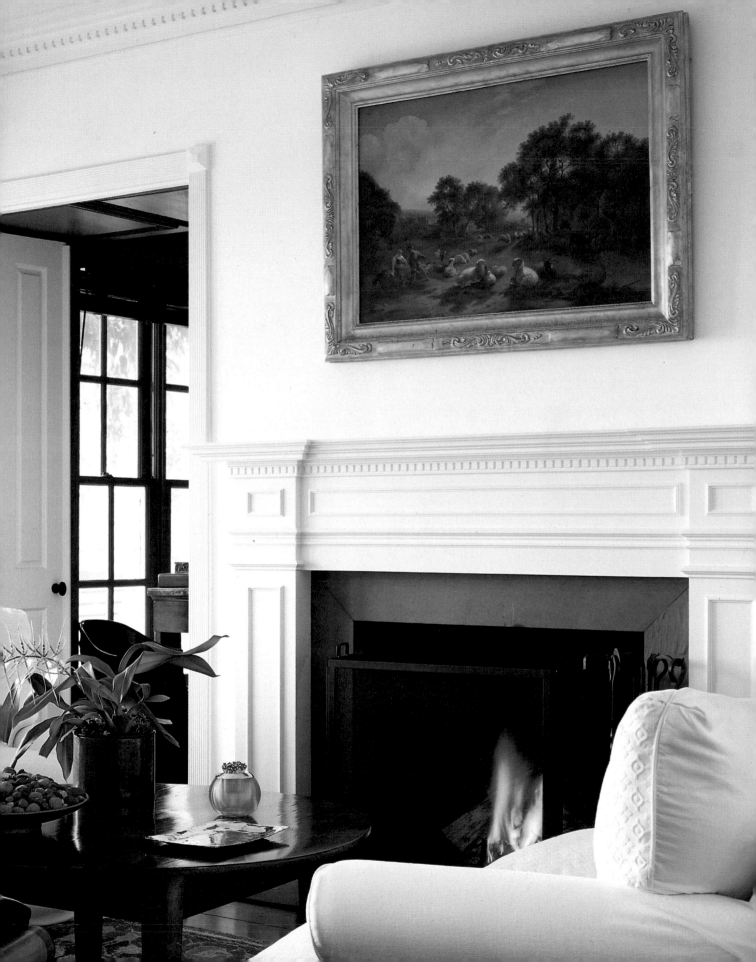

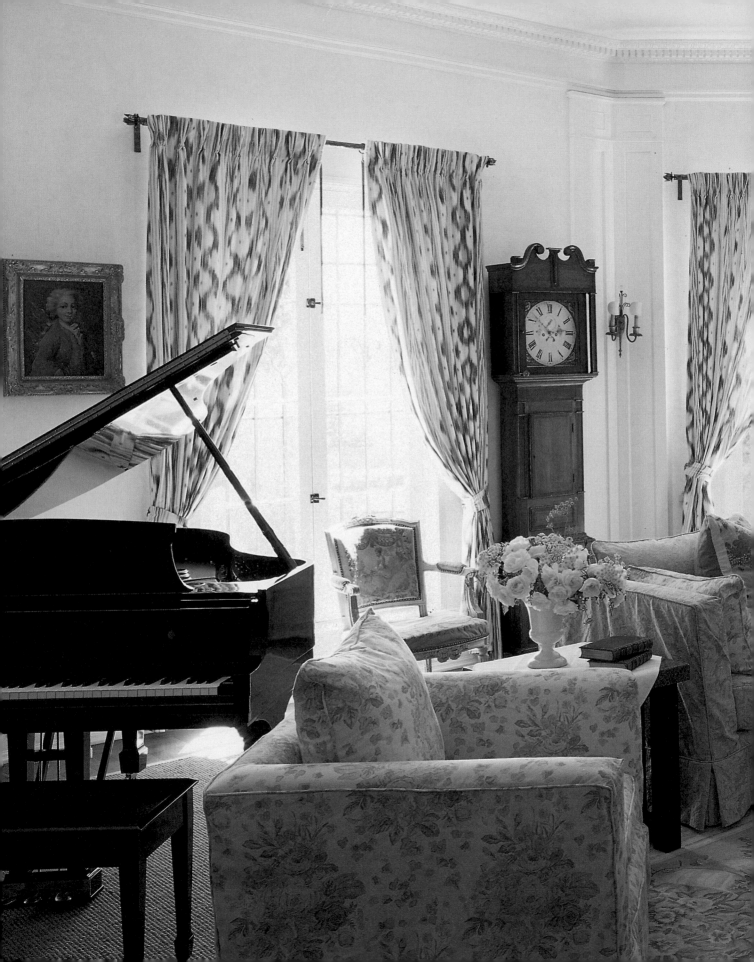

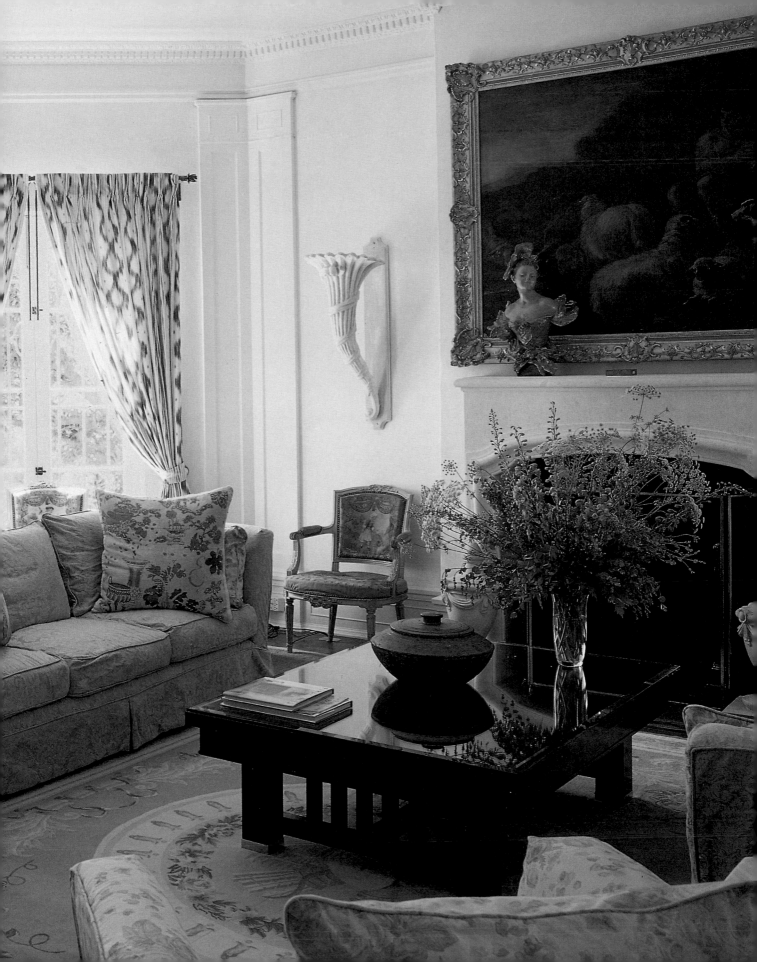

FORGOTTEN SPACES

Entryways, halls, foyers, staircases, and doorsteps are all "nonrooms" that have incredible potential to become interesting spaces, but they are all too often passed by on one's way to another space—in other words, ignored. Often these areas are the first things a visitor sees, so imbuing them with aesthetically appealing characteristics can serve to create a good first impression. Forgotten spaces are perfect spots for decorative pieces like chandeliers, paintings, intricate banisters, or colorful tiles—all of which give a house added character.

The little details that actress Jennifer Nicholson added to her front door area, for example, give visitors a glimpse of her personal taste and set a tone for the ambiance of her home. She hung a crystal chandelier on the doorstep, painted the door seafoam green, and added a sheet of etched glass behind the door's wrought-iron floral peephole. Upon opening the front door to Philomena Giusti's house, visitors are greeted by a colorful staircase with different tiles on every step. Tony and Donna Scott's front entryway could have been left as a mere passage, but the couple turned it into a functioning space with visual appeal instead. They installed a comfortable bench, added a mirror framed in peeling old architectural molding, and put in a traditional hat rack to allow for easy access to jackets. Hallways and staircase

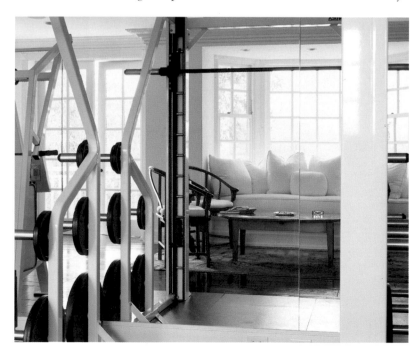

LEFT: **In Sandy Gallin's high-tech black, chrome, and mirrored gym, the cushy, white slipcovered chairs and couch create a cozy contrast to the hard-edged workout equipment.**

OPPOSITE: **Entrances create one of the first impressions of one's home for visitors and as such should not be overlooked. This seafoam green door at Jennifer Nicholson's Spanish-style home demonstrates how an appreciation for detail can make a difference. Nicholson first had the door painted her favorite color, then installed a piece of etched glass behind the floral iron grating covering the peephole.**

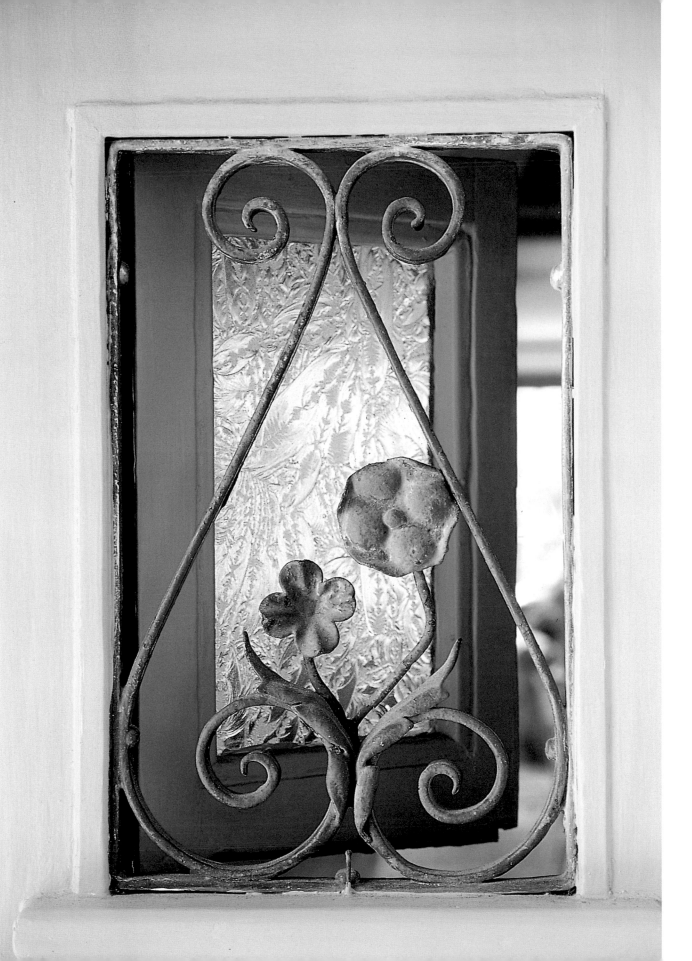

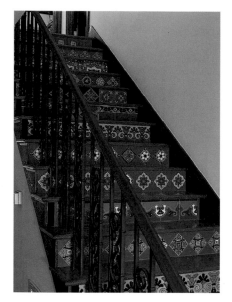

LEFT: The elements within a room or even the parts of the same structure need not match to be appealing. To add color and detail to the front stairway of her home, Philomena Giusti covered each step with a different Malibu tile. "I wanted every step to be individual," she explains. "It gives an early California feel to the house, which is Spanish-style but could have gone in a French direction."

OPPOSITE: Front entryways with warmth and character, such as this sunny, earth-toned entrance at the home of film director Tony Scott and his wife, Donna, welcome visitors. Visual appeal and function come together in this well-used space, where the life of the home is evident. A built-in seating area covered in inviting leather, a traditional hat rack filled with jackets, and leather dog leashes strung over the banister offer evidence of the occupants' comings and goings. A Shabby Chic mirror, with its compos detailing and peeling and worn frame, serves as a spot for last-minute touch-ups. Cleaning footprints is easy on this cool tile floor.

landings throughout the Scotts' house are put to good use with desks that serve as junk holders; sunny, pillow-filled window seats for reading; glass tables for holding pretty floral arrangements; and a variety of decorative yet functional lighting fixtures.

Nontraditional rooms such as home offices and gyms are other areas that are often overlooked from a design standpoint. Chantall Cloutier's home office exemplifies how aesthetics and function can merge successfully. A fax machine, telephone, and date book blend in with vintage pieces Cloutier picked up at flea markets and antique shops. She uses an ornately carved wooden table as a desk, old fireplace andirons as bookends, and the surprise of an antique mirror over the desk to create a sense of space. Sandy Gallin's home gym is another example of how a nontraditional room can be made into a very decorative yet functional space. The enveloping white slipcovered sofas and chairs and a dark wooden table offer a respite from the room's hard-edged chrome and sleek equipment.

Whether a room is the bustling heart of a home or a private sanctuary, the best way to transform it into a comfortable, livable space is to let purpose take the lead and allow appearances or aesthetics to follow. It is also important to keep an open mind about new functions for old forms and to break away from outdated rules about formality and informality. The vintage bedroom vanity used as a bathroom cabinet, the rusty gate transformed into a coffee table, the chipped yet grand chandelier placed in the bathroom, the faded twelve-dollar tablecloth used in a formal dining room—these are the details that create the most interesting rooms and give them the character that is so important to the Shabby Chic style.

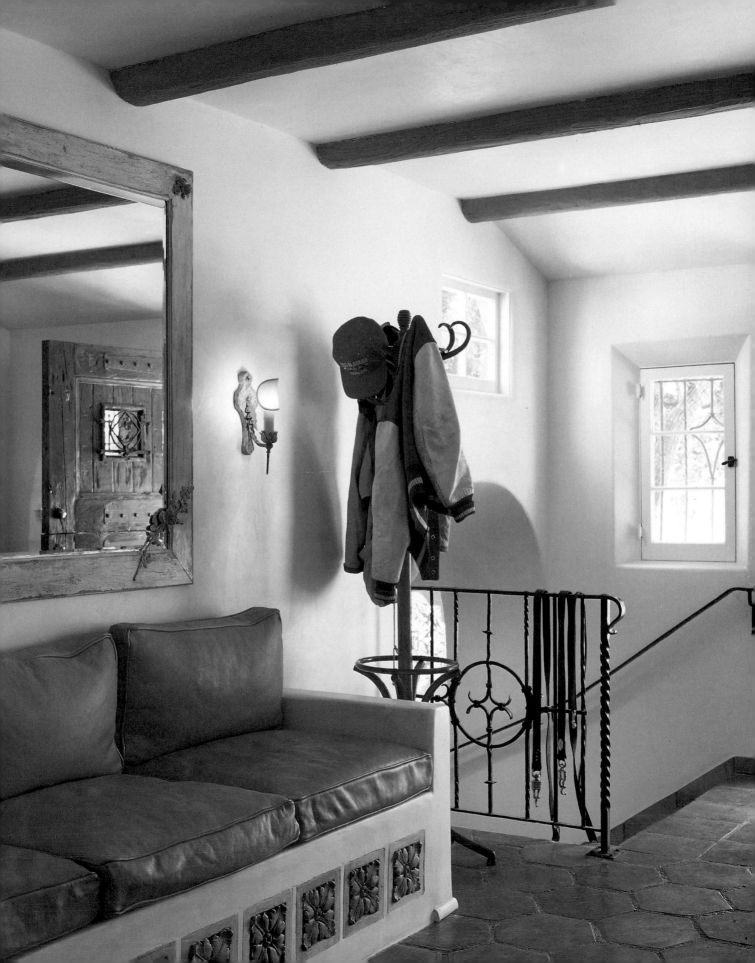

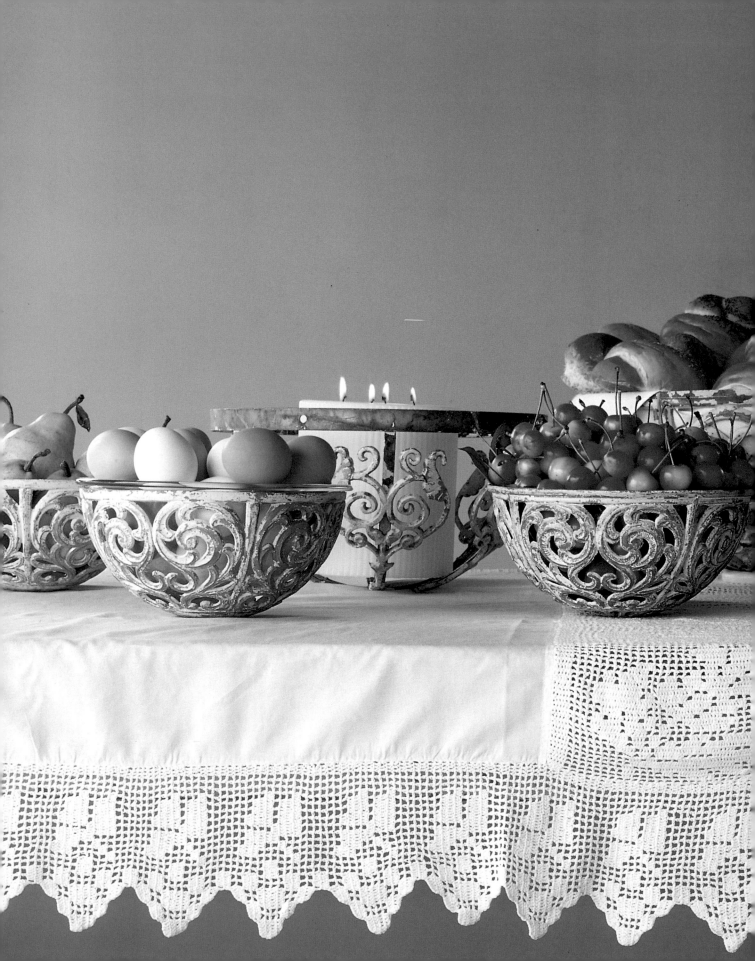

3
—
HIDDEN
TREASURES &
INSPIRATIONS

A faded, peeling old dresser; a cracked white chandelier; a chipped, metal trash can painted with roses: To one person, these items are rejects for the junkyard, to another, they are a bounty of riches. Discovering beauty in and finding new uses for the old and worn discards of others greatly appeals to me, and there is no better place to find the faded and the decayed, the crumbling and the scuffed than a salvage yard or flea market, garage or estate sale.

Most cities and towns have salvage or junk yards, and most also offer some sort of market for secondhand items. Salvage yards are great for finding old bathroom fixtures or iron works, but tend to be a bit more expensive than flea markets, which usually reap the biggest and most economical crops of shabby pieces with the potential to evolve into chic treasures. Although flea markets vary from city to city, I find that weekly markets are less worthwhile than monthly markets, as a week isn't enough time for vendors to restock their inventory.

Articles I like to look for at swap meets include: tapestries and rugs with floral or romantic motifs; lamps (metal wall sconces from the forties are great); crystal or metal chandeliers (but nothing too gaudy); candleholders; floral paintings; vases; wicker furniture (preferably of a

PREVIOUS PAGES AND ABOVE: **New functions for old forms: Found at a flea market, these attractive metal bowls were once the halves of globe-shaped street lamps. Some were lined with cloth, others with glass bowls from the local drugstore, while still others were left as is, depending on their contents. Here, the lamp pieces are used as whimsical holders for fruit, bread, eggs, and a candle, with a crisp piece of cotton and lace serving as a backdrop.**

thick, sturdy variety); painted wood pieces, such as peeling vanities, dressers, and cabinets in pale colors or in colors that can be repainted; architectural moldings; iron-work furniture; and mirrors. (Don't be put off by slight mottling, which can give a mirror added character. Do be wary, though, of mottling that creates too much distortion, rendering the mirror no longer functional.)

I also look for pieces that have multiple uses or the potential for new uses, such as trunks, doors, or gates that can be used as coffee tables; or metal-work half-spheres that were once part of lamps that can be used as bowls for flower petals, candles, or fruit. Old wooden door or window moldings and iron works in intricate patterns and patinas can make great mirror frames. Good architectural moldings come from demolition sites of old houses and can be found at junk yards and some flea markets. I avoid moldings that

RIGHT: **The interesting shape and floral detailing on this chair made it stand out from the rest of its flea market stall-mates.**

BELOW RIGHT: **This flea market trunk was in great condition and would barely need any handling.**

BELOW: **Delicate and shabby, faded velvet roses on this vintage flea market find struck me as being quite beautiful.**

FOLLOWING PAGES: **A typical vendor stand is a mishmash of bits and bobs, odds and ends, clutter and clatter. Once your eye becomes trained, however, certain pieces will stand out as you learn to distinguish between trash and treasure.**

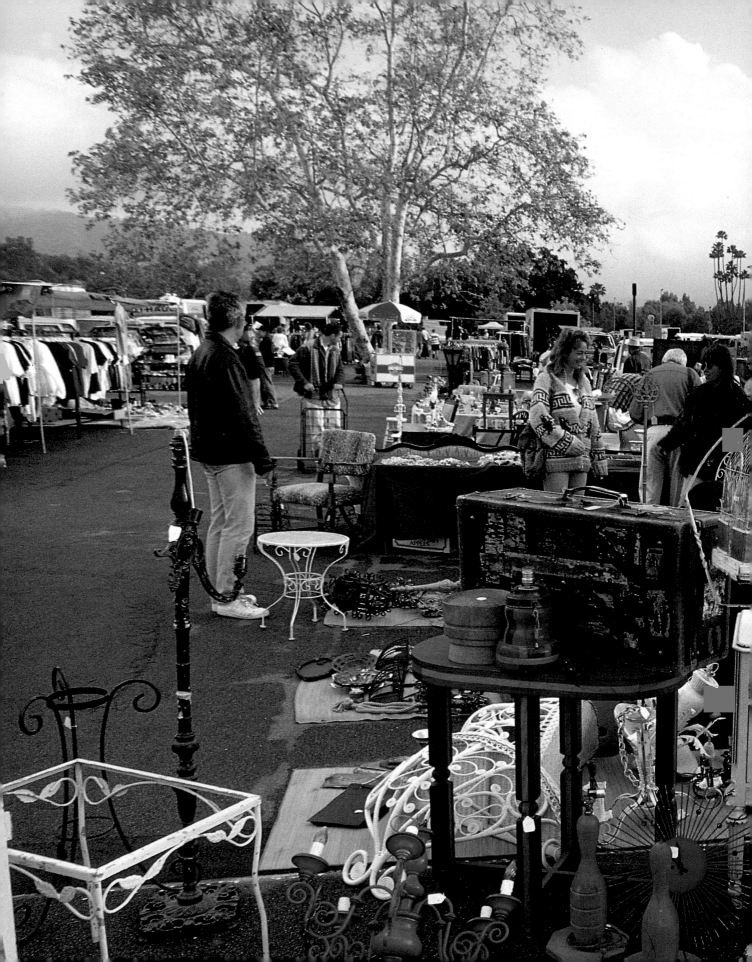

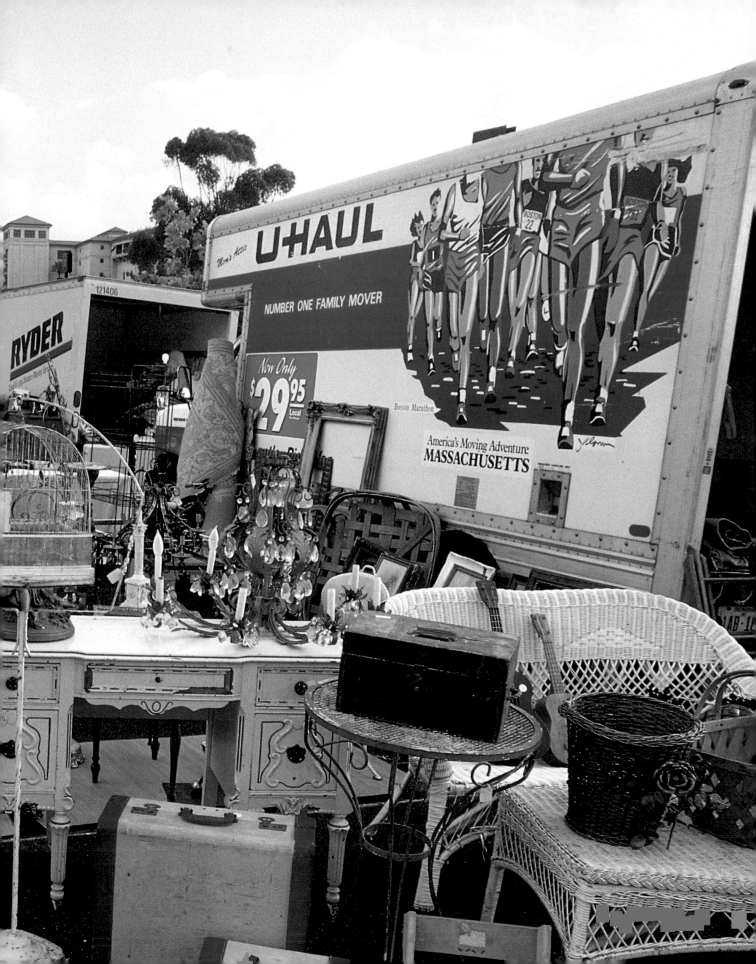

are too scraped up and have more wood showing than paint, because they look too "country" for my taste. I like just enough dilapidation to render character, not true decay.

Flea markets also can be ripe ground for unique pieces. If an object has no real purpose and is purely ornamental, I prefer that it exhibit unusual or whimsical characteristics that imbue it with humor or life. Parts of an object, for example, such as the foot, hand, or head of a statue, can be as beautiful as the whole.

For me, scouting flea markets is never about searching for objects with a certain value or status, that are from a specific period, or by a certain designer. Flea markets are where I find items that I am drawn to instinctively, due to their unique look, their workmanship, their feel, or their character. The attraction for a piece also might be that it seems simply perfect for that empty corner in the bedroom or that out-of-the-way space under the stairs.

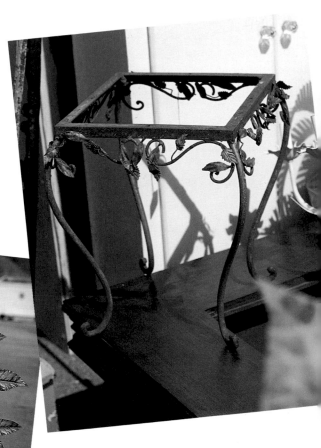

FAR RIGHT: This humble wicker chair cost a friend twenty dollars at a flea market and an additional one hundred and fifty dollars to have a small frayed area on the arm repaired. The intricate detailing and the green paint peeking through the peeling white paint give the chair a mottled appearance that I find appealing, although the entire chair could easily be repainted white for a clean, fresh look. (See Resource Guide.)

BELOW: Old window and door moldings make great frames for pictures and mirrors. I look for those in muted colors with enough peeling and crumbling to lend texture but not so much that the piece looks as if it will fall apart. Salvage yards, flea markets, and demolition sites are good places to look for moldings.

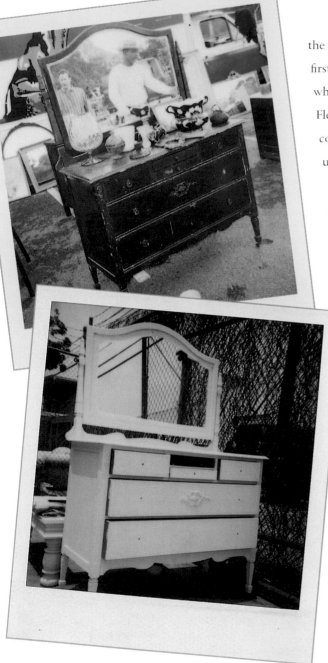

To beat the crowds and to benefit from the widest choice, the most opportune time to go to a market or meet is when it first opens, usually around six A.M. I like to arrive at sunrise, when the vendors are still unloading their vans and trucks. Flea markets have become so popular in the last few years and competition for the best pieces so fierce that I try to snatch up pieces before they even make it off the truck.

Those with an eye on value, however, should consider a trip at the end of the day, which is a good time to get bargains from tired sellers, who, anxious to get rid of their wares, are more amenable to giving discounts.

It's also a good idea to get to know the market a little before buying. Stroll around to assess the variety of offerings and compare prices. Some sellers may even put items on hold for a few hours, enabling you to do a bit of comparison shopping without losing the object you're interested in. Take your time, especially if you are new to the world of flea markets. Once you become seasoned, you'll be able to sense immediately if something is "right" and if the asking price is reasonable. If you buy often enough and in quantity, you can build a relationship with certain vendors, who may even purchase items specifically with you in mind. When I wander around flea markets, sellers often point out some decrepit cabinet and tell me it reminded them of something they thought I'd like.

Don't be afraid to walk away from something. When I really like a piece, I try to act as nonchalant as possible, for if a seller can tell you're going to buy something, he has no incentive to give you a better price. If you appear hesitant, he may come down a few dollars to entice you. When I see someone else looking at an object that I like, I won't show that I'm interested when he puts the object down; I wait until that person actually leaves the stall. Many times a potential buyer has put something down only to become suddenly reinterested when I showed interest, too. Sensing a demand for an item can also make

the seller ask a higher price. When the seller does name his price, you might want to offer anywhere from 20 to 40 percent less so that you can come to a compromise somewhere in between. It's better to barter with cash, and you can also expect better discounts if you buy in quantity.

If you're not buying an object immediately but want to remember where it is, or if you want to come back later to pick up a purchase, jot down the stall number where you found it. If there are no numbers, make note of the surroundings. I often write down little notes to myself like "mirror at stall next to big blue awning, near red truck."

Though a worn-out, weathered look is a quality I look for, it makes sense to look for things that aren't too damaged, especially if you don't have a lot of time and money for restoration. There is sometimes a fine line between trash and treasure, and only the buyer can decide when junk really is just junk. If a piece needs a major restructuring job, is extremely delicate, or if repainting will ruin it or make it look too fake, it might not be worth buying. Trying to restore wicker that is too dilapidated can be as frustrating as attempting to repair a run in a stocking, not to mention expensive. If the flaw is something simple like a torn piece on the seating, I just add a pillow. If the imperfection is a tiny bit of tattered arm, I might decide to live with it. I have a friend who bought an old paper-wrapped wicker rocker for twenty dollars and spent a hundred and fifty dollars to restore it. For her, the piece was so beautiful and rare, restoring it was worth the expense.

OPPOSITE: **This old painted dresser was in great shape, with interesting details—I painted it cream.**

RIGHT: **Before: I loved the muted sea-green color of this old painted headboard. Rather than repaint it, I left the piece peeling and crumbling, and later turned it into a daybed topped with a patchwork of pink floral and cream bedspreads and pillows.**

FOLLOWING PAGES: **After: To transform this headboard and frame, I added big fabric bolsters to the back and sides. For a casual feel, I used a mixture of plaids, florals, and solids and covered the mattress with an Indian-print bedspread of the type that can be purchased at import stores for fifteen or twenty dollars. All I did to the dresser was add some green glass knobs. To make the Roman blinds, I used inexpensive bedcovers and kept them unlined for a natural, sun-bleached feel.**

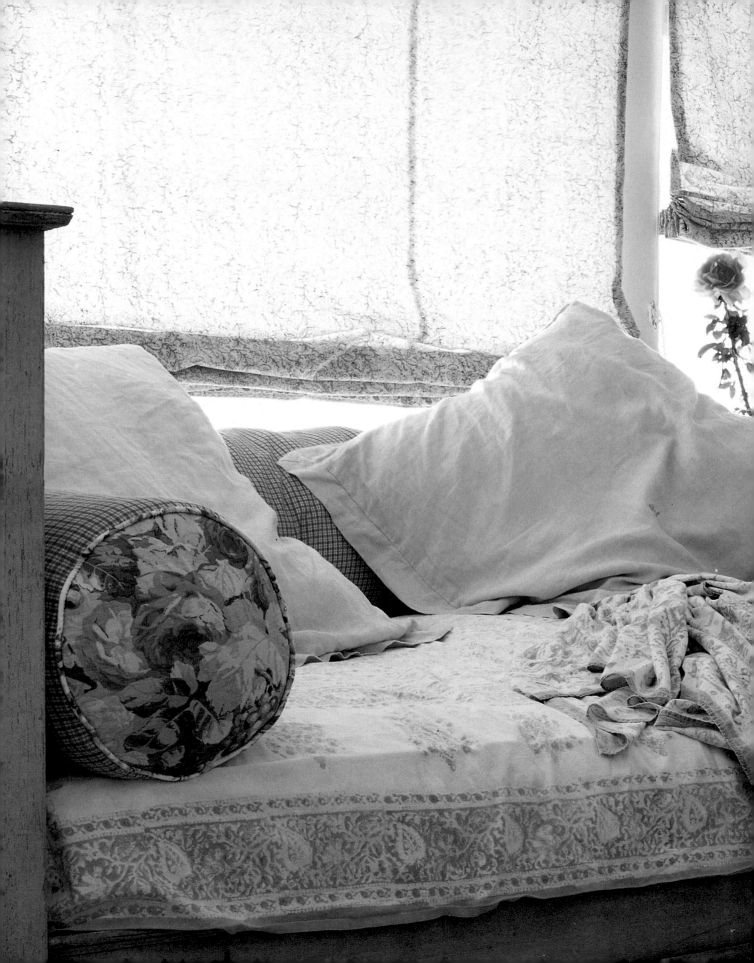

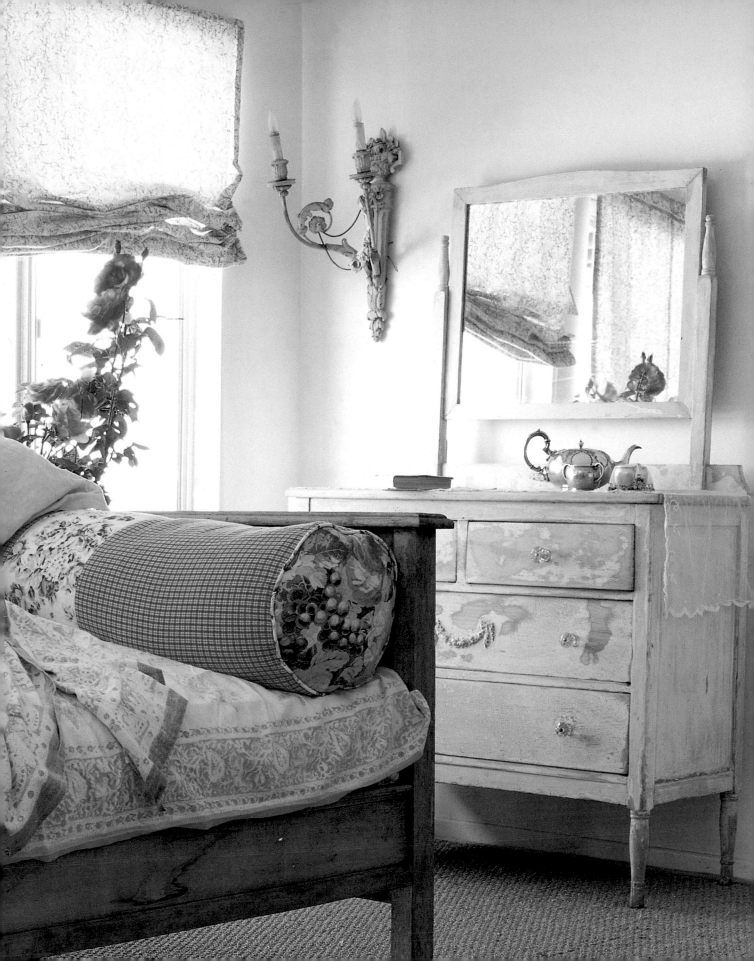

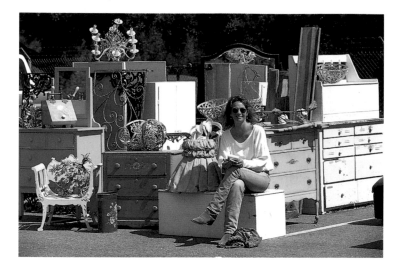

The fruits of a two-hour stop at the flea market. I picked up about twenty-six items on this particular morning, including everything from dressers and trunks to lamp shades and metal baskets.

Equally as important as avoiding pieces that are too worn is avoiding overly perfect or faux old pieces, like furniture that has been painted or repainted, then intentionally scraped and scratched to look worn. With the increasing popularity of vintage painted wooden furniture, this faux old phenomenon is becoming more common as truly authentic vintage pieces become more scarce. To discern if something is truly old versus merely made to appear that way, look for defects that are more random than uniform and colorations that are varied or appear in gradations. Paint jobs that look stroked on only in patches or deliberately rubbed away in spots are other signs of fake aging. To buy a piece that you will have to turn into something shabby is to miss the point, for the appeal of a piece is in its natural aging, not in the false creation of the appearance of age. If I feel as if I would need to chip away at a piece with a hammer or scrape it with sandpaper to give it an aged feel, I forgo it. In addition to distinguishing between real old versus fake old, hunt for pieces that are substantial and have some weight to them—in other words, that aren't too fragile or rickety—and articles with evidence of craftsmanship.

Objects with a real history and a defect or two are more appealing and somehow more approachable, so don't be put off by a few places where the oak wood peeks through a pale green vanity table or by rusty patches of metal on an old candleholder. The beauty is in the imperfection. The charm is in the flaw.

Details give objects an added aesthetic appeal and make the difference between the ordinary and the unique collector's piece. An intricate floral wreath on the drawer of a tiny, chipped green dresser was the selling point that made me take notice. A screen underneath, once used to keep bugs out, gave the piece a historical dimension, and the fact that it was held together by interlocking pieces of wood rather than nails authenticated its age. Carved or painted flower motifs always add to the value of a piece. Because labor costs are so prohibitive, it's rare to find in new furniture a flower carving that is not a separate, decorative piece that was attached later. While these attached pieces can be quite lovely, and I have used them on occasion to dress up the edges of mirrors, authentic carvings are preferable.

The legs and edges of a vanity, end table, or chair are also good indicators of quality and age. Most

vanities made between the turn of the century and the forties have fluted rather than straight-edged surfaces, and their legs tend to be curved and detailed. Curved or bowed drawers are other desirable and hard-to-find features.

In iron works, be they lighting fixtures, gates, frames, tables, or chairs, I look for fine detailing and steer away from pieces that are too clunky or crude. In a toile floral chandelier, for example, I examine the flowers for their intricacy and realism, for the delicacy of their edges and curves, and for the fineness of their lines. Iron works from the forties and earlier are usually more detailed than later works. Because iron works often come in black, I almost always paint them ivory.

RIGHT: The intricate flower carvings and architectural patterns on this vintage dresser are evidence of its age and give it aesthetic appeal.

FOLLOWING PAGES:

(PAGE 90) The fine workmanship and well-thought-out proportions are what attracted me to this turn-of-the-century blue Italian bedside table. Its tapered shape, floral detail, and casters are all features that add to its character and reveal its authenticity.

(PAGE 91) This nineteenth-century French bedside table is a fine example of what to look for in vintage pieces, as it exhibits incredible detail and has an almost sensuous quality owing to its curved legs, drawers, and sides and the intricately painted flowers on its front and sides. The faded color of the paint and the various crackles add to the piece's time-worn appeal.

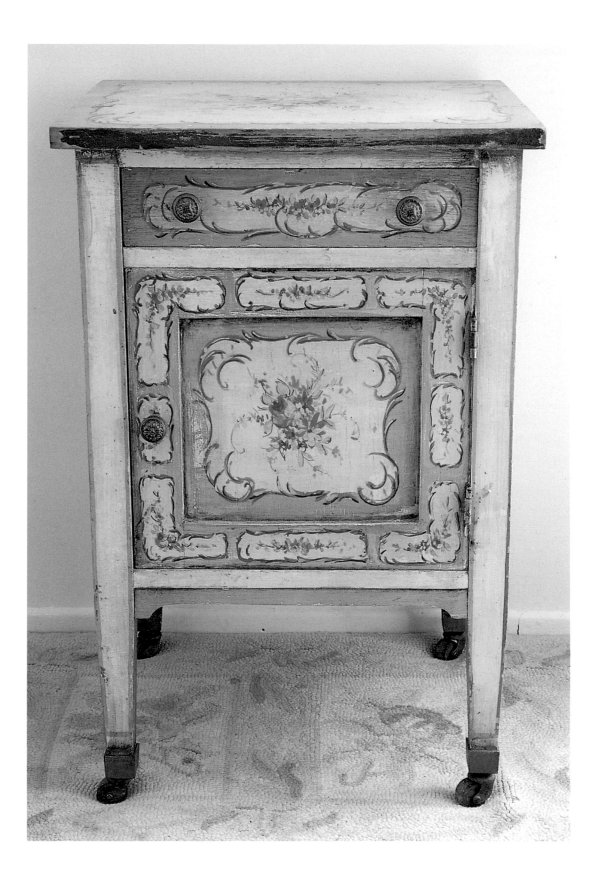

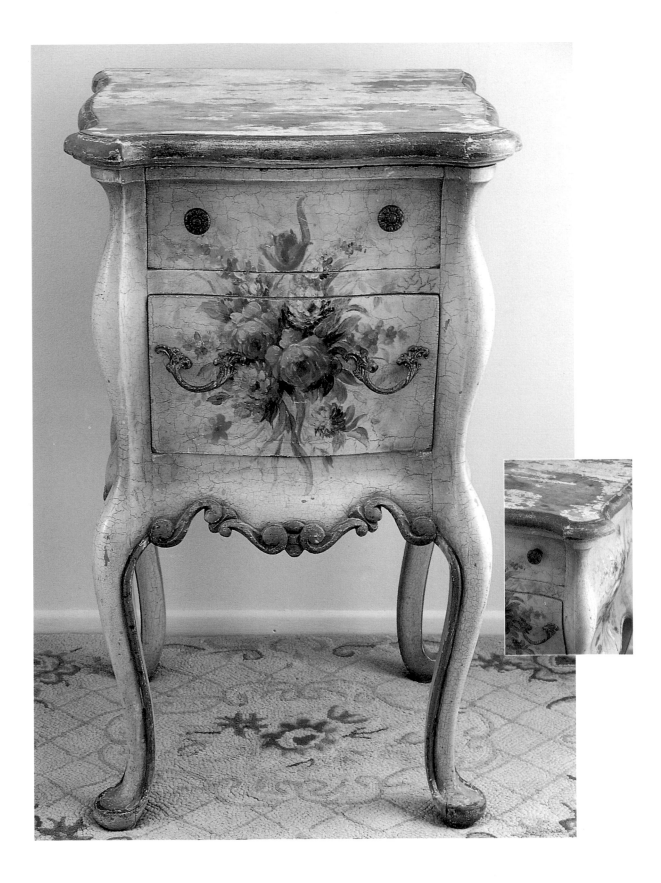

CLEANING AND REPAIRING

Easy ways to spruce up objects that need only minimal help include painting, adding new hardware or lining, or placing a piece of fabric, marble, or glass over a problem area.

If a table, cabinet, or wicker rocker, for example, is attractive in shape and proportion, but is stained in an ugly brown or lime green, it can find new life with a coat of white or cream paint. Semigloss or gloss paint is best, as a matte finish tends to absorb too much dirt. I will give wood pieces a light scour with a bristle brush or sponge and some soap and warm water. (Once the dirt is removed, if

the look and texture still aren't right, the piece can be very lightly sanded—but only lightly; a strenuous sanding can ruin a piece's weathered look. If the piece has been painted with gloss paint, it may need to be sanded a little more.) Then I prime and paint the piece. If I'm going to repaint a piece that has painted hardware, and the piece is already a color I like, I'll leave the hardware as is in order to keep some of its original shabbiness intact. I simply cover the hardware with tape while I paint the rest. The end result is a freshly painted piece with crackled, peeling hinges or handles. Because wicker is so fragile, I don't recommend sanding it or washing it too roughly. Wicker is also fairly absorbent, so I prefer to paint it as is so that it retains some of its coarse texture.

Revamping a piece of vintage furniture can be as easy as replacing unsightly knobs and handles or adding old casters.

ABOVE LEFT: This pile of antique casters includes wood, brass, steel, porcelain, and rubber rollers from the seventeenth through the twentieth centuries. In the late 1800s and early 1900s it was not uncommon for dining room tables, dressers, and kitchen cabinets to have casters for easy mobility. (See Resource Guide.)

LEFT: These glass, crystal, and porcelain knobs date from the late eighteenth through twentieth centuries. (See Resource Guide.)

OPPOSITE: Older knobs and handles with more character can be found at vintage hardware stores such as Liz's Antique Hardware in Los Angeles. They can also be discovered at some salvage yards, or can be scavenged from other pieces of furniture. (See Resource Guide.)

If the knobs or handles on a vanity are too new or unattractive, or if they are missing, they easily can be replaced with detailed antique porcelain, glass, or crystal fixtures. Ranging in price from about seven to forty dollars per knob at vintage hardware outlets (they may run slightly cheaper at salvage yards or flea markets but are harder to find), antique fixtures are not a bargain. But they are well worth the expenditure, as they add to the quality and interest of a piece. The pieces needn't match, either. If you keep an underlying theme—all glass knobs of the same size but with different designs etched on them, for example—the effect can be even more charming than a perfectly matched set.

When the top of a dresser is beyond repair, marred by too many scratches or worn out pieces of wood, I might cover it with a piece of vintage lace then top the lace with a sheet of glass (glass costs an average of fifteen to twenty dollars per square foot—slightly more if the glass has beveled edges). I may also conceal the damaged area with a slab of marble, which I often use to rejuvenate the tops of consoles or side tables. I opt for dull rather than shiny, glitzy finishes and for marble that is gray, white, or cream with gray or brown veins, as these colors are more versatile, working well in a variety of surroundings. Marble from a marble and/or glass specialist can run anywhere from about seven to one hundred dollars

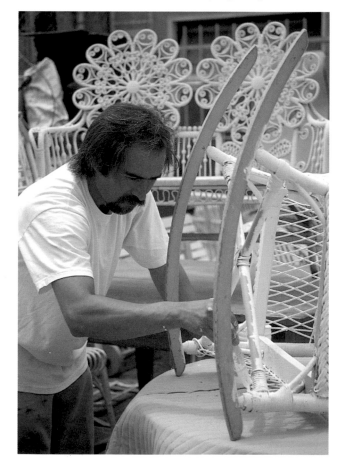

per square foot, or more, depending on its quality, color, and thickness; the marble dealer I use has more than one hundred different styles to choose from. The edging treatment of the marble can also add to its cost. A three-by-three-foot slab of a basic marble with rounded rather than flat edges costs anywhere from $250 to $325. Where appropriate, I prefer rounded, bull-nosed edges; these cost a little more but create a facade of extra thickness.

Though wicker furniture is fairly hardy despite its frail appearance, weatherproofing is a good idea if the furniture will be exposed to the ravages of sun and rain for an extended period of time. Adding a coat of paint is one way to lengthen the life of wicker (LEFT); another way is to cover it with a sheet of glass (OPPOSITE).

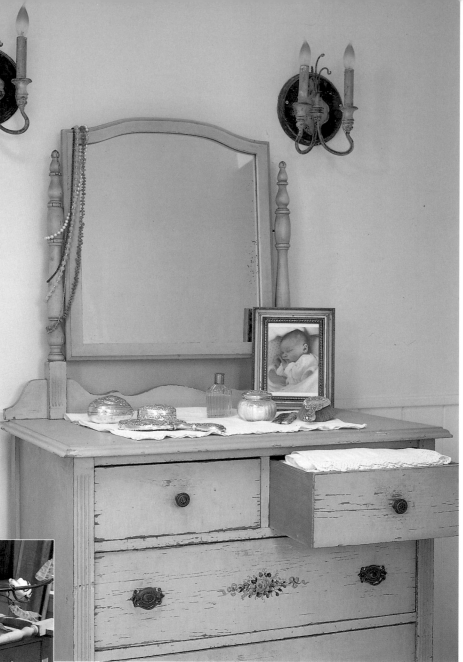

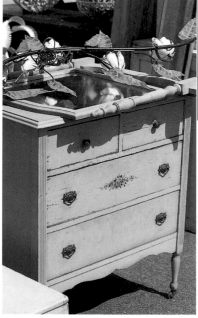

I use pieces in ways that are different from their original intention. This pale yellow antique vanity retrieved from a flea market (LEFT) was later placed in a bathroom lacking built-ins, where it functions as a cabinet for towels, toiletries, and other bathroom necessities (ABOVE). The mirror is useful, while the top of the vanity serves as a place for a pretty lace runner, a brush and comb set, and family photographs.

This old green chest of office drawers I picked up at a flea market (RIGHT) works perfectly as a storage space for paints, fabrics, and other odds and ends in this light-filled artist's studio (BELOW). Finding its degree of shabbiness perfect, all I did to restore the cabinet was to add some new glass knobs.

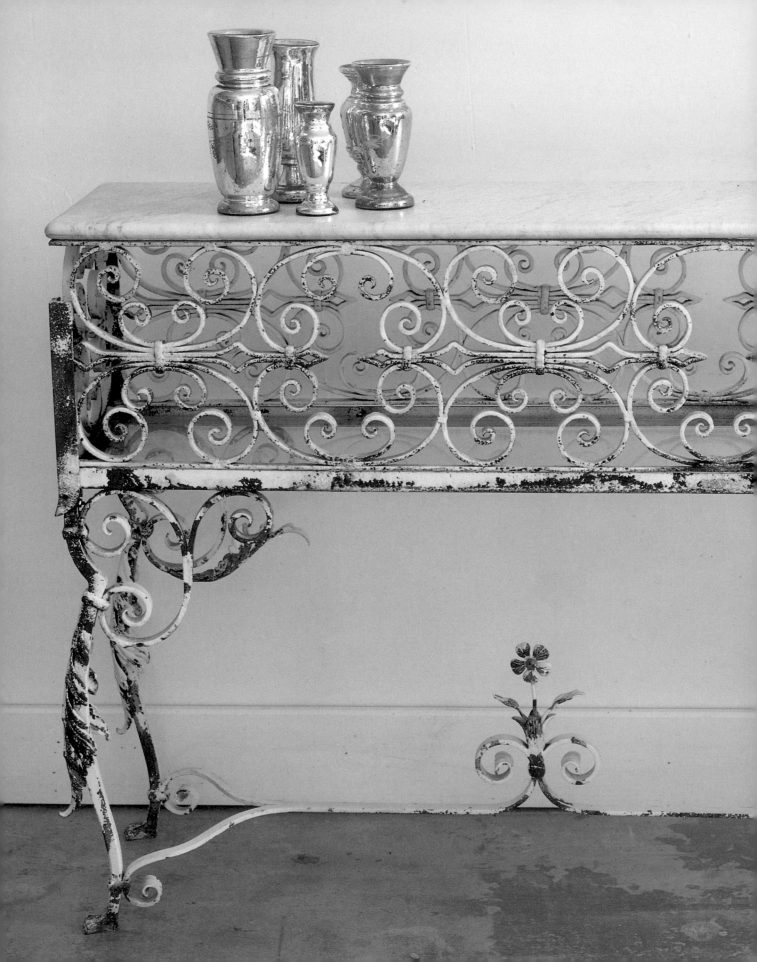

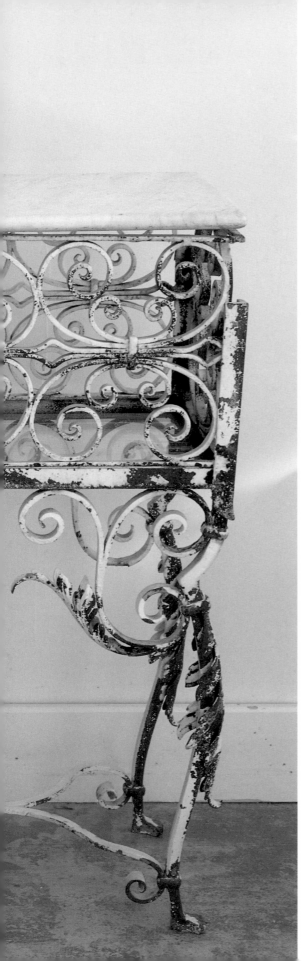

For iron table bases that lack lipped edges to set the glass or marble into, I buy glass or marble that is approximately two to six inches bigger all the way around in order to create a slight overhang. To keep the glass or marble from slipping, I secure it with small pieces of green felt that can be purchased at hardware stores for just this purpose. With small end tables, I might replace the glass with a cushion to create a small seat.

Mirror, like glass, is not expensive— a plain four-by-four-foot mirror costs around forty dollars, but runs about a dollar per inch more if it has beveled edges. The type of mirror I choose depends on how intricate the frame is. For a very detailed wrought-iron floral frame, I would probably use plain mirror. For a simple wooden frame, beveled mirror adds nice detail. Whatever frame you use, make sure the mirror is securely fastened. This is best achieved with wood bracing.

For old cabinets, I either repaint the inside, add contact paper, or put in a mirrored back to give the illusion of depth. If the inside back isn't too decrepit, I may leave it as is to keep some of its character.

A trunk with an inside that is a bit dilapidated can be inexpensively freshened up with a fabric lining and a satchel of potpourri. Be sure to check the trunk for termites before lining it. (Termites can be easily gotten rid of with a spray treatment.) For an average-size trunk, you'll need anywhere from a half to two or three yards of fabric, the price of which can vary enormously in price per yard, depending on the material and its quality. You might even use some old fabric scraps from around the house. I usually use an inexpensive cotton floral that I

I placed a slab of marble atop this somewhat rickety, weathered iron console to give it substance as well as ground it. The mercury glass vases are from the turn of the century. A few years ago they could be bought for about fifty dollars apiece; now they have become so popular that they may sell for as much as three hundred to four hundred dollars each.

OPPOSITE. If a tapestry is too worn, with large rips in prominent places, or just looks too delicate, I walk away from it no matter how lovely it is, because it will very likely fall apart. However, if, like this tapestry I picked up at a flea market (LEFT), it is merely frayed in spots, it may be well worth the restoration. Loose threads can be fixed by catching them with another thread about every one half inch or so as needed (INSET). In more extreme cases, edges and hems can be cut and new pieces of fabric added as trimming and reinforcement.

simply tack on with push pins, although fabric also can be fastened in place with a staple gun or fabric glue.

Tapestries with frayed edges can be refurbished by catching stray threads and/or cutting off the damaged area and adding a new fabric border that acts as a reinforcement. If the fabric is too moth-eaten, avoid it, as it will eventually deteriorate.

Overall, when shopping a flea market, I look for items that have character but aren't completely dilapidated. The less one has to fuss with an object, the better. Not only does a minimum of tampering better maintain the original integrity of an item, but it also means a lot less work for the buyer. There are, however, times when there is something so unique or eye-catching about a piece that it can't be passed up, no matter how involved the restoration process.

WHAT TO BRING TO A FLEA MARKET

- ☐ A flashlight: A crack that may look charming in the darkness of dawn may be a disaster by the light of noon. Be sure you can see what you're getting.
- ☐ Cash: Having plenty of cash on hand is more likely to get you good deals and some vendors don't accept checks.
- ☐ A cart or dolly: Lugging pieces back and forth to your vehicle can get very tiring without a cart or dolly, and some pieces are just too heavy to be carried on their own. Some vendors may be willing to lend you their carts, but others won't.
- ☐ A truck: Borrow one from a friend or rent one for the day if you're planning to buy large or numerous pieces. There's nothing more frustrating than having inadequate room to carry your purchases home. Very few vendors will deliver.
- ☐ Cords, rope, and blankets: Bring plenty of rope and bungee cords to insure a secure transport home. Blankets help protect pieces of furniture from damage and breakage. It's especially important to wrap mirrors, glass, and wicker.
- ☐ Fingerless gloves: These keep your hands warm while still allowing for maneuverability. Bulky gloves might make you hesitate about touching or picking up objects, which is a big part of choosing a piece.

INSPIRATIONS

There is a lot more to creating a beautiful, functional living space than skimming through lifestyle magazines, reading design books, and consulting interior decorators. Plays, movies, life events, articles of clothing, or accessories may also provide inspiration for home design as well as new uses for old forms and ideas for unexpected placement of new forms. A circus might reap a color idea or salvage parts perfect for a child's room. The petticoat from a theater costume spurred me to create a new ruffle to be used for a tablecloth and napkins. A wreath design on a vintage sewing bag I picked up was the inspiration for a new fabric pattern.

Observing people and animals and how they sit, snuggle, move, and interact can influence the design of a piece of furniture or its placement in a room. I created a round, low, cushy fabric chair I call the Pouf after watching my daughter, Lily, and son, Jake, and their friends consistently choose to plop on the floor rather than the couch, complaining all the while about how uncomfortable it was as they lolled about—an example of necessity truly being the mother of invention or of function serving as inspiration.

For me, the landscape is a great place to find stimulation for design. Flowers or seashells, for example, often can be used in new and unexpected ways. I've used roses and other flowers to adorn cakes, deco-

ABOVE: I call this oversized fabric poster "The Lonely Clown." Cut from a big-top tent canvas, this was the remaining loner unsold for several months after I had sold thirty-eight others in sets of two. But eventually it too found a home. Pieces like this are the perfect impetus for decorating an entire children's room.

RIGHT: Although I usually prefer mismatched table linens, I found these gossamer napkins of iridescent gold organza belonging to Jennifer Nicholson inspiring. Their holders made from seashells also have an appealing elegance.

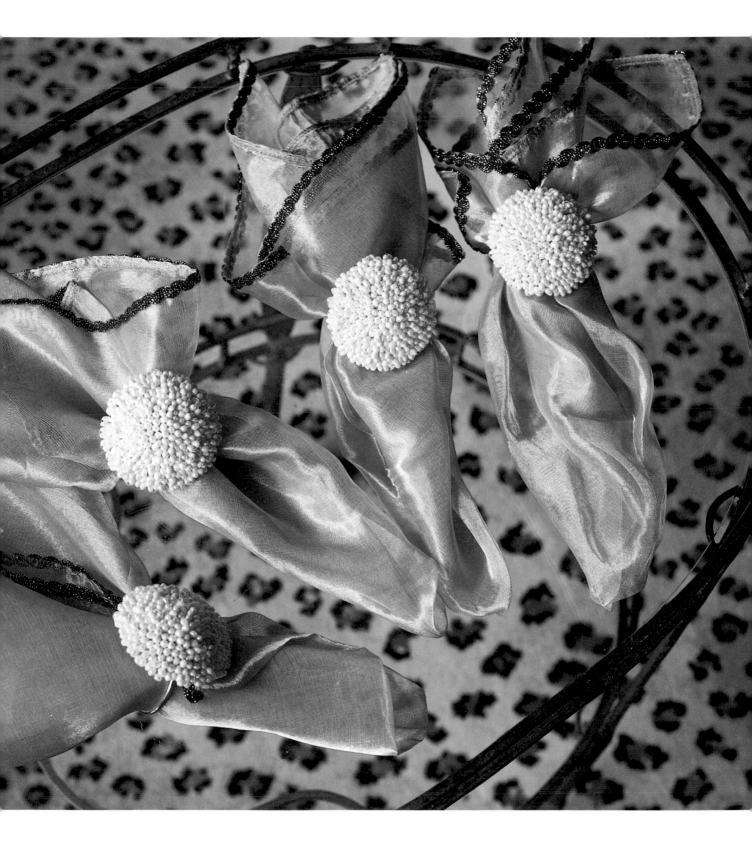

rate mirrors and presents, and accompany place settings. The random color variations in a meadow or field and the scale and proportions of those variations can inspire color schemes. Observing the subtle gradations of greens and creams in a garden, I used those same hues in the design of sofa and chair fabrics. Looking to nature's imperfections and the natural wear and tear that occurs over time induces a new appreciation for flaws and irregularities in manmade objects. The faded, dusty pink of a dying rose has inspired me to sun-bleach a bright floral fabric over time in order to mimic a real rose's natural passage from vivid to muted.

Personal collections, whether family photographs or something as commonplace as children's art, can inspire a display that gives a home individuality and character that cannot be acquired through a decor shop. I have strung some of my children's paintings across a clothes line and hung it above the counter in my kitchen. Others I have framed and hung in my bedroom.

When it comes time to finding a place in the home for flea market or other finds, I usually adhere to my less is more philosophy: negative space serves as my guide. Leaving ample breathing space around large objects such as vanities and dressers gives a room a more open feel and prevents the jumbled look of clutter upon clutter, even if their surfaces are filled with personal treasures.

I also find inspiration from taking what is meant to be formal and placing it in a more casual setting. While giving the pleasing effect of making the object seem more accessible, this also renders the setting slightly more refined. A crystal chandelier, expected in a formal dining room or a grand entryway, is a

LEFT: **A weathered, red wooden milk bucket, its surface scratched, its paint peeling from years of wear and tear, becomes a handy container for all kinds of utensils when placed on an iron plant holder in Philomena Giusti's kitchen.**

OPPOSITE: **Though often overlooked when decorating, wastepaper baskets can be attractive additions to a room. To make this wire-mesh basket more functional, I lined it with muslin to prevent small objects from slipping through. The wicker ones are appealing in their frayed state.**

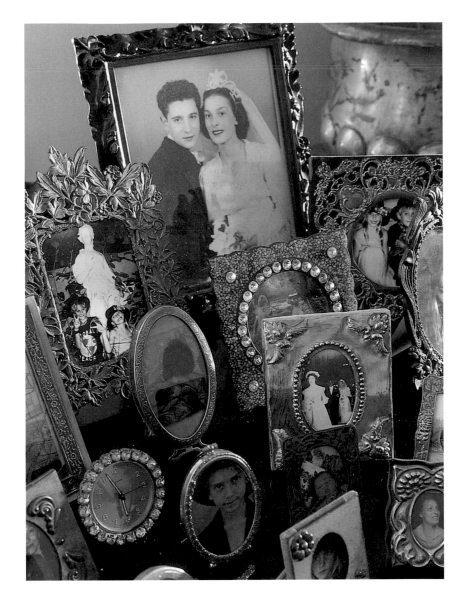

OPPOSITE: I add vintage buttons to the backs of pillows to give them additional visual interest and detail. I gravitate toward buttons with intricate patterns in glass, plastic, or tortoiseshell. These generally cost about one to five dollars at flea markets.

RIGHT: Photographs of family and friends are among our most personal articles, adding individuality to any room in a home. This collection of old and new portraits in Philomena Giusti's living room inspired her to display them within an attractive array of wood, silver, and enamel antique frames.

wonderful surprise in a bathroom, while a mirror designed for a fireplace mantle can give a hallway an air of casual grandeur. Taking the casual and placing it in a more formal setting, on the other hand, also sets up an appealing contrast. Metal patio furniture doesn't have to be relegated to the outdoors. An intricate iron-work garden table and chair set can be charming in a breakfast nook, study, or bedroom.

Inspiration is about paying attention to the smallest of details and noticing subtleties of form and color. Beauty is found not only in a finished object but in all its parts, the processes that create it, the evolution that transforms it, and the environment around it.

4
FABRICS

Fabrics are meant to be comfortable and inviting. Whether they are used to cover sofas and make them more plush, to prevent tables—and laps—from becoming stained by meals, to give layers of warmth to a bed, or to keep out—or let in—light from a window, fabrics serve a purpose. Fabrics also give visual life and depth to an environment.

Fabrics, more than any other decorative aspect of a room, are most influential in creating its overall ambiance. From couch to window, from bed to table, fabrics should lend softness, warmth, and color. Transforming bare landscapes into rich woven tapestries of texture, hue, and pattern, fabrics set tones of casual ease or grand formality. Draped or folded, stiff or falling gently, textiles lend flexibility and versatility to environments made of less mutable elements like glass, wood, stone, and metal. The main point to keep in mind is that fabrics should always be of fine quality. Good-quality fabrics last longer and wear better over time; this is why vintage fabrics of good quality are still so appealing.

The types of fabrics that are in keeping with a shabby yet chic mood are generally casual, light, loose, and flowing, rather than formal, dark, and stiff. I find that simple materials—a plain white muslin window shade, a washable cream denim slipcover, or a faded rose-print cotton tablecloth or pillow—work in a wide range of environments. Weight is another consideration. I use lighter fabrics such as cotton and linen to create a more casual or summery mood, and heavier velvets, damasks, and chenilles to create a formal or warm wintry feel.

Like a painted dresser that has naturally peeled over time or a wrought-iron table rife with rusty scratches, fabrics that have aged naturally, faded, been mended, and that are slightly rumpled are representative of Shabby Chic style. A

PREVIOUS PAGES: **The delicate, faded pattern on this vintage sewing bag inspired me to design a fabric that mimics its design.**

OPPOSITE: **This intricately layered tablecloth ruffle gathered up with three silk roses to display the lace cloth underneath was inspired by a petticoat costume from a theater production** (SEE SKETCH ABOVE). **While this particular cloth has its own series of ruffles, any tablecloth can be given this layered effect by putting a piece of lace underneath the cloth and gathering up a portion of it with some faux silk, cotton, or velvet flowers.**

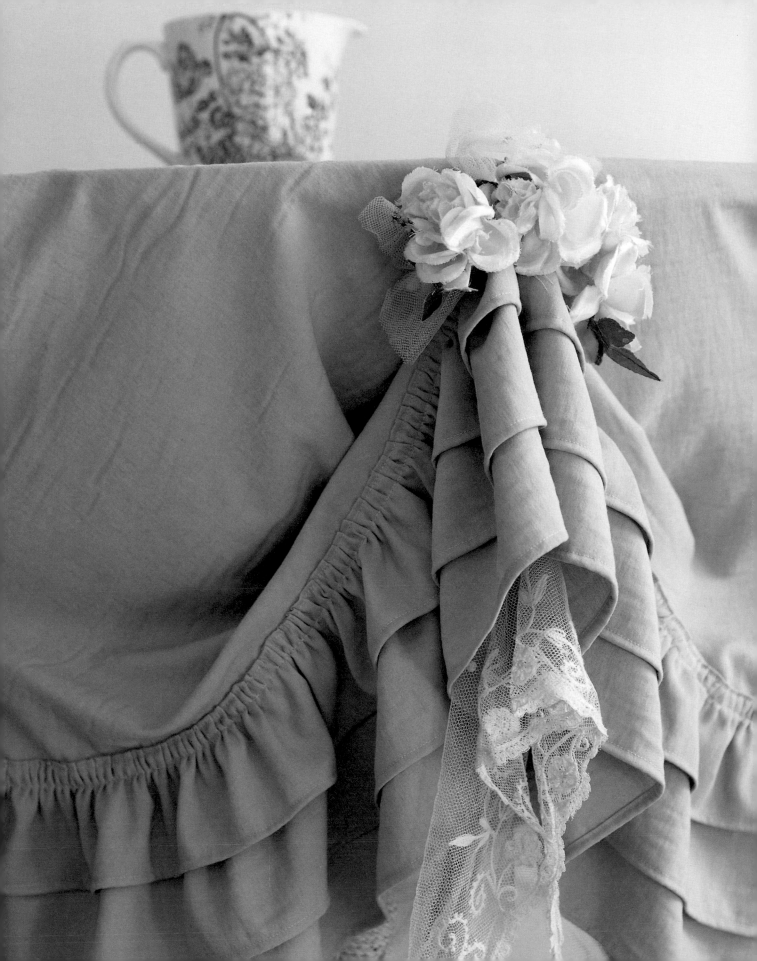

couch with patches where the fabric has been worn by time or a faded tablecloth, its colors muted by long hours in the garden sunshine, offer traces of real living. If a spot on the back of a velvet chair gets too worn, I might drape it with a chenille, velvet, or cotton throw rather than replace the whole piece. Not only is this more economical, it adds a layer of texture and color that can be very inviting.

But while some stains can be ignored, covered up, or patched over, sometimes it's better to remove them altogether. If you're dealing with a white fabric and the treatments listed below don't work, you can try bleaching it, but experiment with a small spot before doing the whole piece. The key to removing a stain successfully is to act immediately—before the stain dries. Dried stains are far more tenacious than wet ones. When using professional stain removers, which are often inflammable, make sure you do so in an adequately vented area, carefully following label instructions.

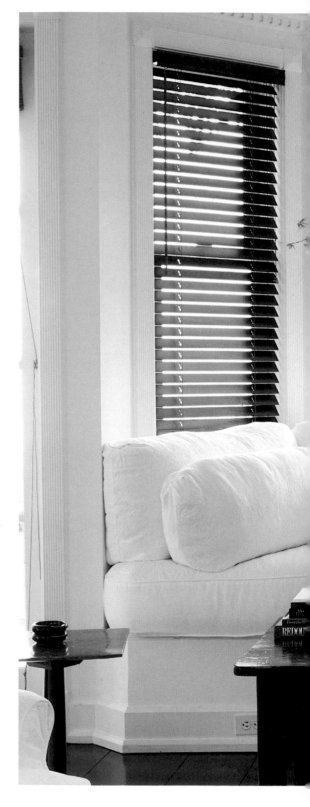

LEFT: Cashmere throws, the ultimate in luxury, can be used almost anywhere in the house, on beds, over chairs, or across the back of sofas. They add warmth, cover up imperfections, and can add new colors to a room's decor.

RIGHT: The white slipcovers in Sandy Gallin's living room are both durable and elegant.

FOLLOWING PAGES: These pillows show a variety of different ruffle and trim treatments.

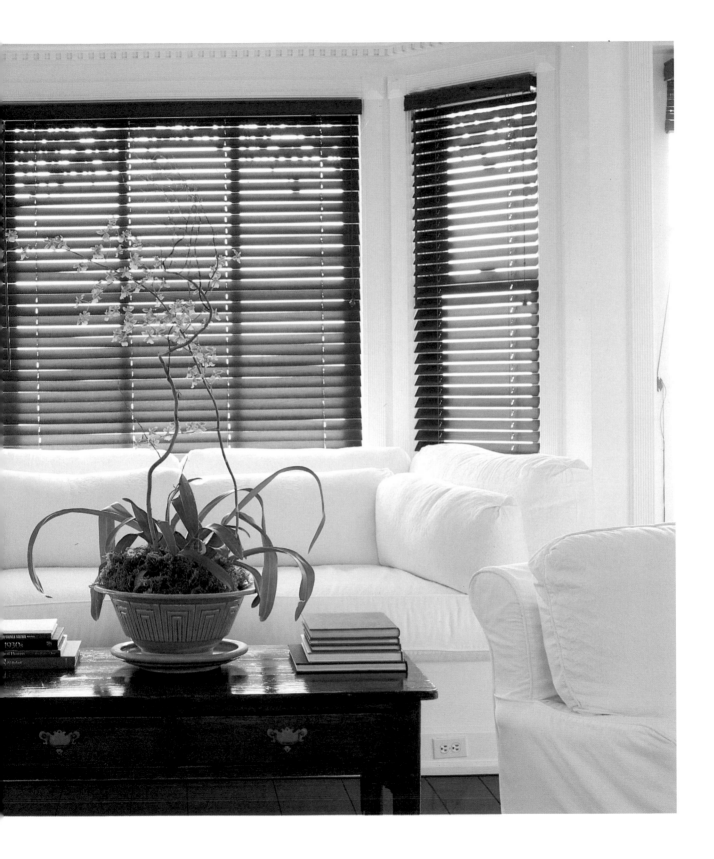

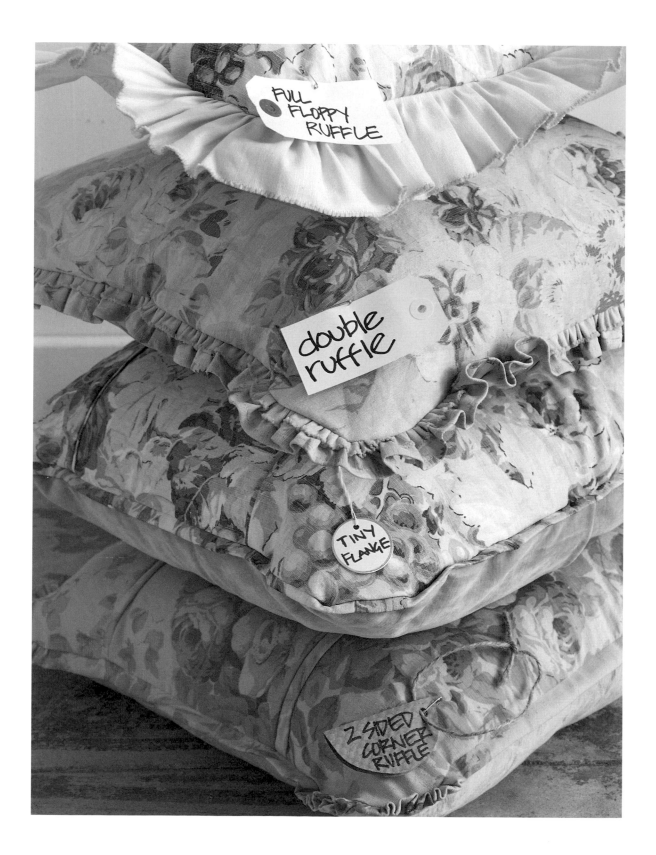

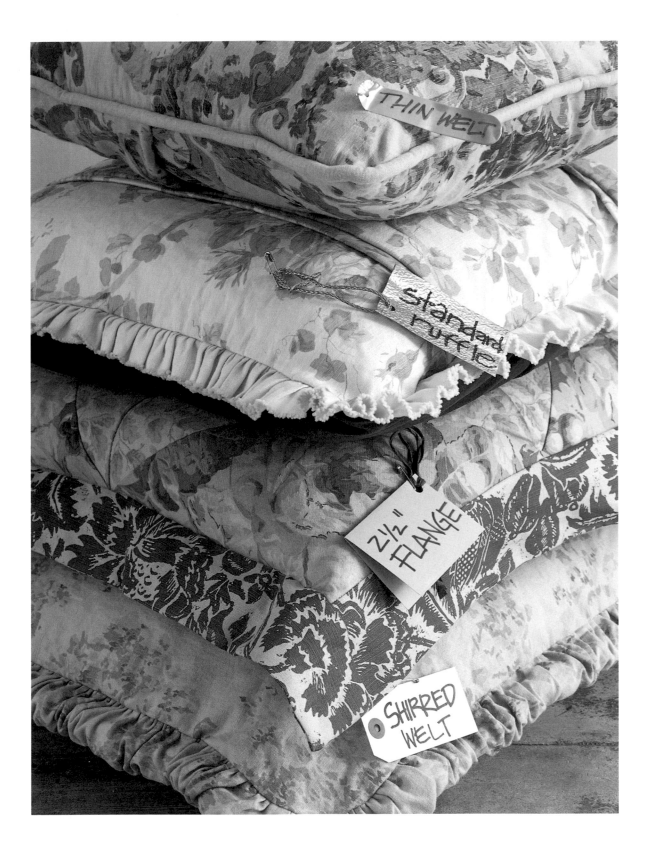

OPPOSITE: **These pots of paint illustrate the rainbow of color choices available today for fabrics.**

ABOVE LEFT: **For a brushed and softer feel, fabric is run through a sanding machine, like the one at this fabric factory.**

ABOVE CENTER: **Awaiting approval, samples of printed cotton fabric hang above a cutting table at a fabric factory. Five to ten yards are printed initially to make sure the color and registration are correct before running a major production.**

ABOVE RIGHT: **Here, rotary rollers imprint fabric. This process is less expensive than hand-screened printing and creates sharper definitions in pattern lines.**

When deciding between fabrics it's helpful to know that the variance between the processes and level of workmanship that go into creating different types of fabric patterns makes a marked difference in quality and price. The type of cloth used, the number of colors involved, whether a pattern is woven or printed, and the particular printing technique used are all factors in quality and price. A silk-screened linen fabric with several colors can cost up to a hundred dollars per yard, while a rotary-printed cotton with only two colors averages about twelve dollars per yard.

Whereas woven patterns are actually different colors of thread woven together into a design, printed fabrics are created by applying colors in certain forms to the surface of a fabric. Rotary, or machine, printing is by far the most common method used today. Metal rollers with tiny pinholes, engravings, or etched surfaces (also called intaglio) for different colors are rolled onto the fabric to create intricate, sophisticated patterns with clearly defined lines and subtleties of shading. Silk screening can be done either by hand or by machine, and is a variation of stenciling. A separate screen (or roller with mesh screens set into it) is used for each color for a specific design repetition. When one color dries, a new screen and color are added. Silk screening by hand gives a slight irregularity to a pattern and produces less defined forms. Like hand blocking, this imperfection adds character and individuality.

Hand blocking, the most primitive form of fabric printing, is done with actual blocks of wood with raised areas for color that get stamped onto a material. The resulting patterns, such as those found on Indian-print bedspreads and children's school projects, are imperfect yet quite charming and work very well when the idea is to create an informal, almost arts and crafts appearance for a particular room or table setting.

When I design fabrics, I usually let the base cloth determine my choice of silk-screened versus rotary-printed techniques. With linen, which is rougher than cotton, I most often use silk screening, which has a less defined look. For cotton, which has a smoother surface, the finer details of rotary printing work well.

In choosing a fabric for a particular room or piece of furniture, let both the function of the piece and the surroundings dictate your selection. Cotton is a more practical choice than linen for pieces that will suffer more wear and tear and undergo frequent laundering, as linen tends to shrink with every washing and is somewhat less sturdy.

When combining fabrics to come up with your own individual look, I recommend staying with fabrics that complement each other. I choose a common theme—either color, pattern, or texture—that will unite my different fabric choices and create the most harmonious look. Various shades of whites, creams, and beiges could be an underlying theme that appears in an array of textures, such as fine poplin, denim, damask, or nubby chenille—with or without patterns. A specific design—be it florals, stripes, or checks—could be an underlying theme that is repeated in a few or in a range of sizes and colors. Unexpected pairings and stark contrasts can also work if they are not overdone. The surprise of bright red pillows on a white bed or florals mixed with gingham can add life and whimsy to an otherwise predictable room.

Before buying a fabric, take a few swatches home with you. This way, you can judge whether the color looks different in the light of your home and whether it matches its potential surroundings. You might even want to buy a larger piece of fabric so you can experiment with the way it drapes as well as see more clearly how its pattern looks on a larger scale. If you choose silk-screened fabric, note that the inconsistency of dye lots from batch to batch may make it difficult for you to reorder the fabric in the exact color that you first purchased. That's why it's a good idea to buy extra yardage if you think you might need more of the fabric later. Then again, a perfect match may not be so important to you. Also, the farther away in the room an additional piece is from the original, the less noticeable the match.

These fabrics, which can be used for curtains, tablecloths, or upholstery, are among some of my favorites. (TOP TO BOTTOM) A classic red-striped cotton, a celadon stripe on a tea-stained linen, donkey plaid linen.

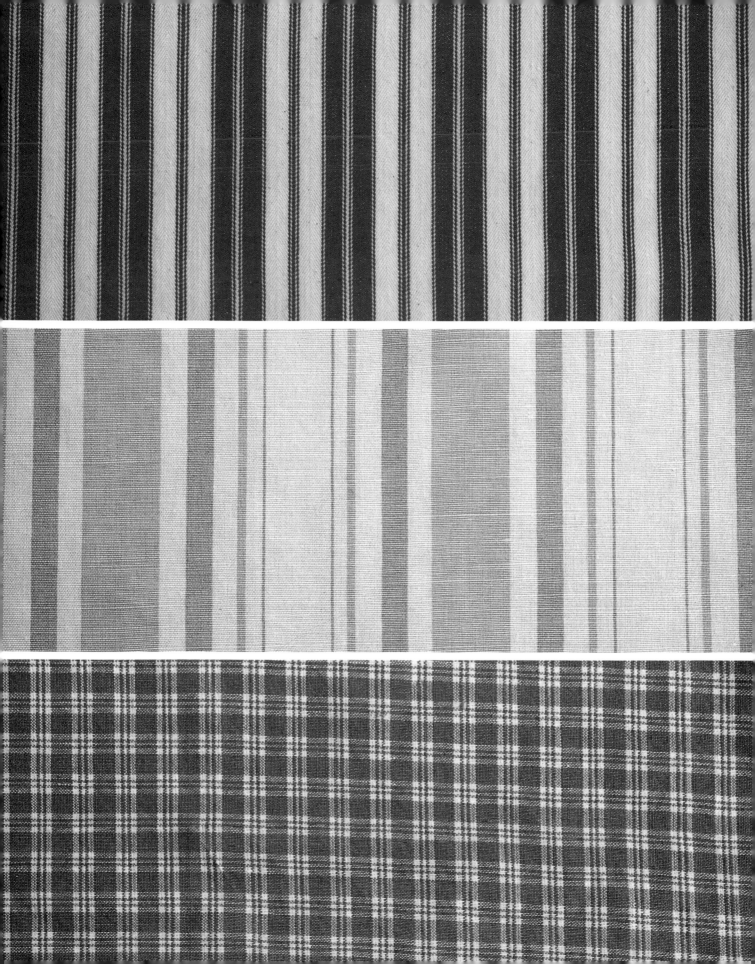

TOP: This willow damask becomes more puckered and dimensional with each washing.

ABOVE: A green rose and ribbon damask. Washing gives it a deeper texture.

RIGHT: This "blue grapes on oyster" print is hand silk-screened on linen.

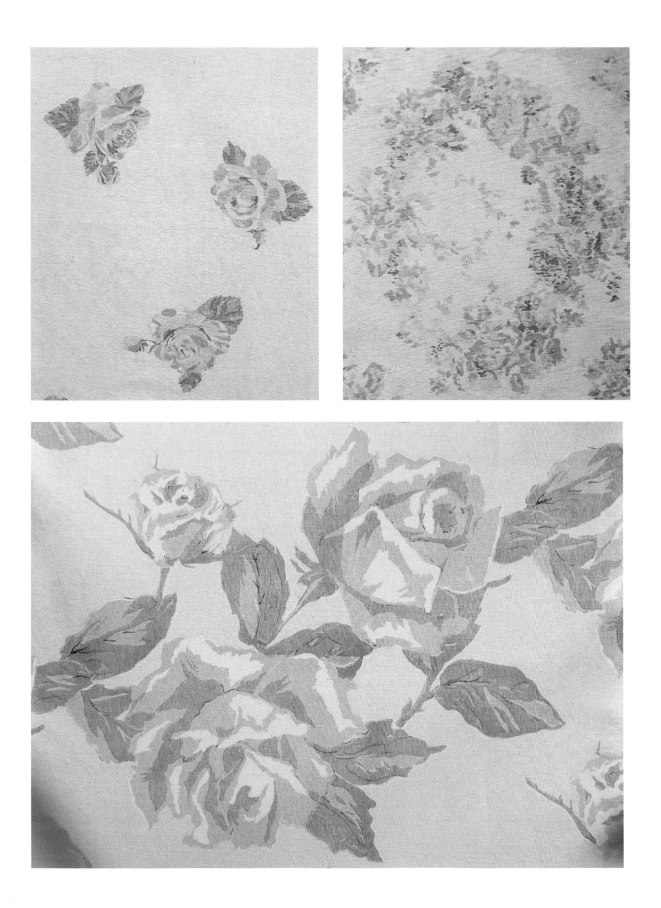

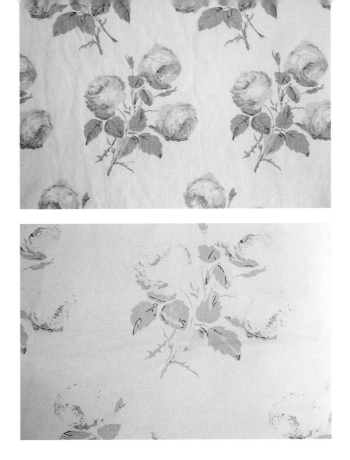

If you find a piece of vintage fabric that you want to turn into a bedspread, tablecloth, or curtain, but don't have enough material, consider adding a border or edge in a complementary fabric. Flea markets, textile specialists, and secondhand shops can be great resources for old lace and linen swatches as well as for Marseilles bedcovers in white-on-white cotton. (If the edges of Marseilles bedcovers are frayed, simply cut them off. Another alternative is to buy several different pieces and sew them together to create the size fabric you want.)

Don't be deterred by the rust stains very commonly found on lace, as they can usually be removed by over-the-counter stain products designed especially for this purpose. If the lace is not too delicate, it can sometimes be bleached. A combination of crisp white cotton with lace trim looks beautiful and is usually easier to care for than an all-lace piece. This cotton and lace combination is also versatile; it can be laid on a tray, used as a guest towel, or placed in a bread basket as a liner.

Remember, you don't have to use a piece of fabric for its original purpose. A hardy lace curtain can make a great tablecloth and, conversely, an old lace tablecloth can make a pretty curtain.

OPPOSITE: Hand silk-screened on Belgian linen. (See Resource Guide.)

LEFT: An earth-green chenille. When washed, its colors become more defined, and the fabric more dimensional.

ABOVE: A new gray and white rose print on cotton chintz and its sun-bleached version, which appears naturally faded and feels softer.

LEFT: This faded floral is an example of a hand-blocked cotton print that has become soft and muted due to repeat washings and exposure to sunlight. CENTER: A one-screen, hand-silk-screened print on linen. RIGHT: A one-screen rotary print on poplin.

WINDOW DRESSING

The function of a window covering, be it a curtain, drape, or blind, is to provide privacy and to keep out (or let in) light, heat, or cold. But as the French discovered in the late nineteenth century, curtains are also a great way to frame a window grandly and add decoration to a room. In intricate patterns and rich fabrics, with the addition of accessories such as pelmuts and valances shaped into swags, pleats, or rosettes, and using fancy trims such as banded ties, tassels, and ropes, curtains can become works of art.

I prefer window coverings made of fabrics that are simple and relaxed rather than fussy, soft rather than stiff, and shaped into loose rather than tight formations. I also prefer floaty gatherings, with a rounded rather than hard-edged look. In general, such arrangements are more casual than formal. Sometimes, though, I like to make the formal look more casual by using light easy-care fabrics. Lightweight velvets, moirés, muslins, and poplins are good for creating a floppy, draping effect, while tapestries, denims, damasks, and heavy velvets work to create a more structured mood. Like slipcovers, however, these more formal fabrics can be laundered to alleviate their severity.

For an unstructured, effortless look, windows should be draped with generous amounts of loose fabric that is allowed to puddle softly onto the floor. The simplicity of a plain white blind, such as the one covering the

LEFT: **The handmade Scottish lace curtains in Jennifer Nicholson's dining room admit light yet still provide privacy.**

ABOVE: **This slightly transparent Roman shade with a delicate rose print adds a decorative touch to Tony and Donna Scott's guest house, yet still lets in plenty of natural light.**

OPPOSITE: **Jennifer Nicholson created a curtain out of an old cream lace bedspread depicting peasants gathering wheat. Accented by a vintage crystal chandelier, toile sconces, and a leopard print–covered stool, the entire entryway has vestiges of decadent glamour.**

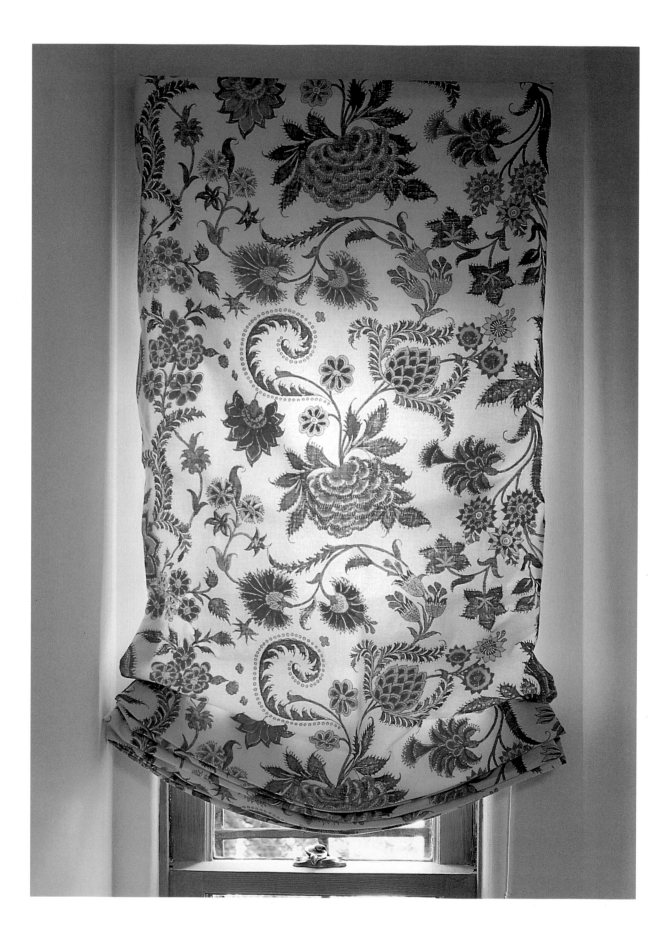

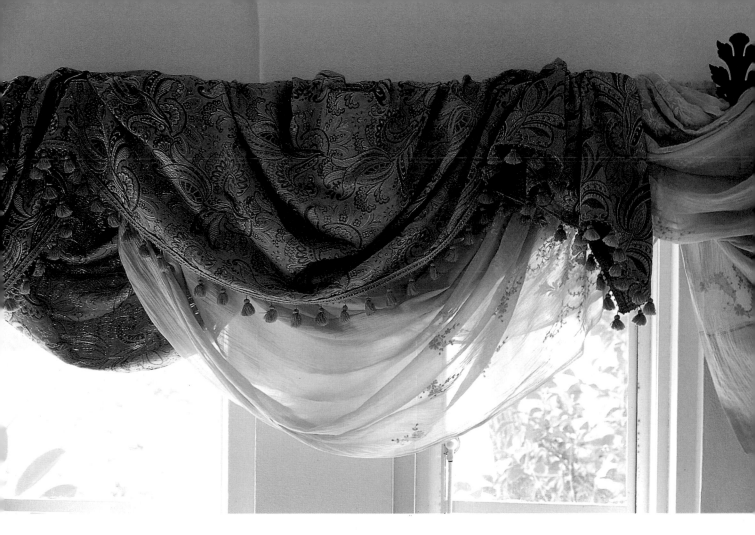

OPPOSITE: A simple Roman shade in a rose print adds life to this bathroom window in Tony and Donna Scott's home. Down, the shade is a decorative covering; up, it lets in sunlight and serves as a valance to frame the rectangular window.

ABOVE: This tapestry swag valance with a sheer underlining is an example of draped, flowing, loose window treatments. Though they add formality to a room, the curtains appear almost lazily hung, which makes them more approachable than stiffer, straight-lined drapery. (See Resource Guide.)

ocean view window in the living room of my beach house, works nicely, as do Roman shades, which give the appearance of a valance when pulled up, and balloon shades, which fold in soft billows.

Lining is an important element for helping curtains last longer and protecting them from the sun. Blackout lining—a dark fabric sandwiched between two pieces of white material—is good for bedrooms with eastern exposure that receive intense morning light. Thermaline lining helps insulate a room. Sheer underlinings made of chiffon, cheesecloth, or batiste can be left closed all day to add privacy to a room while still letting in the light.

Above all, never skimp on yardage when choosing fabrics. Inadequate width or length can detract from the elegance and luxury of a dressed window.

LINENS

Bed linens are, above all, meant to provide luxury, warmth, and simple comfort, for these are the first fabrics to touch the skin in the morning and the last materials to do so at night. Because they are in such close contact with our bodies, natural fabrics, such as cotton, linen, and flannel, work best for sheets and blankets. Duvet covers or bedspreads, however, can be of richer velvets or silks.

Layering is key to the look and feel of a bed. Whether done in contrasting or complementary patterns and colors, layering gives a bed a pleasing visual and tactile impact, and offers a practical option of warmth should the night become cooler. Fabric pillows add color and depth. Overall, because beds serve as a sanctuary at the end of the day, their feel should be rich and inviting.

Whereas bedding is foremost about comfort, fabrics for the table are meant to protect the tabletop from the ritual scratches of silverware, the banging of dishes, the telltale rings of glasses, and the stains of daily feasts. Since table linens serve as the backdrop for entertaining and socializing, however, it is also desirable for them to be aesthetically pleasing. Whether you use an embroidered white linen covering or

a colorful chintz is a choice that depends upon whether a meal is formal or casual, though my preference, no matter the occasion, is a mix of the two.

My favorite table settings consist of mismatched fabrics (see Chapter 2, "Rooms"). If you have several incomplete sets of napkins, don't throw them out. Mix and match them in different colors and patterns, and use them with different tablecloths. I often see oddball sets of napkins at flea markets, where it's not unusual for vendors to sell them in threes or sevens. Like fabrics elsewhere in the home, table linens can boast a few wrinkles, exhibit some fading, expose frayed edges, and reveal a patch or two. The marks of time and years of enjoyment make them all the more appealing.

LEFT & TOP: Beige poplin bedcover, pillows (see Resource Guide), and duvet.

OPPOSITE: In bedding, comfort is essential. I was inspired by the inviting feel of a baggy old T-shirt softened by years of use and washing for the soft, white, wrinkled sheets, pillowcases, and duvet cover on this old-fashioned iron bed.

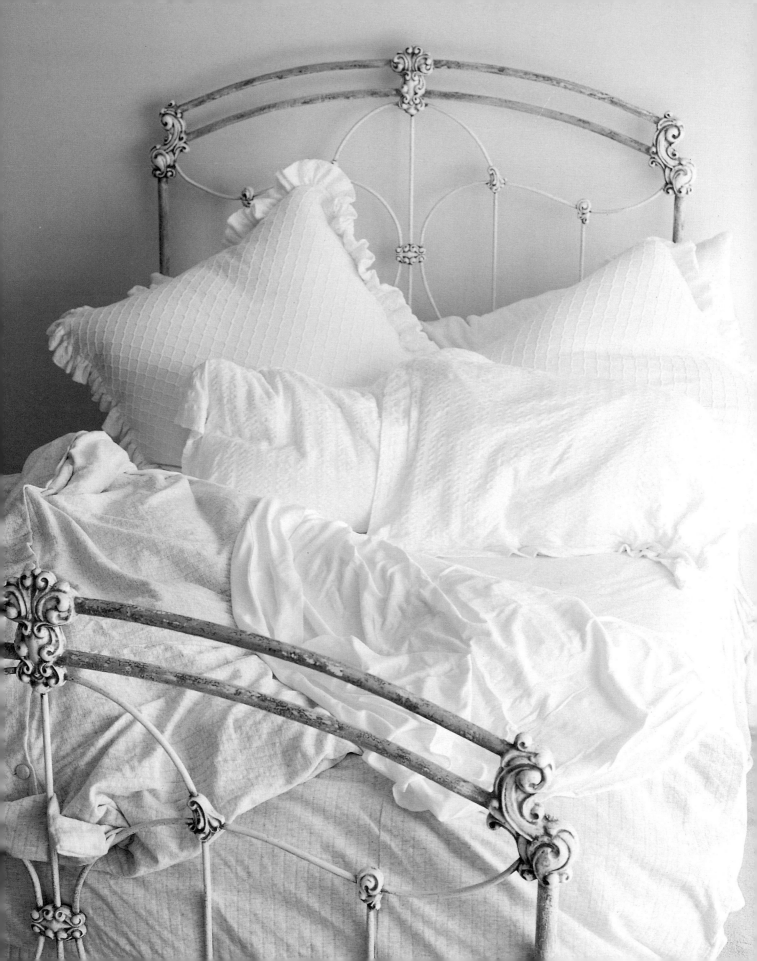

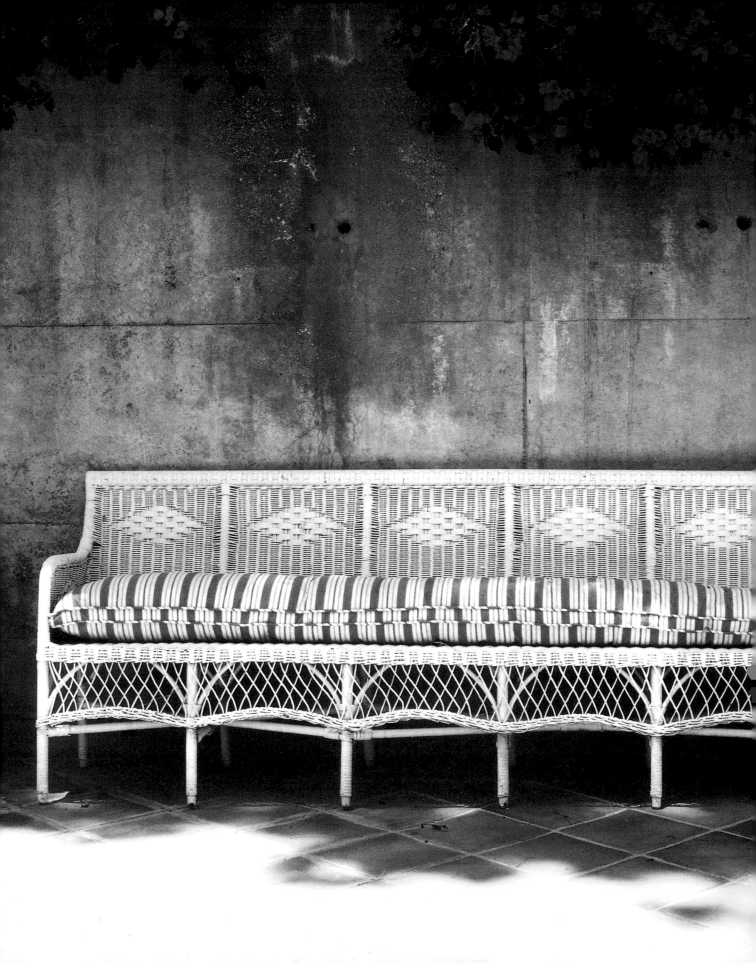

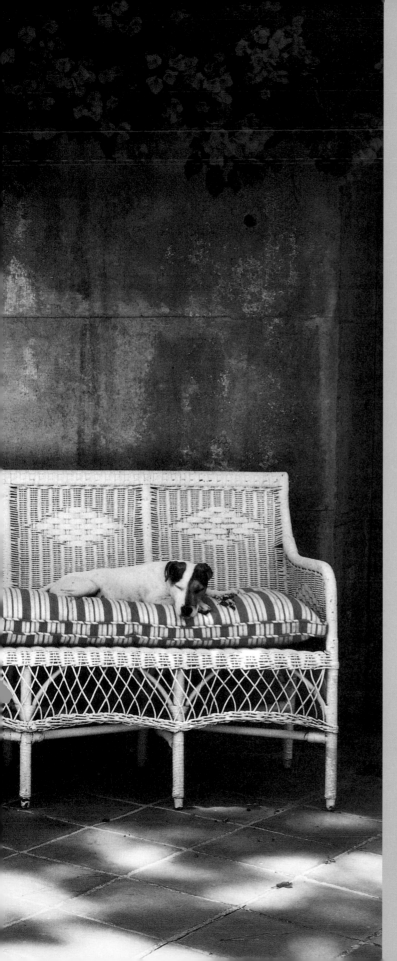

5
—
SEATING

Because sofas and chairs are the most important functional pieces in most of our living spaces, I want to give them special attention in this book. Although slipcovers are my first choice for chairs and sofas, leather and wicker are also materials that work well to create the Shabby Chic look. Leather is appealing because it is timeless, classic, natural, comfortable, and ages beautifully. I love wicker because it is lightweight, can be used indoors or outdoors, comes in an array of weaves, and can add an aura of casualness to otherwise formal surroundings.

If a leather piece is simply too worn, with distracting bare patches or scratches, parts of it can be reupholstered inexpensively without ruining the antique look of the whole. A different fabric can even be brought in to save money. I have replaced the worn leather cushion of an armchair with a velvet one, which added a new texture, cut down on cost, yet kept the piece plush. Wicker, though it can be costly to restore, is easy to repaint and has the uncanny ability to fit into a variety of different environments. (For more on wicker, see Chapter 3, "Hidden Treasures and Inspirations.")

When considering both the appeal and function of sofas and chairs, shape, size, and fabrics, and the way the pieces are placed in a room are all important elements. A chair meant for reading should be comfortable but not so cushy that it induces sleep, and it should of course be placed near good lighting. A chair for dining or the home office should be upright to facilitate eating or studying. Chairs meant for socializing should be comfortable and arranged in a way that promotes communication by minimizing the need to crane one's neck or raise one's voice to be heard. Seating meant for relaxing and napping, such as body pillows, poufs, chaises, and some armchairs, should be cushy, comfortable, soft, and over-sized—my favorite look. All these points may seem obvious, but it's amazing how many stiff, upright chairs I've seen that were intended by their owners to be comfortable and inviting.

PREVIOUS PAGES: Wicker—especially painted white—has long been a favorite material for outdoor furniture, due to its loose weave and easy portability. On Tony and Donna Scott's patio is an old convent bench that appears to be comprised of seven chairs fastened together. Its unusual length and comfortable striped cushion make it the perfect spot for a lazy afternoon nap for people and dogs alike. The cool stone walls and bougainvillea overhead add to the shady mood.

OPPOSITE: This worn leather chair in Philomena Giusti's home is marked by years of loving use. The faded patches and scratched studs make the chair an inviting sanctuary for one to curl up in and read. The original cushion, which became too tattered, was replaced with a velvet one. A silk pillow adds extra color and comfort.

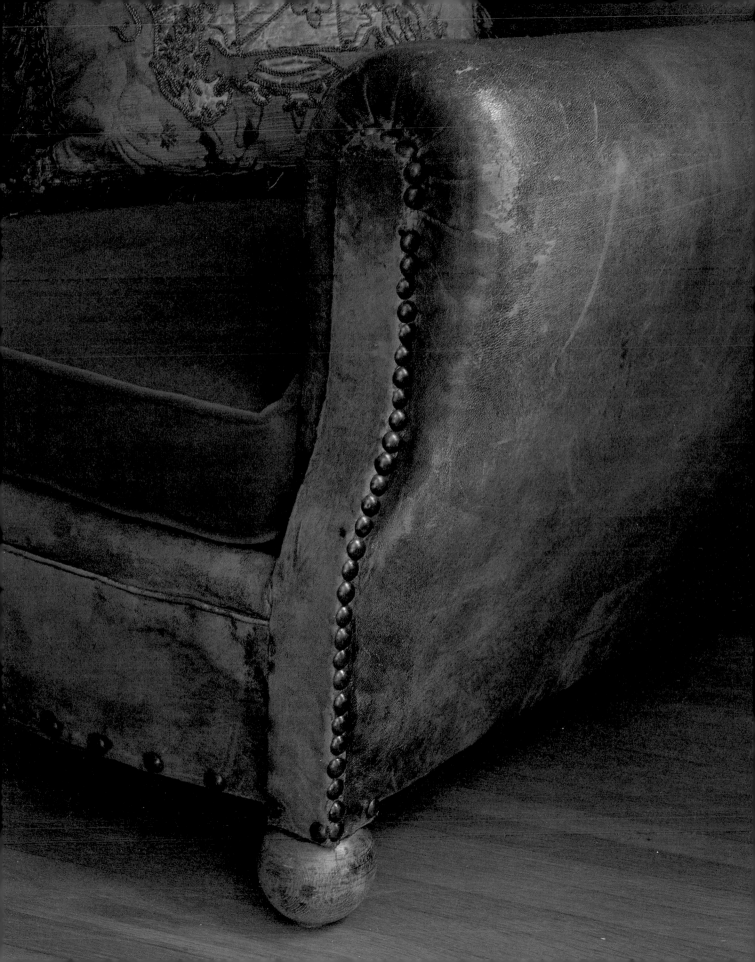

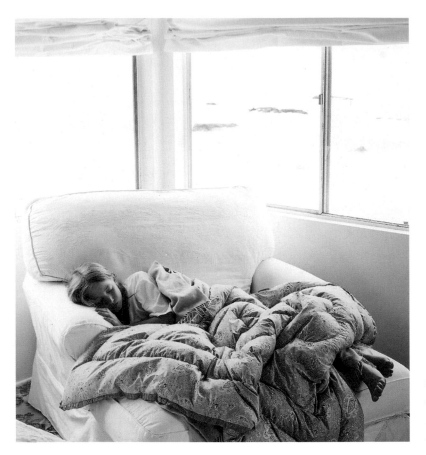

Simply expanding the dimensions of a chair can give it a whole new function, like this extra-roomy slipcovered chaise. (See Resource Guide.)

In the case of sofas and chairs, need should dictate form. My children have inspired many of the chairs I've designed. An upholstered rocking chair was born after observing their love of rhythmic movement (although I installed a long wicker bench that resists rocking on one side of my dining room table, as the temptation for a child to rock while eating is just too great). I have also made arms on certain chairs rounder or bigger, backs straighter or more relaxed, depending on the intended use for a particular chair. Personal tastes can account for fabric choice, though for seating I suggest casual fabrics that can stand up to wear.

Ottomans or footstools not only elongate a chair by adding foot room, they also offer additional, casual seating in their own right and can add new colors, textures, and patterns to a room. Pillows are another way of bringing in color, detailing, and comfort to existing seating. Pillows are also very versatile—they can be contrasting or complementary, plain or detailed—and they are relatively inexpensive. If large enough, pillows can even be scattered on the floor and used as casual seating.

S L I P C O V E R S

Slipcovered furniture is at the heart of the Shabby Chic style. Slipcovers can be made to look sleek or frilly, fancy or plain, depending upon the fabric and whether it has detailing, such as ruffles or welts (see Chapter 4, "Fabrics"). Myriad fabric and detail choices, ease of care, and their homey look make slipcovers my primary choice for new or old furniture.

Slipcovers are washable, so they offer the utmost in convenience and practicality. Like blue jeans or sweatshirts, slipcovers become more cozy and individual with each washing, and allow furniture to be lived on rather than merely looked at, to be used freely rather than cautiously. Marked by the feeling of being handed down and touched by the factors of real life—dog

BELOW LEFT: When cutting fabric for a chair like the upholsterer is doing, the fitting is crucial. I prefer oversized slipcovers to allow for extra tucking, but sometimes, as in the case of more modern, streamlined furniture shapes, a tight fit is more appropriate.

BELOW RIGHT: When slipcovering a chair, the chair is measured first. Then, like an haute couture gown, the fabric is custom-cut to size. Once cut, the fabric is pin-fitted to the chair to make sure it fits, then removed and sewn into a slipcover, like this one at an upholsterer's.

PAGES 138–139: This is the type of squashy, floppy sofa I love. I call this one of matte lassé the Squadgey because it's so cushy and enveloping. When washed, the texture of the slipcover becomes even more inviting.

PAGES 140–141: The quintessential Shabby Chic sofa with smooshy feather-down seats.

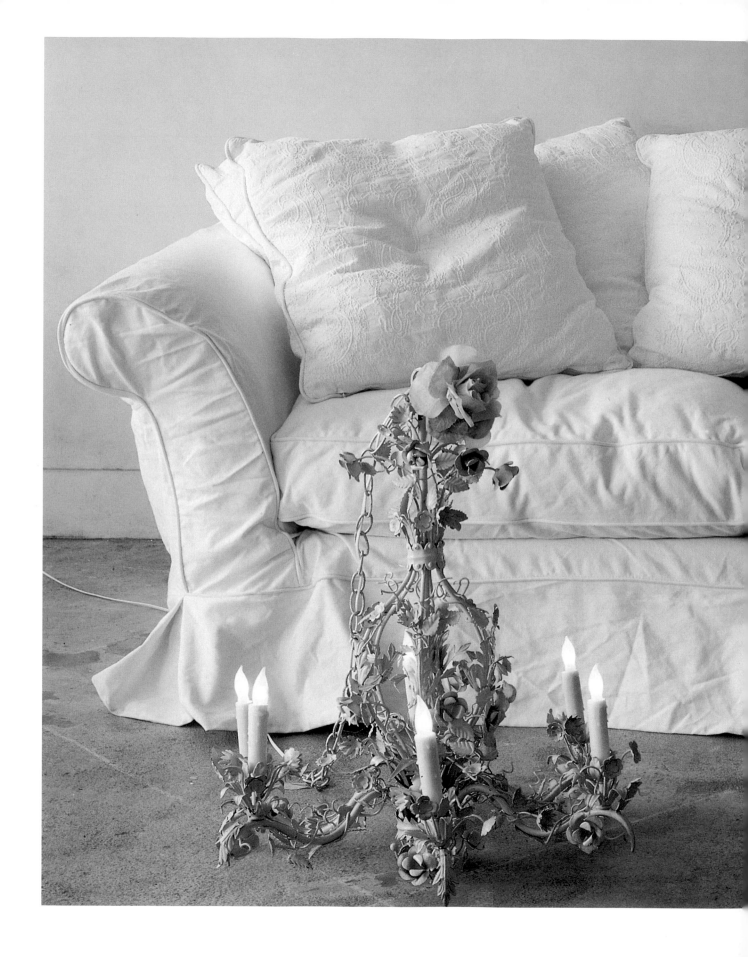

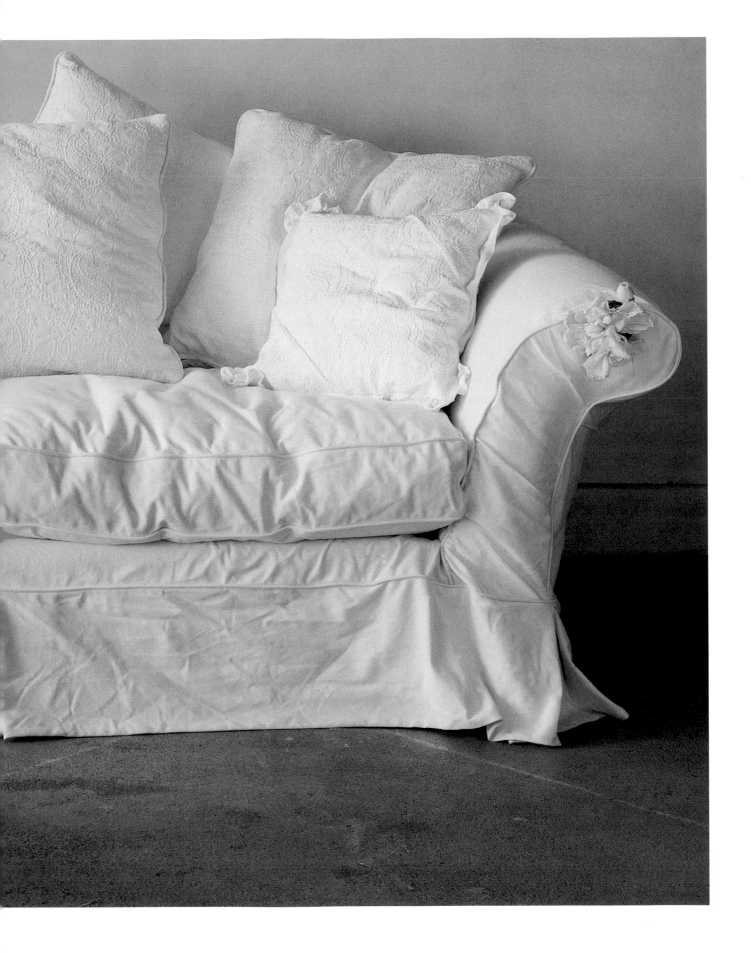

hairs, a spilled glass of wine, an ink stain—accidents are taken in stride when they happen on a washable slipcovered sofa. If a stain doesn't come out, you can add a throw or pillow, or replace the damaged panel with a new piece of the same fabric. If I have trouble finding the same fabric, I often use a completely different fabric, but along with replacing the damaged panel, I balance out the look by adding the new fabric to other parts of the chair or sofa as well.

Today, slipcovers are not limited to just cotton or denim. When I first started my business, a washable slipcover made of a classic upholstery fabric such as velvet or chenille was almost unheard of. Now there are an array of fabrics that not only can be washed but that gain a whole new desirable texture and character as a result. After washing, damasks become more two-dimensional or puckered, chenilles gain a relaxed feel, and chintzes lose their stiff gleam and become smooth. But not every material is conducive to laundering, however. Running embossed velvets or moirés through a washing machine can ruin their delicate patterns. And shrinkage is something to be aware of when measuring your fabric. Avoid laundering colors such as deep blues and bright reds as they tend to run.

If you have trouble finding a fabric in the exact color you want, you can always experiment with dyeing your own at home. An inexpensive way to obtain a color you can't find elsewhere is to buy a cotton sheet and some fabric dyes from the drugstore. Experiment with small amounts of material and dye before you actually work with the sheet. Once you achieve the color you're after, you can have the sheet fashioned into a slipcover.

Other ways to save money on slipcovering include mixing pricier fabrics with less expensive ones. The more visible back cushions, arms, and skirt of a chair or sofa can be covered in a silk-screened floral print for a hundred dollars a yard, while the seat cushions, back, and sides can be covered in a white denim for fifteen dollars a yard. The resulting look is a comfy, quiltlike look.

Another advantage to slipcovered furniture is that it does not lock you into one look all year round. You can have two different sets of slipcovers—a denim or cotton for summer, and velvet, chenille, or damask for winter. Having two sets is also convenient when your slipcovers are being laundered: You're never stuck with bare furniture—though you might want to consider whether the upholstery underneath the slipcovers is something you can live with while the covers are being washed. Just be sure that the existing upholstered fabric is of a lighter color than the slipcover to prevent it from showing through when the slipcover is on.

The fresh simplicity of stripes is perfect for slipcovers for outdoor furniture. I chose a red and white cotton, which has faded pleasantly over time, to cover my beach lounges. I never press the covers—the wrinkles and rumples add to the easy charm.

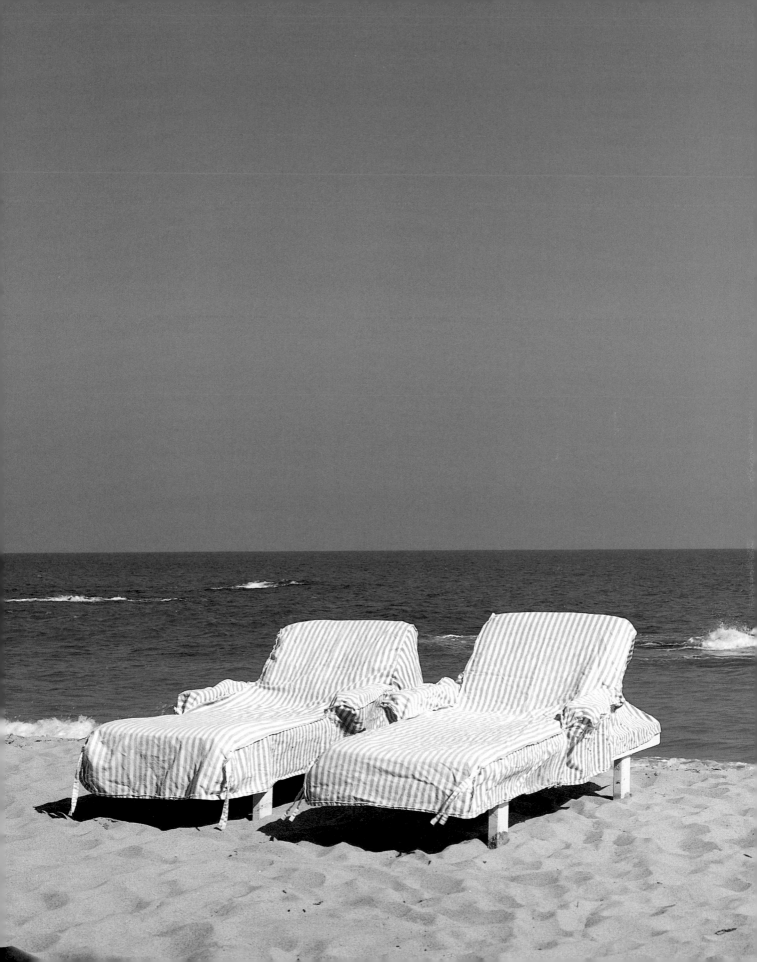

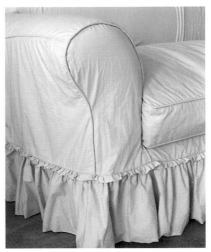

Double ruffle.

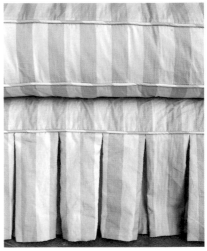

Box pleat.

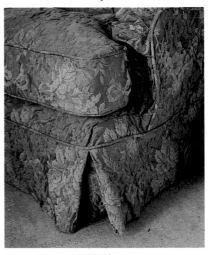

Kick pleat.

Floppy ruffle.

SLIPCOVERING BASICS

There are some basic guidelines to follow in order to insure that your slipcover fits well and that you get the look you envision. The following are tips to keep in mind whether you are making your own slipcover or having it done professionally.

1. Measure the piece of furniture to be covered. Generally, a six-foot-long by three-foot-deep sofa takes anywhere from twenty to twenty-five yards of fabric; an average love seat, about fifteen to seventeen yards; a chaise lounge, thirteen to seventeen yards; a chair six to twelve yards (these measurements include pillows); an ottoman, two to four yards. Keep in mind that yardage needed for slipcovers is always a little more than that needed for upholstery due to the slipcovers' looser fit. Fabric can range in cost from $10 to $110 a yard, and labor anywhere from $150 to $650 per piece, depending upon its size.

2. Choose your fabric and make sure it's prewashed to allow for shrinkage and to give it a softer texture, if that is your preference. Damasks and chenilles, for example, can shrink up to 25 percent. If you're using a fabric with a repeating pattern, it's very important to buy extra yardage for matching up the design. Extra fabric also needs to be factored in to allow for the lining of skirts and to have excess material for tucking in at the back and sides as well, to achieve the oversized slipcover look I prefer.

 For more formal or streamlined furniture, however, a tailored fit is more appropriate. If you want the piece to stay sleek, as is the case in more contemporary styles, you should have the slipcover dry cleaned rather than washed, as this creates the look of upholstered furniture but still offers the functionality of a slipcover.

3. Decide if you want piping around the cushions and what type of skirt and ruffle treatment you want, if any. There are a variety of different ruffle styles to chose from, including kick pleats, box pleats, double ruffles, and flanges. The amount of total fabric you'll need will be influenced by the type of ruffle you choose. If your chair or sofa has interesting legs, you might consider letting them show. If that's the case, as it often is with more modern shapes, then you may want a shorter skirt or no skirt at all.

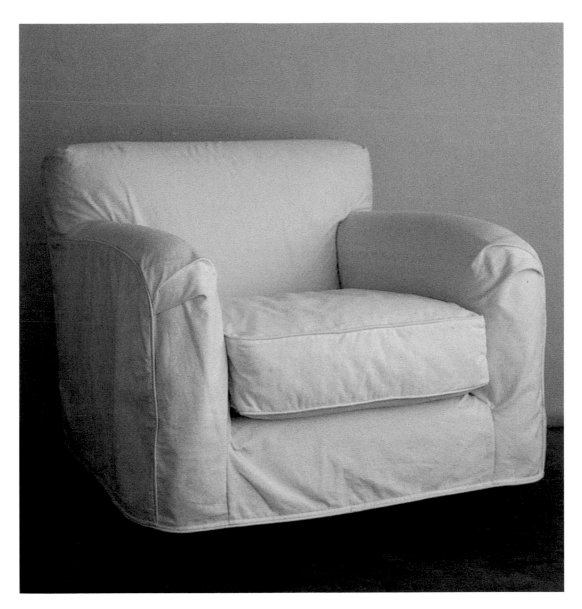

4. Have the fabric fitted to the piece of furniture. Most slipcover suppliers make house calls. Some will take the furniture back with them to be covered, while others will take the fabric only and return with the finished slipcover for the final fitting.

5. Make sure the edges of your slipcovers are overlocked—that is, overlapped and resewn for reinforcement, especially if you're going to be washing your slipcovers rather than having them dry cleaned. Overlocking prevents fraying, although the process is expensive and can add as much as an additional one-third to labor costs.

STUFFINGS

hough not visible, the stuffings of chairs and couches are crucial to their comfort and longevity—a factor not to be overlooked whether you're buying ready- or custom-made furniture. While older sofas and couches have springs as their basis of support, most seat cushions today are made of a piece of synthetic foam core, which is available in a range of firmnesses, from super soft to extra firm. The foam is then enveloped by softer cotton, feathers and/or down, and sometimes Dacron to make it more cushy. To make your sofa or chair last longer, it's important to change the foam every few years. You can buy foam core at many fabric stores or you can have an upholsterer change the foam for you. The back pillows of a couch or chair, as well as freestanding pillows, which don't need to offer as much support, don't require the foam core and can be made entirely of softer feathers and down—my favorite stuffing material.

Feathers and down, used by most high-quality cushion makers, are generally considered to be most desirable stuffings. Because feathers and down can conform to different body shapes, they create a more squashy feeling than synthetic polyester or

RIGHT TOP: The stuffings of this nineteenth-century Danish sofa—hay, flax, burlap, linen, jute, and horse hair, which are no longer used as stuffings—reveal its age. Today, various stuffings can be mixed to achieve different degrees of softness and hardness, as taste dictates.

RIGHT: Shown here are piles of different sofa and chair stuffings—synthetic, cotton, and kapok. Today, most cushions are a combination of different stuffings. Most commonly, a foam cushion is surrounded by cotton or down to create a firm center and soft outer layer.

OPPOSITE: The type of stuffing used in a chair or sofa is as important as the piece's structure and fabric covering. Fine feathers and down, considered to be the most desirable stuffing for cushions today, are used at most high-quality cushion makers like this one, where the feathers fly. For seat cushions, which require more support, the feathers usually surround some type of foam cushion, while back pillows are often made entirely of feathers and down.

urethane foam, both of which have less give. Made from the fine, soft feathers that keep the under-bellies of geese or ducks warm, down is more expensive than regular feathers. Varying the proportion of down to feathers in a cushion creates not only a difference in feel, but can also keep costs lower.

When making decisions about stuffing, try out a variety of cushions from super-soft to extra-firm to find out what your individual needs are. But whichever your preference, don't ignore stuffing, as it's critical to the longevity and comfort of your furniture.

Whether leather, wicker, or slipcovered, I look for comfort, quality, ease of use, and a certain aesthetic appeal or character in seating—the same qualities that are essential, in fact, to almost every aspect of my home decor philosophy.

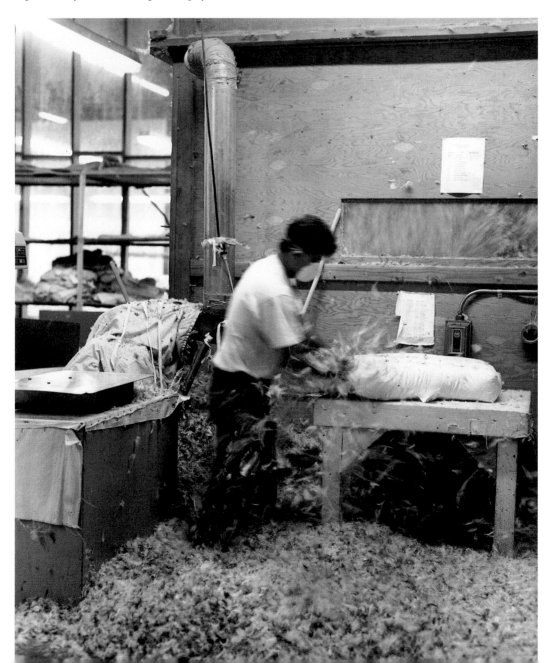

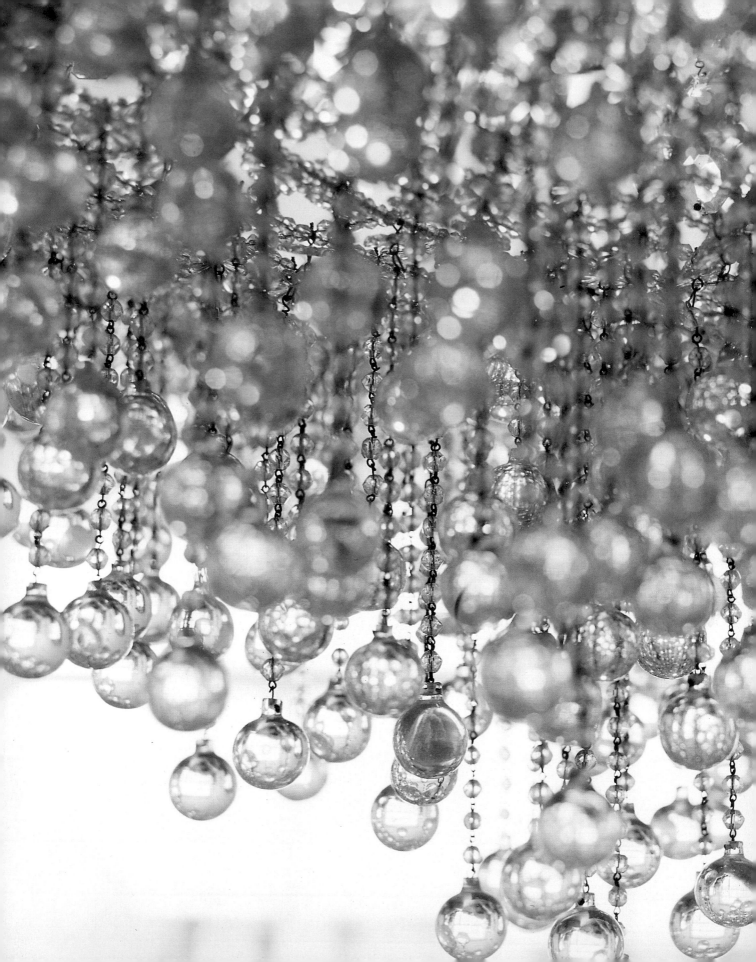

6
LIGHTS
&
LIGHTING

W hether subtle or bright, ambient or accent, cool or warm, light dramatically influences the mood of a home. Lighting has the almost magical ability to enhance a beautifully decorated room or to make a room that may be lacking in some way appear more flattering.

Lighting serves an important array of purposes from room to room and from moment to moment. A front entryway for example, should offer warm, inviting, welcoming light; a kitchen, light that is functional for cooking; a bedroom, various options of light for either relaxing, reading, or getting dressed by. The quality of light one desires changes both according to need and personal preference.

If you find a chandelier you want to buy but it has a few missing pieces, it may be worthwhile to purchase some new crystal or glass and do the work yourself. Depending on their size and quality, and whether they're glass or crystal, vintage or new, these replacement pieces range in price anywhere from a few to twenty dollars. An old cabinet serves as a storage space for chandelier parts (BELOW LEFT). A chandelier in need of some repair (OPPOSITE). Work in progress— a pile of crystal and some bulb holders wait to be added to the fixture (BELOW RIGHT). The finished product (PAGE 155).

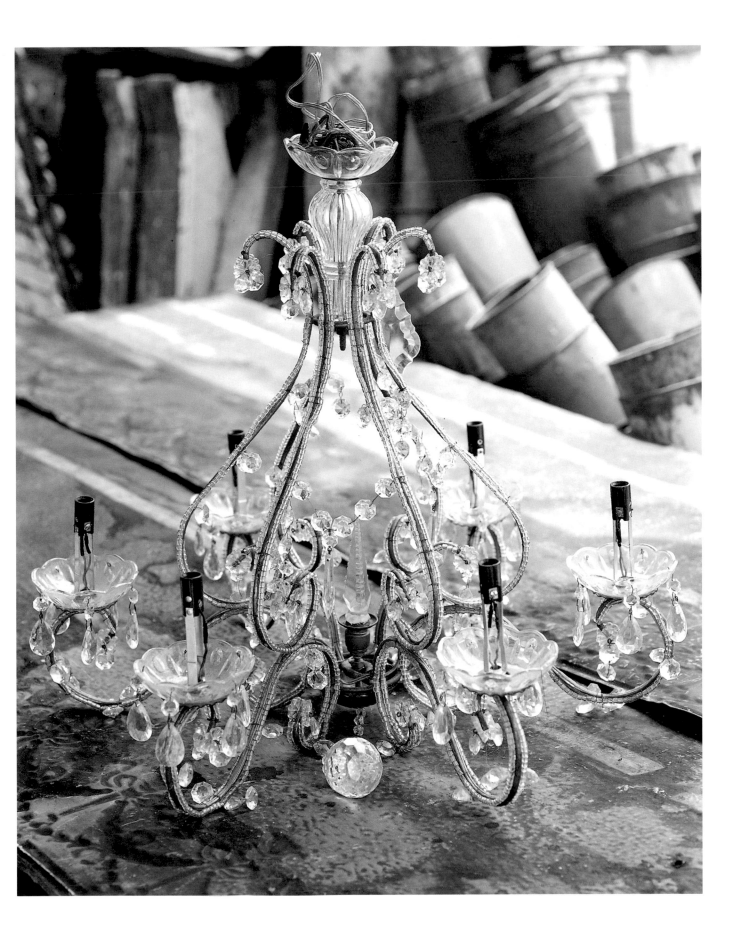

There are three main elements of lighting to consider—fixture, function, and quality—and my approach to them is simple. The fixture should be attractive, unless it's a hidden source of light. The quality (determined by intensity, type, and placement of the light fixture) should be both pleasing to the eye and fulfill the intended function, that is, it should be suitable for reading or establish a mood, and so on. Natural light is important, too—be it sunshine pouring through windows or the comforting mood of fire and candlelight, both of which are among my favorite ways to light any room.

ABOVE: **Vintage chandelier sketches that inspired me to restore some old fixtures.**

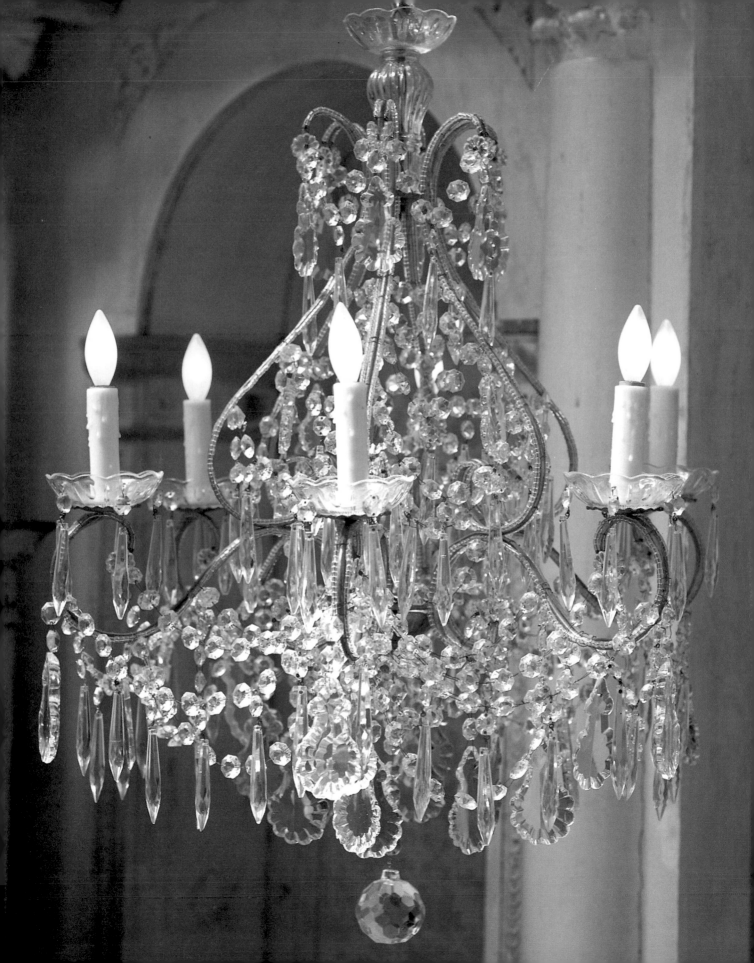

FIXTURES

Lighting fixtures can be attractive accessories that serve as decorative aspects of a room, regardless of the quality of light they emanate. Sometimes the physical structure of the light itself is determined by the function for which it is intended. The form of a chandelier, for example, does not make it conducive to reading by, while a desk lamp is not structured to create a warm, ambient light for a living room.

Crystal chandeliers, intricate wrought-iron Italian sconces, colored glass lamp shades that give off a warm glow, interesting vintage lamps made of porcelain or glass, or casual wicker lamps—these are the types of lighting fixtures that work best in humble Shabby Chic environments. Chandeliers and sconces, electrical or candlelit, add glamour and formality to otherwise casual surroundings. They can serve as excellent focal points of a room and make dramatic statements when hung low or in unexpected places. Colored glass shades or pieces of colored glass set into hanging fixtures

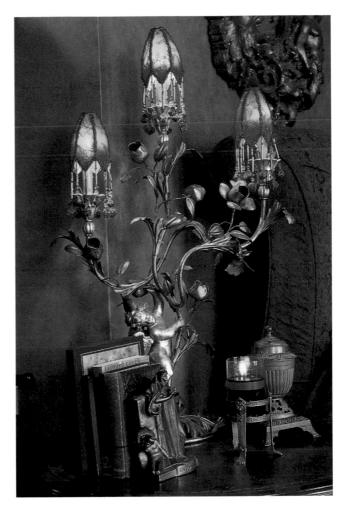

OPPOSITE: Wicker lamps have a fresh look and can make a room feel a little more casual instantly. Here, a collection of wicker lamps from my own home in various weaves—loose, tight, and basket.

ABOVE: A flea market angel adorns the base of this vintage lamp with custom shades in the home of Chantall Cloutier. The amber hue of the shades gives the soft light an even warmer feel.

are attractive because they seem to glow from within and also create interesting patterns of colored light on other surfaces. I like wicker lamps because they have a fresh and natural quality, fit in well with casual settings, and can provide contrast in formal settings to create a more welcoming atmosphere.

Flea markets and yard sales are great resources for discovering vintage lighting fixtures with lots of character. Don't walk away from a wicker lamp just because the weaving is torn. Don't ignore a broken chandelier or lamp that you love only because the wiring doesn't work. Wicker can be restored (see

Chapter 3, "Hidden Treasures and Inspirations"), and wiring problems can be fixed easily by an electrician. Cracks in a metal chandelier can be fixed by a welder.

With regard to electrical fixtures, I suggest having an electrician look at any used lighting fixture as a precaution against sparks, shorts, or fires, even if the piece seems to work perfectly. Of course, the restoration costs of rewiring vary drastically and are dependent upon the intricacy of the job. Internal wiring costs more, for example, than external wiring. You can expect to pay anywhere from forty to two hundred dollars to have a chandelier rewired. A less expensive alternative is to transform a lighting fixture into a candleholder by removing all the wiring and placing candles in the bulb sockets. If there are cracks in the sockets, adding small holders made of glass or metal will help prevent the candle wax from dripping, or you can use dripless candles.

To avoid fire hazards, be sure the chandelier is placed well away from fabrics, wood, and other inflammable materials and avoid leaving candles unattended.

When replacing lamp parts, keep quality and authenticity in mind. Cloth-covered cords and brass pull chains are more appealing than plastic ones. If you're replacing light bulbs, frosted ones not only look better but offer a gentler radiance. If a chandelier is missing a few pieces of crystal or has colored pieces and you'd prefer an all-clear look, this too can be corrected with new crystal or glass pieces. If the job is simply a matter of replacing a few pieces, you might attempt it yourself. But if the job entails an entire re-creation, you may want to reconsider the purchase. Such restoration is not only costly but finding a qualified specialist in what is now becoming a lost art can be difficult and time-consuming.

Sunlight coming through this jeweled Moroccan candle lamp makes it a terrific lighting fixture, even in the daytime. Another of the lamp's features is that it works equally as well outdoors as in. Here, it hangs over my sun deck, its cool blue and green jewels mimicking the tones of the sea.

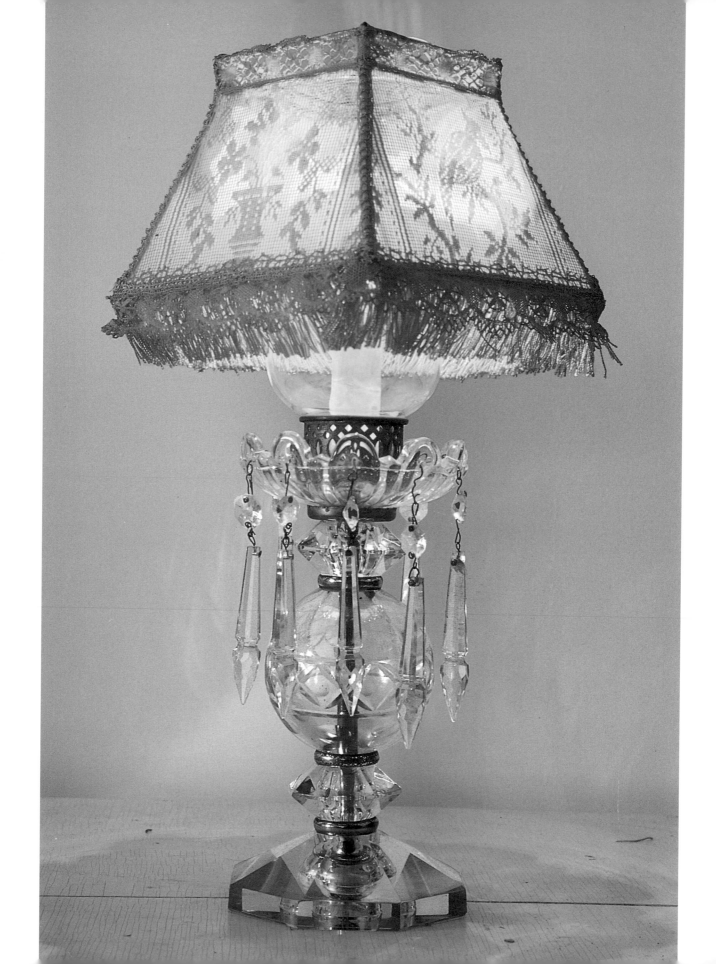

FUNCTION
AND QUALITY

The function of a particular light—whether it be for reading, cooking, or creating a relaxing environment—in turn determines the quality of light that should emanate from it. The quality of light is comprised of the type of light, its brightness or intensity, its warmth or coolness, and its placement. The two most common types of home lighting are fluorescent—the flat, cool light commonly found in kitchens—and incandescent—either halogen, a harsh, bright light often used as desk lamps, or tungsten, a warmer, lamp light commonly found in living rooms and bedrooms. The brightness or intensity of a light is determined by the wattage of the bulb and can be altered by putting the light on a dimmer switch. Available at hardware stores for about twenty dollars, dimmer switches are easy to install.

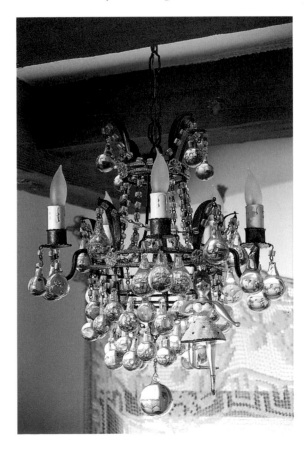

OPPOSITE: A "chandelier" lamp from the forties lends elegance to a simple white bedside table in the home of Philomena Giusti, imbuing the room with a soft, warm light.

LEFT: Not only is the type of light that a source gives off crucial to creating a mood, but the look of the lamp or light itself is important, too. The faded grandeur of this flea market crystal chandelier in Jennifer Nicholson's front foyer sets up the ambiance for her entire house. As a personal touch, Nicholson added a tiny glass ballerina ornament.

ABOVE: This intricate iron chandelier found at a flea market hangs amid the vines on Jennifer Nicholson's front porch and is the type of warm touch that makes a good first impression and sets the tone for the decorative style within the house.

I love cool, flat, clean light with an almost bluish tone. Whether a light is cool or warm depends on the type of bulb and its intensity but also on its surroundings. If a room is done in hues such as greens, silvers, grays, and blues, like the floral guest room of Tony and Donna Scott, you're more apt to achieve a cool blue versus a warm rosy quality of light. Light reflected off stone surfaces and windows facing lots of greenery or covered in cool, sheer shades are also ways to attain this calming, tranquil quality of light.

The placement of a lighting source—whether direct or indirect—can also make a vast difference in the perceived depth of a room and its overall ambiance. Lighting, like most other aspects of home decorating, is about balance, a compromise between aesthetics and function. Just as I don't believe in decor that is precious or ostentatious, I steer away from lighting that is overly dramatic or decorative. Even when coming from artificial sources, lighting should appear as natural as possible, blending in with, rather than standing out from, the comfortable, practical, livable aspects of a home.

TOP LEFT: Walls along staircases are opportune places for whimsical or welcoming accessories to greet passersby. This delicately carved metal wall sconce depicting a female nude with a horn in the 1926 home of Tony and Donna Scott dates from the residence of its former owner, John Barrymore.

LEFT: The empty area between two doorways is an unexpected spot for a touch of whimsy. A floral toile wall sconce from the forties, set between bunches of dried flowers, lends color to this space in Philomena Giusti's home.

OPPOSITE: Sometimes one great piece can inspire the look of an entire room. A relic from the home's former owner, John Barrymore, this grand, intricately detailed, angel and floral Dresden chandelier from the palace of Archduke Francis Ferdinand sets the mood for Tony and Donna Scott's formal living room.

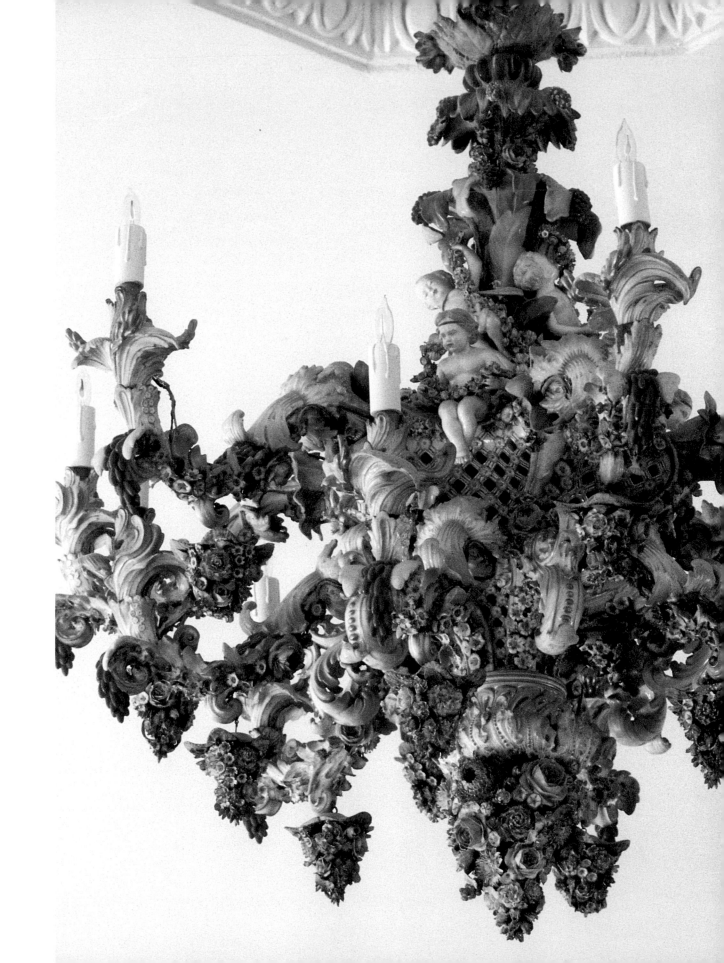

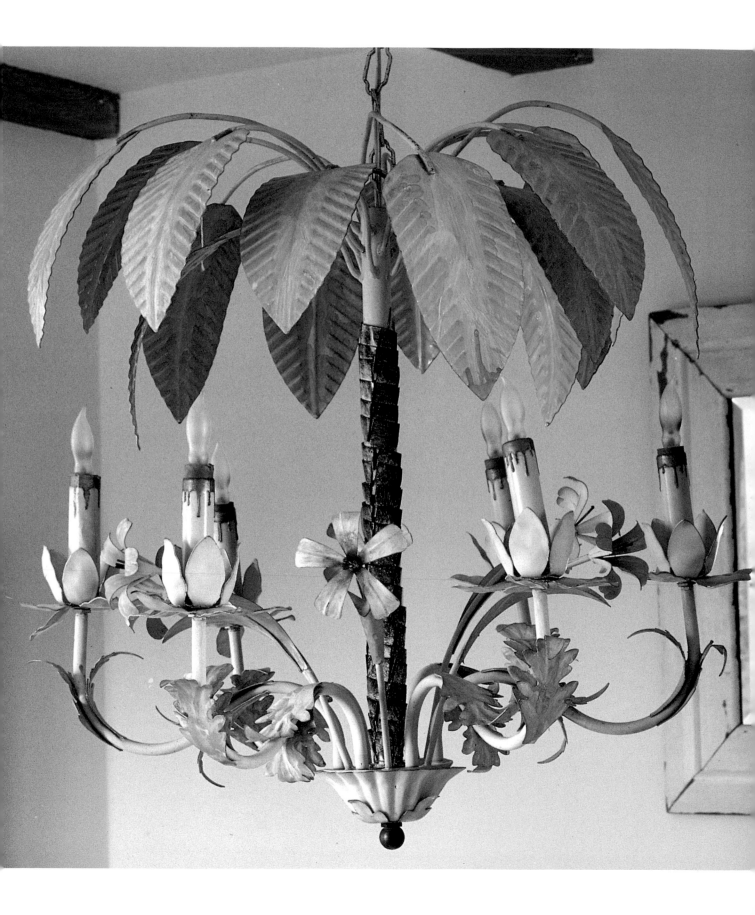

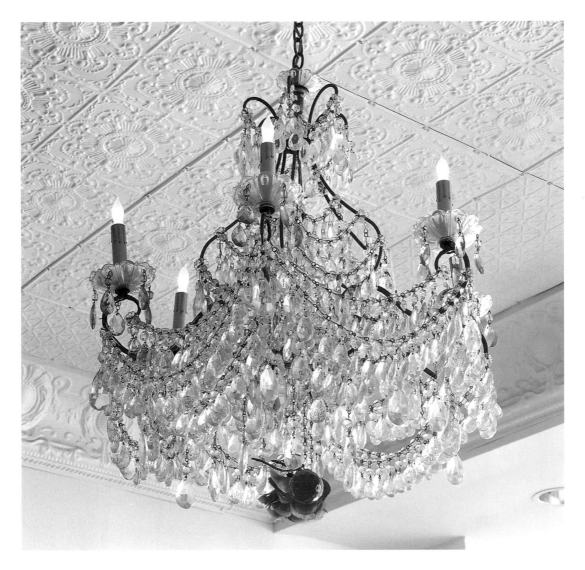

OPPOSITE: A palm tree hanging lamp dating from the forties lends an air of whimsy to Tony and Donna Scott's guest house bedroom.

ABOVE: Ceilings, very important to creating a sense of height and space in a room, can add real design interest, too. Tin ceilings, though expensive, give a room a rich feeling and make great backdrops for beautiful lights. I love the play of pattern upon pattern created by this crystal chandelier against the embossed tin ceiling shown here.

FOLLOWING PAGES: Jennifer Nicholson decorated an entire corner of her home around this unusual vintage Czechoslovakian chandelier with glass in the shape and color of grapes. The first piece she bought for her home, it illustrates how lighting sources can be aesthetic as well as functional.

NATURAL LIGHT

Natural light sources, such as sunshine, fires in the hearth, and candles, not only give off a warm, comforting glow, they bring an element of simplicity back into the home. If you have lots of windows, use them. Shades and blinds can be left up or kept very sheer, and curtains can be pulled back. In fact, window coverings can be dispensed with altogether to let in more sunlight. Candles and flickering fires give off a flattering, soft light that is almost impossible to create artificially.

Candles are one of my favorite accents for any room, for they set an excellent mood for entertaining and can be luxurious additions to everyday living—as long as you are mindful of fire hazards—especially when used in the day or placed in unexpected spaces, such as bathrooms.

Natural and ambient light warms Tony and Donna Scott's guest quarters.

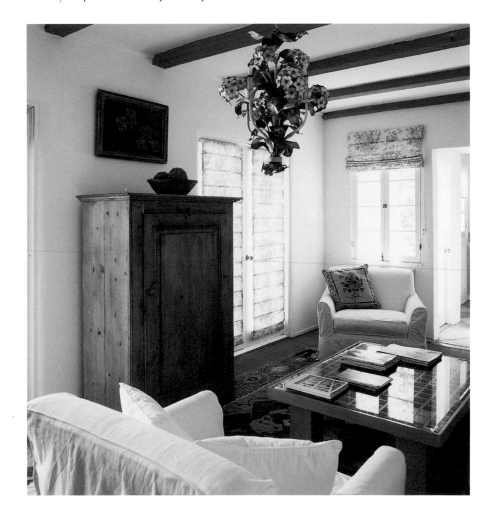

T I P S F O R
C A N D L E S

- Candles with the most versatility are neutral in color. Creams, whites, and beiges blend well with all colors and styles. Large, thick candles last longer and look more substantial than tall thin ones, although the latter are good for chandeliers and elegant table settings.

- Placing candles in groups and mixing and matching various shapes and sizes makes the candles themselves a decorative focal point.

- The look of candles can be completely changed according to the holder in which they are placed. Tall silver or crystal holders and chandeliers instill candles with a grand quality, while shorter holders made of glass, porcelain, or other materials—or even no holders at all—give them a simple, homey character.

- Fragrance is another unique aspect of candles. Although an array of fragrances is available, I think it's best to stick to one scent, such as vanilla, for the most pure effect.

- Drips and drops of wax from a candle are part of its shabby appeal and help make a room feel more lived in. So avoid dripless candles, unless you're using them in a chandelier.

There is nothing like candlelight to create an instant mood. I love clusters of candles, like these fragrant ones in Chantall Cloutier's living room. I like to use candles in natural tones—creams, whites, and browns—that have different textures but that work together. Cloutier has collected a variety of interesting metal holders that reflect each other's light.

As a subtle, rather than a dominant, characteristic of a room, lighting—whether from a candle, window, or table lamp—is all too often considered only a sidenote or afterthought when decorating a home. Yet, as I have illustrated here, lighting is as important as fabric, furniture, or color scheme in creating an ambiance.

It is important to recognize that it is often the more subtle aspects of a room that make a lasting impression—the almost indiscernible blending of the muted hues of pillow, couch, and rug, or the afternoon light casting a glow across the hardwood floor. These are the touches that give a room its unique mood and atmosphere, its coziness or comfort level. These are also qualities that cannot be bought prepackaged from a home decor store or an interior designer. They must be created and blended together in the kind of individual combination that makes a house a home.

7

—

FLOWERS

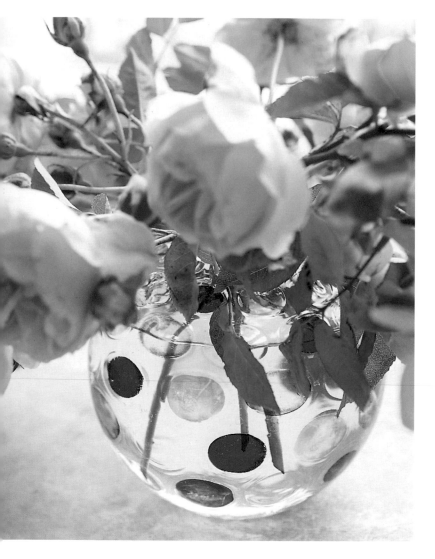

eal flowers and their abstract representations are one of the most important characteristics of the Shabby Chic style and an essential ingredient for creating the simple, unaffected look I love. As reminders of the natural evolution of life and the beauty of all its stages—from glorious budding and blossoming to delicate withering and fading—flowers bring the outdoors into the home, adding life, color, and fragrance.

PRECEDING PAGES: Because of their undefined, almost blurry shape, muted coloring, and soft texture, peonies, available in many varieties, are good flowers for casual arrangements.

LEFT: Unexpected colors, a bit of humor, or an offbeat pattern on a vase can prevent a floral arrangement from being too romantic. The lively, circuslike polka dots of this glass bowl offset the dreaminess of the roses and lend the arrangement a bit of whimsy and modernism.

OPPOSITE: Large, loose arrangements can lend real impact without being overpowering, as demonstrated by these giant white poppies paired with eucalyptus leaves. This arrangement dominates the corner of the room while also blending in with its surroundings, picking up on the green floral print of the chairs and sofa and complementing the white floral oil painting behind it.

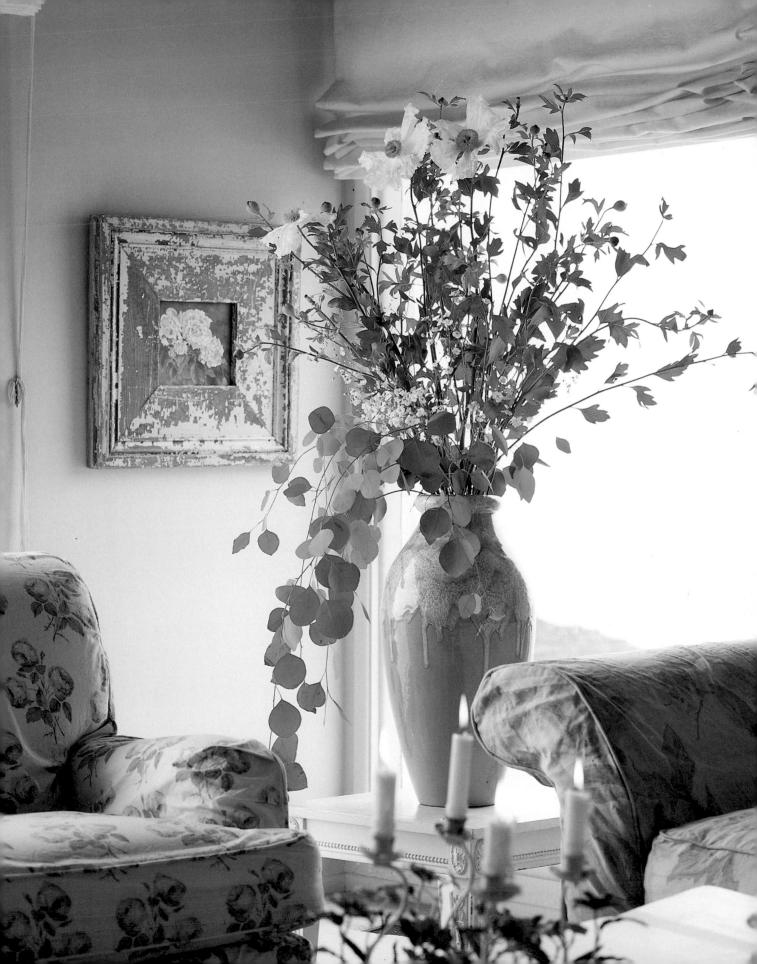

FRESH FLOWERS

Farmer's markets, fields, gardens, meadows, nurseries, and flower marts in major cities are prime locations for finding quality fresh flowers. Farmer's markets are my choice, as they are so accessible and usually offer a mishmash of meadow and field flowers that look less cultivated than flowers from other outlets. Large bunches can be purchased for anywhere from two to ten dollars. City flower marts are usually restricted to those with wholesale accounts, so unless you have a connection, they can be frustrating to use. I try to avoid hothouse flowers because they tend to look too artificial. Small imperfections and slight irregularities give flowers a more individual, natural feel.

Varieties of flowers that serve as good basics for the kind of bountiful arrangements I love include bearded iris, garden roses of all varieties, lavender, lilacs, Casablanca lilies, camellias, tulips, peonies, delphinium, hollyhocks, and dahlias. Flowers good for floating in bowls of water include lilies, orchids, roses, and gardenias.

Rounding out bouquets with fillers gives them more depth and fullness. Some of my favorite fillers include eucalyptus leaves (silver dollar or knife blade work better than spiral varieties), lemon

leaves, Queen Anne's lace, and flowering fruit branches, such as peach, apple, and cherry—but almost anything tall with interesting branches or leaves works well. Some fillers are available at farmer's markets. Others can often be found in your own backyard or on a nature walk.

I prefer large and abundant arrangements in wide-lipped vases filled to bursting. Though bright flowers can be dramatic, I usually select more subdued hues, like dusty pinks, blues, laven-

LEFT: Orchids work well in sophisticated settings and bespeak an elegant beauty. Most orchids should be kept in light, airy soil or bark and misted as much as possible.

OPPOSITE: Just as the natural irregularities of flowers add to their beauty, imperfections in vases can hold appeal. The chipped flowers on this porcelain vase imbue it with a wilted feel that echoes the appearance of the roses inside. If such imperfections are too distracting, they can be covered up economically with a bit of nail polish.

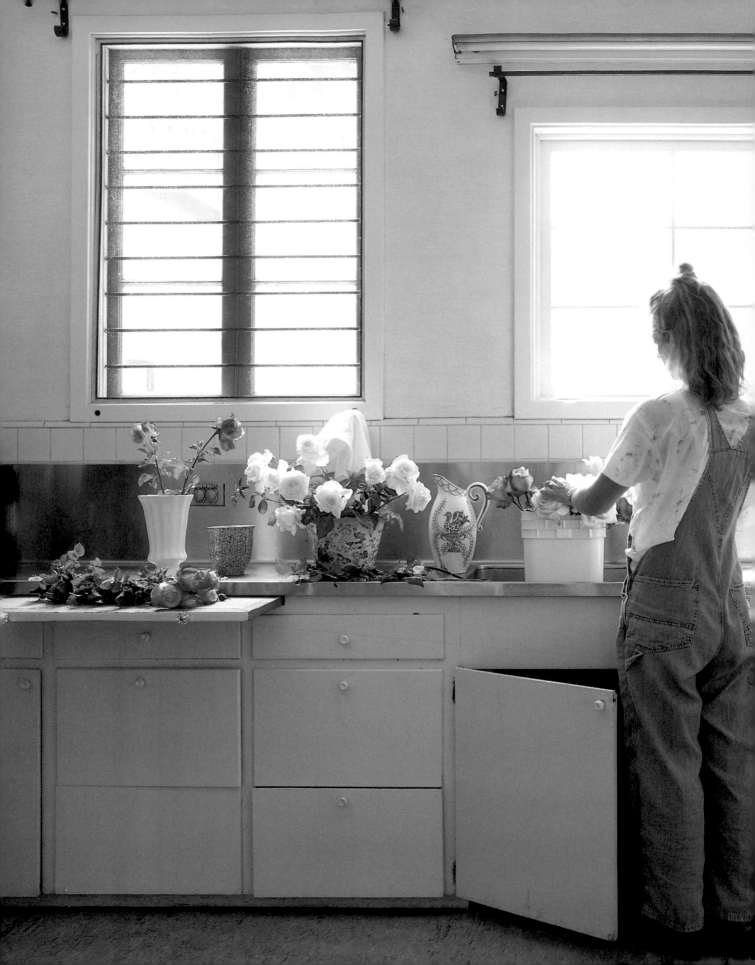

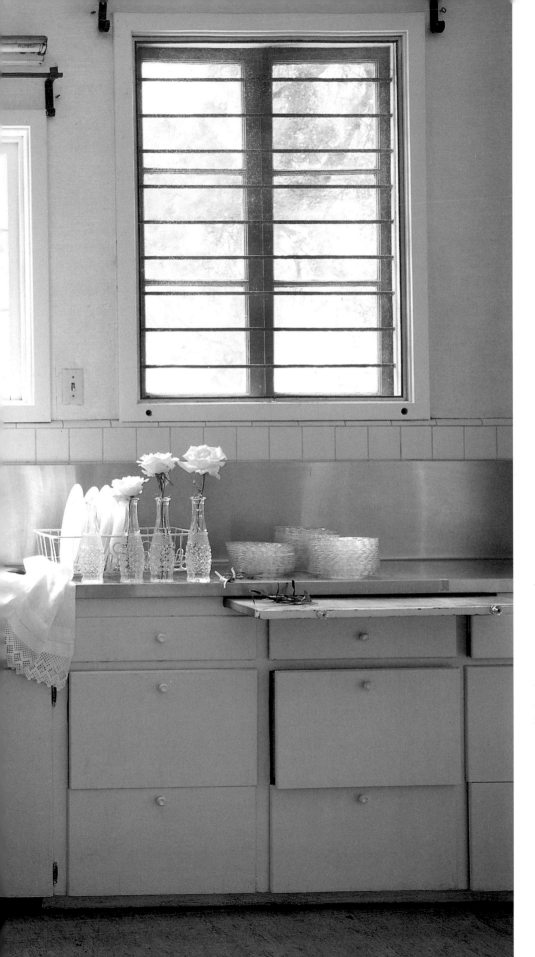

For me, arranging flowers is
not work but one of my
most enjoyable pastimes. I
love playing with roses in
particular. If possible, work
where you'll have lots of
room to spread out.

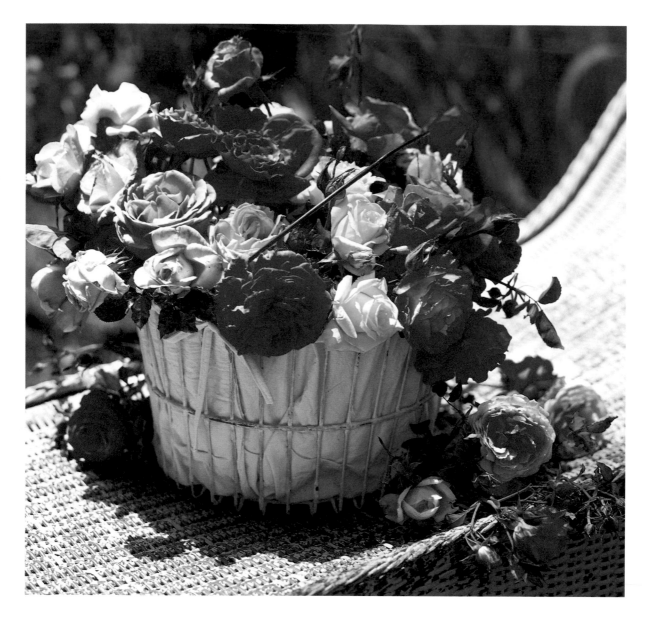

1. JARDINS DES BAGATELLE
2. ANGEL FACE
3. CALICO
4. HEINRICH MUNCH
5. ABRACADABRA
6. SOUTH SEAS
7. WINCHESTER CATHEDRAL
8. PRISTINE
9. GRAHAM THOMAS
10. CHARMIAN
11. ARLENE FRANCIS
12. BROADWAY
13. MISS ALL AMERCIAN BEAUTY
14. PARTY TIME
15. COTTAGE ROSE
16. PERDITA
17. PARADISE

1. PEACH BLOSSOM
2. LEANDER
3. PEAUDOULE
4. LUCETA
5. SILVER SHADOWS
6. LILAC ROSE
7. COTTAGE ROSE
8. PERDITA
9. LEANDER
10. ENGLISH GARDEN
11. GEORGIA
12. PRISTINE
13. WIMI

A giant bunch of garden roses is eye-catching wherever it is placed. Garden roses have bigger blooms and are more fragrant than the typical hothouse variety sold in most shops. Rather than being bred to look identical, garden-rose blooms are individual, with several buds or branches attached to each stem in a unique pattern. When placed in a group, the particular characteristics of the roses become all the more exaggerated.

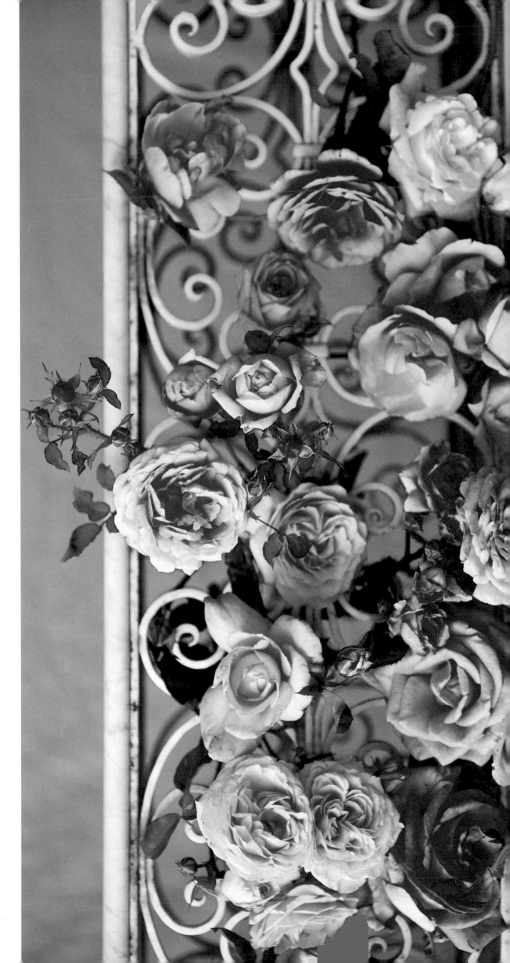

ders, and creams and arrange them in monochromatic or subtle color variations. In keeping with the imperfect, comfortable look of the furniture and fabrics that appeal to me, I'm attracted to flower arrangements that are asymmetrical, irregular, wildly shaped, and loosely, almost haphazardly, assorted. An arrangement should never be so studied that it dominates the flowers themselves. I much prefer random arrangements of flowers that can be enjoyed from all angles, like the flowers growing naturally in a garden. To keep an arrangement from becoming one-sided, I rotate the container as I work. I gravitate toward vases with unique details, preferably old ones with cracks and chips caused by the vagaries of time. Occasionally, an old vase will not be watertight, but that is a problem easily solved. Professional liners can be purchased inexpensively at most floral supply outlets. I often just place a glass jar filled with water inside the vase.

Flowers need not be confined to short periods of display. The evolution of their life cycle, even in their later stages of subtle wilting and slight drooping, is a part of their appeal. Discarding an arrangement after a few days does not allow for an appreciation of its graceful aging, which can be as dramatic and beautiful as its peak, fresh from the garden display. I like to let petals that have fallen from an arrangement to the table below remain there as part of the look. Gathering the fallen petals in a porcelain or glass bowl (with or without water), using them in satchels of potpourri, or drying them are other ways of appreciating the loveliness of flowers longer. I also love the feeling of bringing the outside in with a potted rosebush. Not only is it a creative alternative to more predictable floral displays, it ultimately lasts longer and is less expensive. Costing anywhere from eighteen to twenty dollars each, rosebushes typically last for about two weeks before needing to be replanted outside.

While flower arrangements are common in living rooms and dining rooms, placing them in unconventional, less-expected locations can add new life to any space. An arrangement of flowers might pop up in a forgotten corner, a hallway, under the staircase, or at the edge of the bathtub. Fresh flowers—or those made of silk, velvet, or linen—can also be a wonderful surprise on a plain wrapped present, as an adornment for a frame, or decoration on a birthday cake. For gifts, I often just use a plain brown paper bag, adding flowers or vintage milliner's trinkets in the shape of fruits and berries, and scraps of fabric, lace, string or raffia as trim. Old hat or vintage shoe boxes, which can be found at flea markets and secondhand shops, can also make very pretty containers for presents.

Fabric flowers can be used in place of real ones if they are made of high-quality material. Linen, velvet, and silk, for example, have the ability to mimic the soft folds and frays of real flowers.

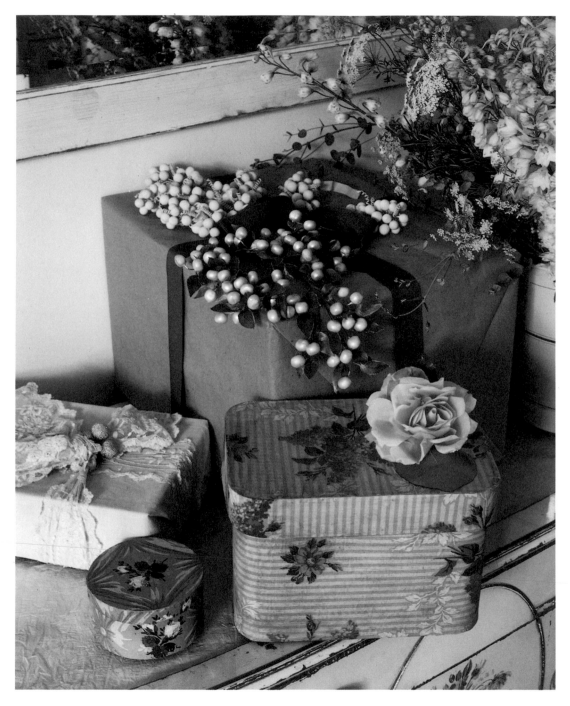

ABOVE: Flowers, whether real or faux, make attractive accents for presents. Some butcher paper or paper bags, scraps of old fabric, ribbon or lace from around the house, and a bit of raffia or string are all you need to wrap a lovely gift.

OPPOSITE: Fresh flowers from the garden are an inexpensive, easy way to decorate cakes. The large roses atop this green marzipan cake make all the difference between ordinary and unique ornamentation.

FLOWER CUTTING
AND CARE

- Have water immediately available when you are cutting flowers and put them in the water as soon as possible. For maximum freshness, flowers should never be out of water for very long.

- Cut stems with a sharp knife at a diagonal, scraping the sides an inch or so above the cut to maximize the amount of surface that can absorb water. If the stem is thick or woody, make a few crisscross cuts and scrape off an inch or two of bark up the stem so water can penetrate more easily.

- Remove all leaves below the vase line and any excess foliage. The idea is to steer the water to the flower, not to leaves that you can't see. Remove blossoms and leaves as they die to conserve energy for the remaining flowers, unless, of course, you like the look of the wilting flowers.

- Always use clean water and add new water often, keeping the stems submerged, even if you change the water completely or move the flowers to a different container. Some stems are very delicate and can close up their cuts after only a few moments of air exposure.

- To revive flowers that have become droopy, completely submerge them in cold water for about an hour. This works for any flower that does not have a fuzzy texture (fuzzy-textured flowers tend to get water spots). Misting leaves in hot weather can also help refresh them.

- Bleach can act as a preservative for flowers by keeping the water clean and preventing bacteria growth and malodorous fumes. But don't overdo it. A teaspoonful is sufficient. Professional floral additives, which inhibit bacteria, stimulate growth, and condition water can be purchased at florists or floral supply stores. Bleach is also good for cleaning containers thoroughly.

White tulips are a simple classic that works everywhere.
Here Chantall Cloutier uses them to lighen up the rich-
ness of this dark corner of cobalt bowls and candles.

F L O R A L
R E P R E S E N T A T I O N S

Oil and watercolor paintings of flowers are one of my favorite accessories for a room. Good examples tend to come from the mid- to late-Victorian era and depict flowers scattered randomly across the canvas rather than in the formal, stylized vase arrangements paired with birds or fruit that were predominant in the twenties. "Yard longs"—named for their size—are relatively rare, horizontal floral paintings or prints, mainly from the nineteenth century. The proportion of a yard long makes a good choice for hanging over couches or beds, in long hallways, or behind tables. Floral paint-

ings have become extremely popular in the last few years, and so are much harder to find and more expensive than they used to be, although good ones can be found occasionally at flea markets.

I try to avoid paintings that require restoration, although small flaws can be covered up with minimal work. If a canvas has a small rip, as opposed to a missing piece, you can smudge a bit of oil paint that matches the color in the painting onto the front side of a piece of acid-free tape, then fasten the tape to the back of the canvas. Larger flaws can be repaired professionally, beginning at a cost of about two hundred dollars. One positive aspect of paintings with flaws is that you can bargain for better deals.

Most of the floral paintings I'm attracted to are from the turn of the century, when artists created less formal compositions. Although I don't look for works by registered artists, sometimes I'll happen upon a work that is by a well-known painter such as these pink roses (OPPOSITE BOTTOM) by Marie Johansen. Sometimes, a painting doesn't require a frame at all, such as this slightly more formal composition of fruits and flowers (OPPOSITE TOP).

BELOW A frame can be as much a part of an artwork as the canvas. The size of this frame, made from an old architectural molding, almost overshadows this tiny painting of a rose in my living room. Chipped and peeling, the frame adds a feeling of glamour and delicate decay.

ABOVE: My favorite floral paintings are flowers simply laid across a table, unrestricted by a vase, framed with old architectural moldings.

OPPOSITE: These Victorian rose studies are a rare find. They are leftovers from an art school session in the late 1900s, when women used to gather in small groups and paint their own renditions of the same still lifes.

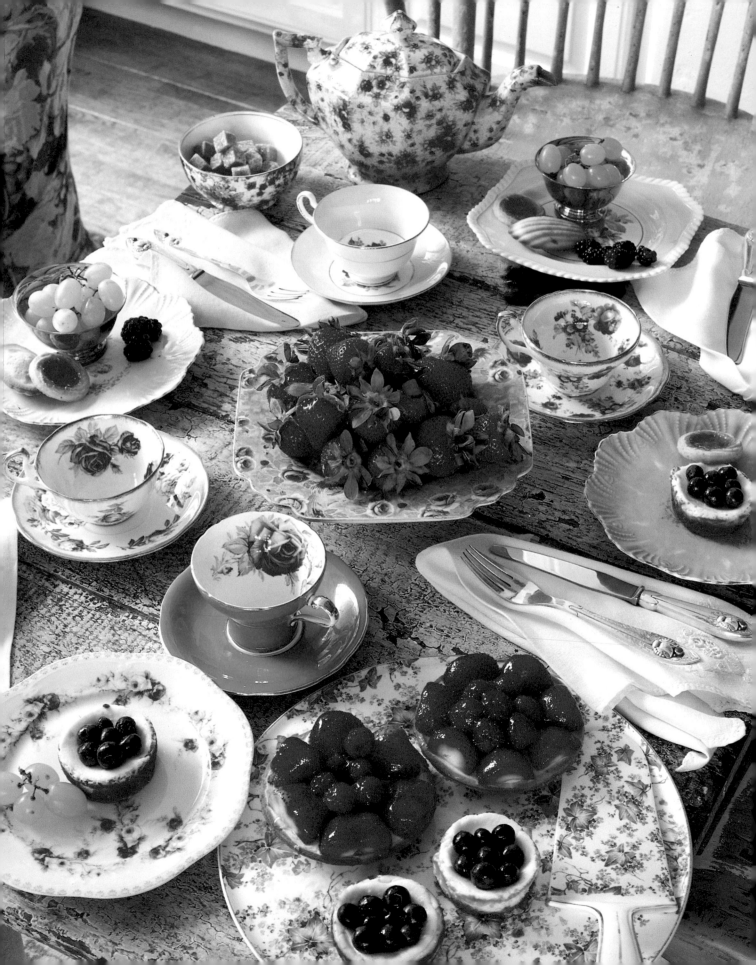

OPPOSITE: These teacups with "chintz" patterns and floral designs inside as well as outside are Jennifer Nicholson's favorites. Here she uses them informally, with mismatched dishes and colors that complement one another. The worn pink table's scratches and cracks are left to create an interesting contrast with the dainty floral teacups, fine linen napkins, and silver. Nicholson collects cups from small shops, flea markets, and antique sales all over the country. She much prefers these to perfectly matching pieces, which she finds to be too stiff and uniform. (See Resource Guide.)

ABOVE: The unique qualities of this silver teapot that my friend inherited from her grandmother are its delicate floral etchings and hinged lid. The creamer is covered with a shell and bead-trimmed net from Africa. The cracks in the wooden tray and the tiny reproduction roses added to its edge give this tea setting a wonderful, crumbling, shabby mood.

LEFT: Beautiful form and useful function merge perfectly in this delicate, hand-made rose teacup belonging to Jennifer Nicholson. The muted color, wilted look of the petals, and the rose-bud handles are examples of the types of details that make a piece exceptional.

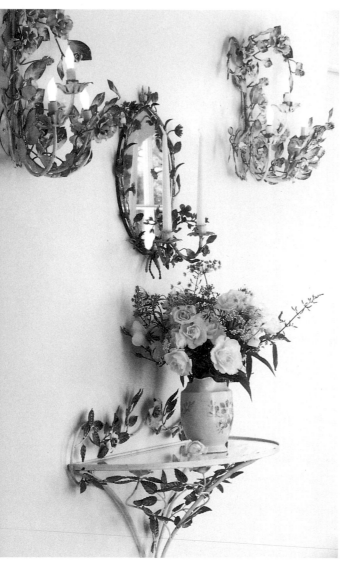

LEFT: This plain white wall in a hallway of Tony and Donna Scott's home was turned into a visual feast of flowers, with every piece serving a practical purpose. Delicate Italian ironwork is shaped into sconces, a circular-trimmed candleholder frames a mirror, and a leaf-motif half-table provides the perfect spot for a flower-painted jug of fresh white roses.

OPPOSITE: Flowers do not have to be fresh in order to bring a feeling of nature into a room, as in the intricate and delicate detailing of the flowers on these Italian candlesticks.

Old architectural wooden moldings, their paint cracked and peeling, make eye-catching frames with lots of character, though a canvas with no frame at all is also appealing in its simplicity. Glass can be used to protect watercolors, but do not place it on oil paintings, as they need to breathe.

I often look for floral details on vintage wooden furniture, whether painted, etched, or in relief. Though some artists are masters at adding floral details to furniture, I much prefer pieces with original flower work—as evidenced by cracked, faded, and peeling paint.

Fabrics with floral patterns and accessories such as chandeliers, napkin rings, candlesticks, wastebaskets, lamps, and dishes adorned with flower shapes or painted floral details are additional ways to bring the appeal of flowers to a room. When combining different floral looks, a few well-chosen objects work better than an overabundance of knickknacks, and soft tones and subdued mixes work better than loud colors and sharp contrasts. In my living room and bedroom, for example, the use of complementary tones and subtleties of print and detail help prevent the floral motif from taking over, enabling the look to enhance rather than dominate the room.

Whether real or represented, flowers are a crucial element of interior decor, not only because of their natural beauty but because they enliven the static of the indoors with the more mutable, ephemeral, and sensory quality of the outdoors.

RIGHT: The decayed, delicate look of these dried roses is as beautiful as that of fresh flowers. To keep dried flowers from crumbling, spray them with hair spray and handle them gently. Like real flowers, they can be used in arrangements or to adorn hats or gifts, or can be hung simply in bunches from the wall.

FOLLOWING PAGE: Frilly, edged cotton tablecloths in pale colors left out to dry and benefit from fading by the sun make a lovely sight in their own right, surrounded by rose petals.

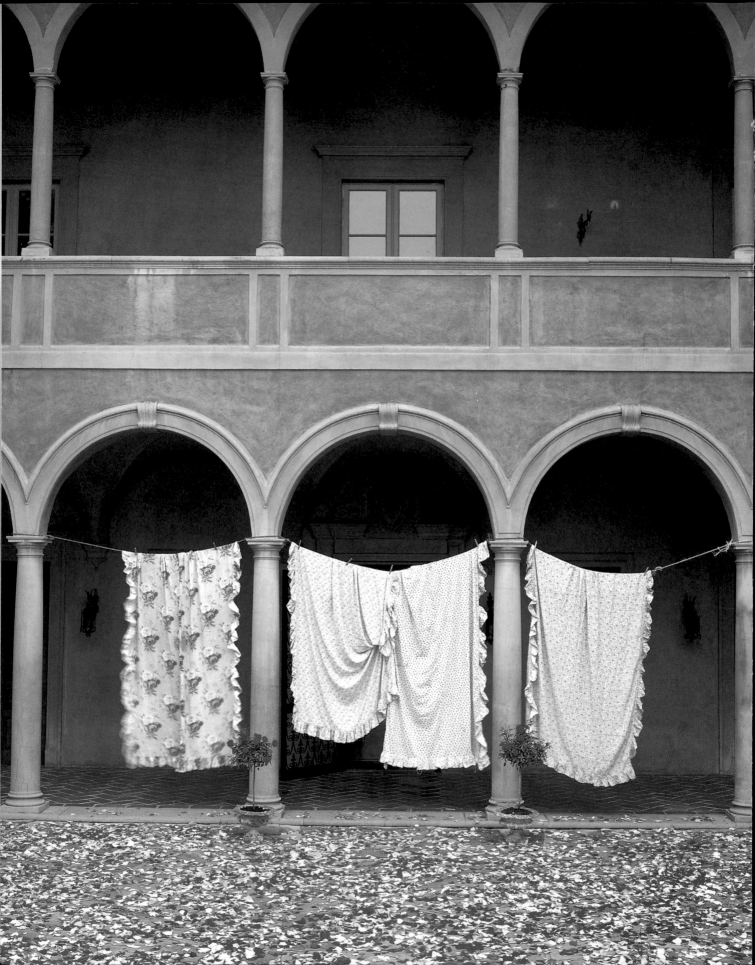

RESOURCE GUIDE

AA-Abbington Affiliates Inc.
Dept V.H. 26
2149 Utica Ave.
Brooklyn, NY 11234
718-258-8333
Page 41: Tin ceilings

Aga John Carpet
8687 Melrose Ave.
Suite B 130
Los Angeles, CA 90069
310-659-4444
Pages 18–19: Rug

Blackman Cruise
800 N. La Cienega Blvd.
Los Angeles, CA 90069
310-657-9228
Page 16: Apothecary jars,
 Indian stone bowls

Bountiful
1335 Abbot Kinney
Venice, CA 90291
310-450-3620
Pages 42–43: French leather club
 chairs
Page 44: Jars
Page 83: Wicker repair

Larson Carpet
1480 Ridgeway St.
Union, NJ 07083
908-686-7203
Page 17: Rug

Liz's Antique Hardware
453 South La Brea Blvd.
Los Angeles, CA 90036
310-939-4403
Pages 92–93: Assorted vintage
 hardware, porcelain, casters,
 wheels, wooden drawer pulls

Maison
148 S. La Brea Blvd.
Los Angeles, CA 90036
213-935-3157
Page 64: Moroccan glassware,
 French glassware

Marmalade
710 Montana Ave.
Santa Monica Ave.
Santa Monica, CA 90403
310-395-9196
Page 66: Catering
Page 190: Catering

Odalisque
7278 Beverly Blvd.
Los Angeles, CA 90036
213-933-9100
Page 45: Nineteenth-century
 100 percent cotton bedding
Page 129: Nineteenth-century
 100 percent cotton drapery

Room with a View
1600 Montana Ave.
Santa Monica, CA 90403
310-998-5858
Page 6: Amber glassware
Page 16: Towel and soap
Page 59: Cutlery
Page 62: Dinnerware

Shabby Chic, Inc.
1013 Montana Ave.
Santa Monica, CA 90403
310-394-1975
Page 2: "Triangle Chair"
Pages 8–9: Cream chintz daybed
Page 13: "Curly Chair"
Pages 14–15: "B&B Chair," "Elegant
 Sofa"—fabric: Pale Bunch
 Summer on Oyster—**Shabby
 Chic Fabrics**
Page 17: "Swayback Sofa," "Mod
 Chair"
Pages 18–19: Blue floral slipcovers
Page 47: Linen/bedding from **Shabby
 Chic Home Collection, T-Shirt
 Collection**
Page 122: Petite Bloom Fall on Butter
 Linen—**Shabby Chic Fabrics**
 Watermark Spring on Butter
 Linen—**Shabby Chic Fabrics**
 Pale Bunch Summer on Oyster—
 Shabby Chic Fabrics
Page 130: Shabby Chic Home
 Collector
Page 136: "Large Chaise" in white
 denim, shades

*The author would also like to acknowledge
contributions from:*

Nina Krivanek: Flower stylist

Pauline Gravier and Liz Sharp:
Decor style assistants